NORDEAST MINNEAPOLIS

A HISTORY

HOLLY DAY & SHERMAN WICK

THE
History
PRESS

Published by The History Press
Charleston, SC 29403
www.historypress.net

Cover image courtesy of Aaron Goodyear.

First published 2015

Manufactured in the United States

ISBN 978.1.62619.783.1

Library of Congress Control Number: 2014956342

To Astrid and Wolfgang, and oh, the places you'll go.

CONTENTS

FOREWORD

While attending the University of Minnesota in the early 1990s, I observed Northeast's resurgence: tried my first gyro at Holy Land, drank Grain Belt Premiums at Nye's and watched rock bands perform at Mayslack's. After graduation, I lived in the Marcy-Holmes neighborhood within blocks of East Hennepin, Northeast and old St. Anthony. To my parents' chagrin, I refused returning to the suburbs beyond going to my parents' home near Stillwater to wash laundry.

Behind the newspaper, my blue-collar father quipped, "It's funny. We vacation all over the place, but we don't bother learning the history of where we're from."

With my bachelor of arts in American history and facing underemployment, I had a mission. I embarked on reading as many local history books as I could before my university library privileges expired. I had studied exotic histories at the U of M—Latin American, modern Indian and Eurocommunism—while dreaming of escaping Minnesota's cold and snow. But reading state and local history opened my eyes; I would never close them again.

After a Terminal Bar show, I went to a party near Logan Park, where I met my future wife, Holly, who lived in Northeast. Two years after our second date to Holy Land, we got married. We purchased a home in the Southeast-Como neighborhood within blocks of the historic East Division's food, ethnic grocery stores, bars, music, art and beer.

A month after we were married, while writing another book, Holly interviewed local architecture historian Larry Millet. He said, "I always

tell people the most interesting place in the world is the place where you grew up." That left a lasting impression on me. And so did Paul Gruchow's sentiment in the foreword to the anthology *The North Star State*, "All history is ultimately local and personal."

SHERMAN WICK

ACKNOWLEDGEMENTS

Without Lucile M. Kane, Scott Anfinson, Larry Millett, the authors of *Saint Anthony Falls Rediscovered*, Doug Hoverson, Annette Atkins and Lucy L.W. Morris to name a few, a history of Northeast would have been impossible. We are grateful not only for their books on the topic but also for their active involvement in historical preservation. Today, St. Anthony and Northeast are the culmination of their efforts. Also, thank you to Robert and Juanita Hedin for "Northeast: A History," from a special edition of the *Sun* newspaper. It was a critical early source that provided countless insights for further investigation.

INTRODUCTION

I f immigration is truly the lifeblood of America, Northeast Minneapolis is America's story writ large. Northeast—or Nordeast to visitors, tourists and hipsters alike—is a collection of distinct neighborhoods where history abounds. Distracted by the quotidian, we are remiss in glancing beneath the thin patina of the omnipresent past. But on the streets where we drive, bike and walk, it's there, because of the efforts of pioneers, workers, saints and sinners. And it began at the solitary waterfall on the 2,340 miles of the Mississippi River—the Falls of St. Anthony. As Professor Rudolph Vecoli said in the introduction to Richard Wolniewicz's *Ethnic Persistence in Northeast Minneapolis,* "'Nordeast' is, in the minds of many, a distinctive area of Minneapolis."

Father Louis Hennepin recognized the falls' duality in 1680, its natural beauty and yet unharnessed waterpower potential. But permanent European settlement was a gradual process. In July 1838, Franklin Steele, a politically well-connected twenty-five-year-old former Fort Snelling sutler (storekeeper), made the first successful claim to the Northwest's most valuable property, ten years before the city of St. Anthony's genesis. Thereafter, industries developed—such as sawmilling, flour milling and brewing—using the cataract's waterpower.

Steele's financial problems and the Eastman Tunnel collapse in 1869 led to St. Anthony's abrupt end and the merger with Minneapolis in 1872. Minneapolis's East Division, the community's new identity, was transformed by immigration and industrial boom. Minneapolis increasingly turned its

back on the Mississippi River, beginning when old St. Anthony devolved into a polluted industrial wasteland. Waterpower's importance diminished with the emergence of readily available electricity. Immigrant blue-collar workers achieved middle-class status and relocated to the suburbs, especially after World War II.

Northeast declined, but the East Side would rise again. Old St. Anthony and the central riverfront reemerged when artists transformed Northeast's decaying industrial architecture. Immigrants from Mexico, the Middle East, South America and Asia revitalized declining businesses. As the first multicultural neighborhood in Minneapolis, Northeast added additional layers of diversity to the city.

And unbelievably, to some, Northeast Minneapolis became "Nordeast"—a cool place for artists, musicians and hipsters. Moreover, artists, professionals, tech workers and families purchased affordable homes in Northeast, comprising nearly 25 percent and 5,414 acres of Minneapolis's area.

But Northeast feels like a small town.

Reinvention has always characterized Northeast. Whether it was reconstituting churches from the old country, brewing distinct beers or transforming vacant factories into galleries, bars, restaurants and taprooms, the past has mattered in Northeast.

It always will.

THE FALLS OF ST. ANTHONY

Navigation is interrupted ten or twelve leagues upstream by a waterfall. I named it the Falls of St. Anthony of Padua in gratitude for favors God did me through the intercession of that great saint, whom we chose as patron and protector of all our enterprises. The waterfall is forty or fifty feet high and has a small rocky island, shaped like a pyramid in the center.
—Father Louis (1640–circa 1701) was the first European to "discover" the Falls of St. Anthony in *Description of Louisiana,* 1683.

In 1680, Father Louis Hennepin was the first European to see and name the Falls of St. Anthony. Despite his exuberant exaggeration about the falls' height—actually only sixteen feet tall—he developed a new relationship with the immense source of natural beauty. Most importantly, the path of French and British imperialism would be followed by American economic

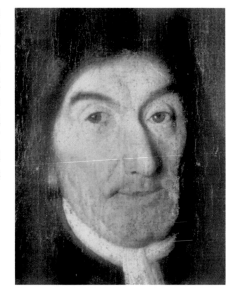

Father Louis Hennepin "discovered" the Falls of St. Anthony. A captive of the Dakota Indians, he named the falls after his patron saint. *Courtesy of the Minneapolis Collection.*

development of the riparian rights. European visitors recognized one key natural resource—waterpower. But that process was well over a century in the making.

Hennepin's "capture" by the Dakota Indians marked a European's first encounter with the falls. Audaciously, he named the Falls of St. Anthony after his patron saint, the saint of lost people. Hennepin, too, was lost. In captivity, he complained about his treatment, but he was not the first to stare in amazement at the falls.

The relationship between the American Indian and white settlers was precarious as the two disparate cultures attempted to co-exist in the city of St. Anthony, the East Side and Northeast Minneapolis. The American Indians' fate was eventually sealed by government policy, though the conflict continued in the West for decades.

Europeans inherently misunderstood the American Indian, as Kathy Davis Graves and Elizabeth Ebbott said in *Indians in Minnesota*:

> *When Europeans named them, "Indians" did not constitute a group with uniform characteristics. They were separate nations spread over the vast Western Hemisphere, living according to the demands of various climates and food supplies. Political and economic styles, language, dress, and religion differed among each nation. Although many had common characteristics, each nation was distinct.*

This led to poor relations and poorer diplomacy. Again, Davis Graves and Ebbott said, "The treaty process and the ultimate taking of the land and resources from the Indians is a sordid chapter in European and American history. Probably no treaty was honestly or fairly handled; frauds, abuses, and cheating characterized the process." A series of nineteenth-century treaties expropriated American Indian lands, and only reservation lands remained. American Indian place names were forgotten—at least by Europeans.

St. Anthony was where many European firsts began. *Saint Anthony Falls Rediscovered* states:

> *The types of residential, business, and industrial districts which characterize Minneapolis today all had their start somewhere on the riverfront. The first markets, the first factories, the first parks, the first warehouses, the apartments, the first rail yards, the first hotels, the first offices, as well as the first houses were all located here.*

If the American Indians remained, European settlement was unattainable. Myths were necessary: America was an unpeopled wasteland, and civilizations not sharing European goals were labeled "savage" and "backward."

Indian removal prefigured immigration. European fur traders, settlers and immigrants journeyed to nearly inaccessible regions. Nature's bounty created commerce—game and the fur trade prevailed for nearly a century—but wasn't possible without nearly complete American Indian removal, a process that traveled across the North American continent. Red Cloud (1822–1909), or Mahpiya Luta, experienced this in his lifetime. Four years after killing eighty-two of W.J. Fetterman's United States soldiers in Wyoming, the Oglala Lakota chief said:

> *The Great Spirit raised both the white man and the Indian. I think he raised the Indian first. He raised me in this land, it belongs to me. The white man was raised over the great waters, and his land is over there. Since they crossed the sea, I have given them room. There are now white people all about me. I have a small spot of land left. The Great Spirit told me to keep it.*

The west hadn't been decided in 1870, but St. Anthony had. American Indian removal opened opportunities for waterpower's development, for both strategic and economic reasons.

Before Europeans arrived, the Dakota and Ojibwe resided near the Falls of St. Anthony. The Ojibwe, or Anishinaabe (their name for themselves in Ojibwe, meaning "original man"), was erroneously misheard as Chippewa by Europeans. The Dakota ("allies" or "friends") were called the Sioux by Europeans from the French corruption "Nadouessioux," the Ojibwe word for "enemy" or "snake." Until the 1700s, the Dakota tribes had the largest population in Minnesota. After Europeans pushed across the continent, so did the Ojibwe, who controlled northern Minnesota by 1750. After the Ojibwe repeatedly defeated the Dakota on the battlefield, the Dakotas retreated to their western tribal fires.

But the archaeological record of American Indians extends eons, twelve thousand years before the civilizations Hennepin encountered. Journalist Charles Mann culled through recent discoveries in science, history and archaeology before Europeans' contact. In *1491: New Revelations of the Americas Before Columbus*, he posited that native populations had been numerically bigger, had lived in the Americas longer and had had a "bigger impact" on their environment. Applying these new discoveries to the Upper

Mississippi River, we can only speculate about the American Indians before the Columbian Exchange. They transported animals, crops, people and, inadvertently at first, disease.

When Hennepin arrived, epidemic disease had already ravished the Dakota and Ojibwe. Algonquian speakers from the western Great Lakes, the Ojibwe battled encroaching tribes from the east and then, following the fur trade, migrated to Minnesota and Wisconsin. According to Mann, the devastation of smallpox, typhus, measles, influenza and diphtheria—diseases not known until European contact—resulted in as high as 90 to 95 percent mortality among American Indians. Academics are labeled "high counters" or "low counters" in the epidemic disease death rates debate as discourse continues on the controversial subject. In *A Short History of the American Nation*, historians John Garraty and Mark Carnes wrote, "Scholars agree on only one fact concerning the population history of the North American Indians following the arrival of Columbus: the number of Indians declined." Regardless, the deaths totals were staggering. As social historian Annette Atkins astutely wrote in *Creating Minnesota*, we are mistaken to think the Dakota and Ojibwe "were always as whites saw them upon first contact." She wrote:

> *When I look over the shoulders of the Dakota, Anishinaabe, and others native to this place, I see a world starkly different from my own. I see loss and hurt too painful to look at for long. I see the rage that comes from a dream desired, a way of life mangled, faces scarred by smallpox, land taken. I see alienation, languages wrenched away, honored images defiled. I see, too, resignation and demoralization, the despair that comes from having lost so much.*

The American Indians achieved great cultural accomplishments before the arrival of Europeans. Between AD 900 and 1200, the Mississippian mound-based city-state known as Cahokia was located near present-day St. Louis. It was larger than the Great Pyramid of Giza. Without further archaeological discoveries, it is difficult to imagine the American Indians before the arrival of Europeans.

In the introduction to *Mill City*, Kate Roberts said:

> *Long before mill owners looked to St. Anthony Falls to drive their saws, waterwheels and turbines, others sought it out for their own purposes. Dakota and Ojibwe considered the cascade a sacred site. There were no*

permanent Indian villages near the falls, but it was on a seasonal migration route and served as a temporary stopping point.

Both tribes believed the falls had vital spiritual significance, and they had several names for the falls. The Ojibwe called it *kakabikah* ("severed rock"), and the Dakota called it *minrara* ("curling water"), *ha ha tanka* ("big waterfall") and *owahmenah* ("falling water"). The Dakota cosmology included Oanktehi, the god of evil and water. He was believed to live beneath the falls.

The Falls of St. Anthony's unique beauty was manifest to every visitor. The waterfall compelled explorers from European colonial empires and then speculators and settlers to discover the majesty of the Falls of St. Anthony and its potential as a power source.

FATHER LOUIS HENNEPIN

Father Louis Hennepin is a figure of controversy. During his lifetime, he inspired European discovery of the upper Mississippi River. The diarist explored New France and Louisiana from 1679 to 1680 while conferring imperial power upon the empire of Louis XIV, the Sun King. On another mission, he explored the Great Lakes as well as present-day Upstate New York and Niagara Falls—the waterfall with the greatest volume flow in North America. Born in Ath, Belgium, and then moving to the Spanish Netherlands, the Franciscan missionary was sent by René-Robert Cavelier, Sieur de la Salle, to explore the upper Mississippi. Despite Hennepin's account in his journal, which made it sound as though he traveled alone, Michel Accault was in command of the voyage, and Antoine Auguelle was also in the canoe with a calumet.

Before Hennepin's voyage with La Salle, they encountered a severe storm. This set the stage for the naming of the future waterfall and city when the father asked "St. Anthony of Padua to protect our enterprise. We promised God that if he granted us deliverance from the tempest, the first chapel in Louisiana would be dedicated to that great saint." The storm abated. They survived. Shortly thereafter, Hennepin named the falls in gratitude to his patron saint while on his mission for La Salle.

During April 1680, Hennepin was captured by "the Issati," recognized today as the Mdewakaton Dakota. In captivity, he wrote about his privations: forced to walk all day, even through ice, while insufficiently nourished and

constantly fearing death. But in captivity, he also gloated about European technology. About his compass, he said, "Observing that I controlled the needle with a key and believing rightly that we Europeans traveled all over the habitable world guided by this instrument, the extremely eloquent chief persuaded all his men that we were spirits capable of doing all things beyond their powers." He witnessed the splendor of the Falls of St. Anthony with their guidance. After eight months, he was rescued by Daniel Greysolon, Sieur du Luth, who was received like a chief because of his knowledge of the Dakota at Lake Mille Lacs.

Hennepin wrote *Description of Louisiana*, a journal about the Upper Mississippi after his journey. The monarchy and the whole of Europe prized the new discoveries. Both propaganda and fabrication, historians questioned the journal's validity. Some speculated it was ghostwritten by Claude Bernou, who had a remarkably similar writing style. Despite these nagging questions, Theodore Blegen summarized Hennepin's significance in *Minnesota: A History*:

> *In his books claims are advanced that have not been corroborated…How much weight can be attached to such aspersions and to inconsistencies in his writing is difficult to say. One must remember that the very authorship of the drafts as printed is open to question and Hennepin's own part uncertain. Certain conclusions are undeniable, however. Hennepin did make the journey in 1680.*

The impact of Hennepin's journey and book is undeniable. In the 1938 edition, the president of the Minnesota Historical Society, Edward Gale, wrote of *Description of Louisiana*:

> *Imaginations were kindled by the stories of its great forests, wide plains, enormous rivers, and strange inhabitants, and by the possibilities of a freer life in the new world unfettered by the rigid artificialities fastened by the past upon life in the old world.*

When the book was released, the Falls of St. Anthony were nearly inaccessible to Europeans. But it inspired the literate population's pursuit of exploration. Years earlier, the Age of Discovery had concluded on the Atlantic coast of North America but now continued as Europeans established permanent settlements in the Upper Mississippi for a century and a half.

JONATHAN CARVER

When his mission commenced, Jonathan Carver was a fifty-six-year-old captain from the Massachusetts Colonial Militia. Under the command of Major Robert Rogers, he was known for his bravery in the American hinterland. But he had joined the British, some historians suggest, to escape counterfeiting charges.

Historian Norman Gelb described Carver's adventure:

> *With the help of previous drawn maps, mostly the work of French explorers and believed to be of limited reliability, he was to proceed through Lake Michigan to Green Bay and then, by way of the Fox and Wisconsin rivers to the Mississippi, along which he was to ascend as far as the Falls of St. Anthony, at the site of present-day Minneapolis. That was expected to be the farthest extent of his journey before winter set in.*

Three years after the defeat of the French in the French and Indian Wars (1754–1763), Carver explored over five thousand miles in the interior of North America. Carver's journey began on September 31, 1766, from Fort Michilimackanac—now Mackinac, Michigan—at the strategic point between Lake Michigan and Lake Huron. His journal commented on the cold, icy and inclement weather when he traveled to the Upper Mississippi River. On November 17, 1766, he sketched the Falls of St. Anthony—and included it in his book, *Jonathan Carver's Journey Through America 1766–1768: an Eighteenth-Century Explorer's Account of Uncharted America.* First published in England in 1778, it became an international bestseller.

Unlike other explorers of his day, Jonathan Carver was empathetic to the American Indians and attempted to understand their cultural differences without denigrating them. *Courtesy of the Minneapolis Collection.*

Blegen wrote, "It was a lively, interesting and informing account that won wide and long-continued popularity."

In elegant prose, Carver described the Great Lakes and Upper Mississippi wilderness. He recorded the flora, fauna, climate and landscapes as well as the customs of the American Indians in painstaking detail. To modern readers, the descriptions sometimes are romantic or incorrect interpretations, particularly of American Indian activities. But his perspective is idealistically empathetic. He excelled at descriptions of nature. The falls are cast to have an indelible Eden-like quality that inspired contemporary readers' sense of adventure. Today, readers can only imagine the once pristine falls before they were transformed into an engine of economic development. His description of the Falls St. Anthony is particularly piquant:

> *The country around the Falls is extremely beautiful. It is not an uninterrupted plain where the eye finds no relief, but composed of many gentle accents, which in the summer are covered with the finest verdure, and interspersed with little groves, that give a pleasing variety to the prospect. On the whole, when the Falls are included, which may be seen at the distance of four miles, a more pleasing and picturesque view cannot, I believe, be found throughout the universe.*

Carver then took a witty, albeit accurate, jab at the local climate: "I could have wished that I had happened to enjoy this glorious sight at a more seasonable time of the year." How did he know about the falls in summer? And "the finest verdure"—he visited in November. Carver, typical of writers of his epoch, imagined the falls in summer time and, with his romantic mind, projected it on paper.

Carver's account to the Great Lakes and the Upper Mississippi was, not surprisingly, well received by the public. It offered a unique perspective before European influence in the area. He delved into American Indian spirituality based on an experience near the falls, "Thus when they arrive on the borders of Lake Superior, on the banks of the Mississippi, or any other great body of water, they present to the Spirit who resides there some kinds of offering, as the prince of the Winnebagoes did when he attended to me to the Falls of St. Anthony." He understood the central role of the falls in the lives of the American Indians, even if he erroneously credited the experience to the Winnebagoes. Ho-Chunk is the contemporary tribal name, which he probably confused with fellow Siouan language speakers, the Dakotas.

Carver's empathy and inquisitiveness resulted in insight into the American Indian that was rare during his time. His curiosity in places then exotic showcased a romanticism that has endured over centuries. His sketch of the Falls of St. Anthony is likewise—beautiful, but definitely exaggerated, in size and scale. He wrote, speculatively, entire chapters on the origin, manners, customs, religion and language of the "Indians." Gelb summarized Carver's extensive writing on the American Indian with historic perspective:

> *The observations Carver made and the conclusions he drew about the American Indians he met and lived among inevitably were influenced by the values of his time and background. But unlike most of his contemporaries, he recognized their distinctive humanity, the intricacies of their culture, and the richness of the environment in which they lived, and he wrote about them without gloss or bias.*

Carver appreciated the Falls of St. Anthony and the American Indian more than any explorer before or after. But he did have detractors. Blegen noted in the 1960s, "Carver's narrative is alleged to be ungenerous, egotistic, exaggerated."

ZEBULON PIKE

Major Zebulon Pike wrote matter-of-factly of the Falls of St. Anthony. In *The Expeditions of Zebulon Montgomery Pike, to the Headwaters of the Mississippi River, through Louisiana Territory, and in New Spain, During the Years 1805–1807,* his writing style and lengthy title with exhaustively detailed prose are typical of the epoch. Unlike Hennepin and especially Carver, Pike's deadpanned journals bespoke his occupation—a soldier in the United States Sixth Infantry. Minnesota was, in part, within the Old Northwest Territory of 1787. Pike led a military expedition, beginning in St. Louis and ending in Leech Lake with a stop at the Falls of St. Anthony, to continue the fur trade and explore the new lands acquired from France by Thomas Jefferson in the Louisiana Purchase. In September 1805, his mission began at the confluence of the Mississippi and St. Peter (now known as the Minnesota) Rivers—the site of Fort St. Anthony in 1819, later renamed Fort Snelling.

On September 26, Pike described with disappointment, "As I ascended the Mississippi, the Falls of St. Anthony, did not strike me with that majestic appearance which I had been taught to expect from the descriptions of former

travelers." Pike was all business. Representing the federal government, he negotiated with the Dakota the purchase of a nine-square-mile strip of land on both sides of the Mississippi River from the confluence with the Minnesota River to the Falls of St. Anthony. Officially named the Treaty of St. Peters, it was known by his contemporaries as Pike's Purchase. *Indians in Minnesota* said about the treaty, "Some sixty gallons of liquor and $200 worth of gifts were used to encourage the sale. Although Pike estimated the land was worth $200,000, when the Senate approved the treaty in 1808, they listed it worth $2,000."

After the treaty was ratified, it was over a decade before Fort Snelling was constructed. The War of 1812 caused the federal War Department to build forts along the major waterways from Lake Michigan to the Missouri River as protection against Canadian and British incursions in the northwestern territories. Once the fort was constructed, soldiers arrived. They dreamed of settling near the tremendous waterpower of the falls. The first step the soldiers took was the construction of a gristmill and sawmill at the Falls of St. Anthony. Colonel Henry Leavenworth began building the sawmill in 1819. It was not completed until 1822, followed by the gristmill two years later. Both were under the command of Josiah Snelling of Boston, who began construction of Fort St. Anthony in 1820 and completed it in 1827. In 1824, General Winfield Scott visited and renamed the citadel Fort Snelling.

STEPHEN H. LONG

Major Stephen H. Long's (1784–1855) sixty-seven-day military voyage commenced in St. Louis. A member of the Corps of Topographical Engineers in the United States Army, he set out with a seven-man crew for the Falls of St. Anthony from Prairie du Chien on July 9, 1817. In the preface to the 1860 edition of Long's journal *Voyage in a Six-oared Skiff to the Falls of St. Anthony in 1817*, the then president of the Minnesota Historical Society, Reverend Edward D. Neill, explained his mission, "The objects of his voyage were to meander and sketch the course of the Upper Mississippi, to exhibit the general topography of the shores, and to designate such sites as were suitable for military purposes."

Long arrived at the Falls of St. Anthony on July 16. He camped on the shore of the site that became Lower Town St. Anthony in over three decades; in the present day, it is near Father Hennepin's Bluff Park. His awe for the natural environment shines through his prose:

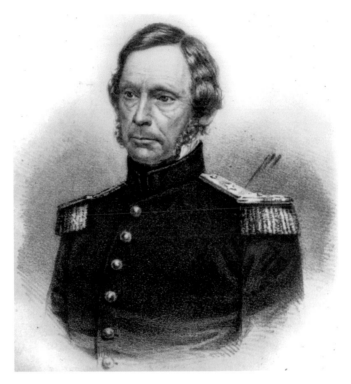

Major Stephen H. Long's detailed descriptions of the flora and fauna around the Falls of St. Anthony give insight to what the area was like before industrialization. *Courtesy of the Minneapolis Collection.*

The place where we encamped last night needed no embellishment to render it romantic in the highest degree. The banks on both sides of the river are about one hundred feet high, decorated with trees and shrubbery of various kinds. The post oak, hickory, walnut, linden, sugar tree, white birch, and American box; also various evergreens, such as the pine, cedar, juniper, etc., added their embellishments to the scene. Amongst the shrubbery were the prickly ash, plum, and cherry tree, the gooseberry, the black and red raspberry, the chokeberry, grapevine etc. There were also various kinds of herbage and flowers, among which were the wild parsley, rue, spikenard, etc., red and white roses, morning glory, and various other handsome flowers.

He described the multifarious collection of trees, flowers and plants on the banks, some of the native species are unrecognizable today because of the then contemporary common names. The world he painted with his

words is idyllic. His prose reflected on the area's grandeur decades before industrialization arrived, polluted the river and destroyed nature's incredible bounty. After reading his vivid descriptions, we are left wondering if ever such biological diversity of flora and fauna did, and could once again, exist. His musings about an Eden too good to be true are often too unbelievable to modern ears.

Long shifted gears in the next sentence when he assessed the falls:

> *A few yards below us was a beautiful cascade of fine spring water, pouring down from a projecting precipice about one hundred feet high. On or left was the Mississippi hurrying through its channel with great velocity, and about three quarters of a mile above us, in plain view, was the majestic cataract of the Falls of St. Anthony.*

Long glowed, again, about the surroundings. He wrote of the falls that "all contribute to render the scene the most interesting and magnificent of any I've ever before witnessed." Then he turned his attention to the height of the falls—no longer a matter for hyperbole as with the explorers before him—claiming it was sixteen and a half feet tall (most modern estimates put it at sixteen feet) in agreement with Zebulon Pike's earlier measurement.

The stage was set. When industry harnessed the incredible power of the falls, settlement followed. Then, industry, employment and immigration were instigated by the natural wonder of the Falls of St. Anthony. But first, the land needed to be opened for settlement. Claims had to be made. Who would control the enormous potential engine of industry and wealth?

Long, a restless adventurer, continued his exploration of the region. In 1823, he was joined by United States Indian agent Lawrence Taliaferro and Italian jurist, author and explorer Count Giacomo Constantino Beltrami (1779–1855). They traveled together from Fort Snelling. Beltrami set off to find the headwaters, incorrectly, of the Mississippi River while Long traveled north to determine the forty-ninth parallel. The northern lands would soon begin lumbering. Later, farmers sent their harvests to St. Anthony. Industry would flourish beside the falls. Long lavishly praised St. Anthony's beauty but also recognized its tremendous economic potential.

The age of the fur trappers and squatters was ending. The region would soon be conferred territorial status by the United States government. Few people knew of the federal government's plans for the future except the soldiers at

Fort Snelling. For those with connections to Congress in Washington, D.C., staking a claim depended on communication—serpentine, mid-nineteen-century communication. Riverboats were the means of communication, and several players awaited news via these conveyances.

THE CLAIM BATTLE: THE BIRTH OF ST. ANTHONY

Military and ex-military officers eyed the Falls of St. Anthony while awaiting treaties with the Dakota and Ojibwe to be signed. The Mississippi River, or "great river" in the Algonquian language, was eventually opened to European settlement claims. William Lass, in *Minnesota: A History*, stated succinctly the cataract was "one of the nation's choicest sites."

Federal laws for settlement were codified in Washington, D.C., before Fort Snelling was constructed. "The land ordinances of 1784 and 1785 set the stage for private real estate transactions and entrepreneurial undertakings for those who ventured to Minnesota during the 1830s and 1840s," stated Jocelyn Wills in *Boosters, Hustlers & Speculators*. The confederacy government and later Congress contested the Great Land Ordinances. The law organized the lands north and west of the Ohio River, south of the Great Lakes and east of the Mississippi River. Every second township was divided into thirty-six sections (or one square mile) by the 1785 law. The Northwest Territory (1787) was legislated after the defeat of the British in the American Revolution. The United States was then thirteen largely autonomous governments without centralized power in accordance with the Articles of Confederation. President George Washington signed the ordinance into law, which was slightly modified by Congress on August 7, 1789. Land was sold at public auction, but the large claims led to land speculation. This plagued the first successful claim at the Falls of St. Anthony.

Franklin Steele (1813–80), a native Pennsylvanian with strong ties to the Democratic Party, made that claim. According to Reverend Edward D. Neill in *History of Hennepin County and the City of Minneapolis*, as a young man, Steele had a position in the Lancaster, Pennsylvania post office. There he met James Buchanan (1791–1868), the future fifteenth president of the United States (he held office from 1857 to 1861). Moreover, his father, John, served as President Buchanan's campaign manager. If those political connections weren't enough, his sister Sarah married Henry Sibley in 1843. Sibley was

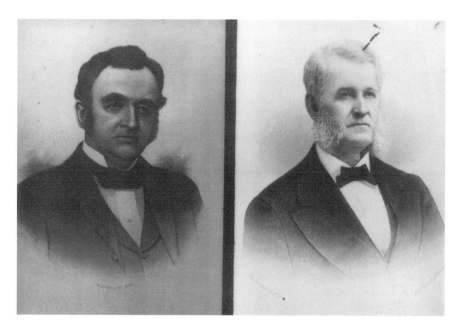

Franklin Steele (pictured with Isaac Atwater, left) formally claimed the land that became St. Anthony, and later part of Northeast Minneapolis, in July 1838. *Courtesy of the Minneapolis Collection.*

a partner in the American Fur Company in Mendota who became the first governor of Minnesota.

Steele served as sutler at Fort Snelling. The Falls of St. Anthony attracted speculators. They identified the possibilities for wealth generated by a claim on the land. Historian Lucile Kane wrote that 157 nonmilitary people squatted on "the Pike cession." On the eve of settlement in 1837, the War Department instructed Fort Snelling to remove them, with the exception of Sibley in Mendota.

Most notoriously, Pierre "Pig's Eye" Parrant lived outside the military reservation. He plied soldiers and squatters with spirits. Many were refugees from Lord Selkirk's failed Red River Colony in Canada. After the settlement failed, Parrant moved down the Mississippi River outside the military reservation and established the settlement of Pig's Eye. Lucien Galtier and the Roman Catholic Church renamed the site St. Paul's Landing and brought religion to the new city, then the only competitor with Stillwater for regional dominance. During this time, the land was reserved for the military, fur traders and the Ojibwe and Dakota Indians. The tribes retained the lands outside the nine-mile strip along the river from Fort Snelling to the Falls of St. Anthony.

Settlers waited impatiently for Washington, D.C., to ratify treaties. Settlement claims were permitted between the St. Croix River and the Mississippi River. Then, at Fort Snelling on July 29, 1837, the Ojibwe signed a treaty. After journeying to the nation's capital, the Dakota did the same on September 29. But until the Senate acted and ratified the treaties, a claim was not legally recognized.

Major Joseph Plympton arrived on August 20, 1837, to assume command at Fort Snelling. Despite his position, he prepared to stake a claim at the Falls of St. Anthony with the assistance of Captain Martin Scott. At the fort, the soldiers awaited information from Washington. Meanwhile, Franklin Steele traveled to Washington for the winter and did not return until June 18, 1838, on the steamboat *Burlington*. The steamboat *Palmyra* brought news of ratification on July 15. Neill stated, "On the 20th of June, the steamboat *Ariel* arrived at Fort Snelling, and one of the passengers said the senate had ratified the treaty." Steele, with his political connections, had been tipped off. He remained silent while preparing to stake a claim.

The race began to the Falls of St. Anthony. The accounts of the claim battle between Plympton and Steele are legendary. In an account published years later in the *St. Paul Daily Pioneer*, the paper claimed Steele enjoyed breakfast as Scott and soldiers from the fort arrived to stake a claim. He asked them to breakfast; they refused. The facts of the story vary widely; details are often unknowable and could have been concocted for dramatic purposes, like in the *Pioneer*'s story. In some versions, the bias is demonstrated by the author. Again, Neill was a reliable contemporary historian, although his perspective definitely was influenced by his friendship with Steele. Here is Neill's 1881 version:

> It is said that in June, and, if this be a correct date, before the official notice was received, Franklin Steele and Captain L. Scott of the Fifth U.S. Infantry, set out post haste for the Falls of St. Anthony, each anxious to secure the best claim, including the falls. Captain Scott came up on the west side of the river, but was unable to cross, while Mr. Steele, who took the east bank, in company, with assistants, was able to make a shanty ready to entertain his friends from the Fort when they made the detour necessary to join him on the opposite bank.

Does this version of history come from an anecdote relayed by Steele at closing time in a bar or on a Sunday after church services? Only Steele, Scott and the soldiers would know. It's an apocryphal story, but it also foretold the

area's future. Steele, in this history, took the east bank, which later became St. Anthony, the East Side and Northeast Minneapolis.

One thing is certain, however, as the courts later proved: Plympton, an active military officer under federal law, was ineligible to stake a claim. In most versions of the land claim, Steele had already built a shanty near the falls.

But the process of settling St. Anthony was slow. It was ten years before the public auction. Then Steele gained a legal title to the claim. During the decade, a succession of men reserved his claim. La Grue, a Métis, and his wife lived on Steele's claim in his absence. The wife of La Grue was murdered when his cabin was burnt down. The Dakota and Ojibwe were in conflict, and La Grue, an old man, found safety among the Ojibwe. Others stayed on Steele's claim, including another voyager, Charles Landry. Steele waited, usually via proxy, and hoped to secure the title for the area's development. In one case, Steele's claim was "jumped" by James Mink when the overseer vacated. Steele paid several hundred dollars to Mink to retain his claim.

In 1841, the Pre-emption Law codified the process of staking a claim: evidence of settlement up to 160 acres. A resident lived in a shanty or cabin until a public auction made it available for purchase. The process dragged on since Minnesota did not receive territorial status until 1849. It remained the westernmost portion of Wisconsin Territory until 1848. Steele also made a claim of 48 acres at St. Croix Falls and formed the St. Croix Falls Lumber Company. But he vacated the claim. Correctly, he speculated that St. Anthony would become the boomtown.

Steele focused on the vast potential on the east side of the Mississippi River. After more than a decade, St. Anthony was platted, but a brief epoch existed before European settlement. Nature, ever so briefly, ruled over concerns regarding riparian rights and the lucrative business opportunities associated with sawmilling and flour milling. As the creation of Minnesota Territory approached, the Falls of St. Anthony changed. As Scott Anfinson stated, "After 1847, the sight and the sound of the falls rapidly disappeared, and human actions came to define its physical character."

The Falls of St. Anthony were the impetus for this development. Steele claimed 322 acres near the falls, including Nicollet Island. He built bunkhouses, stables, a mess hall and carpentry and blacksmith shops. In 1848, he acquired Boom Island—an excellent place for sorting logs with its east and west channels. However, there were competing boom companies until an 1857 merger. He consolidated his claims while he secured the east side and completed a sawmill and a dam. The event ushered in the lumber

boom. St. Anthony, with west bank rival Minneapolis, would become a leader in lumber production until 1887.

In 1914, early settler Caleb Dorr, then ninety years old, recalled St. Anthony before it was platted as a city:

I came to St. Anthony in 1847 and boarded at the mess house at first. Later I was boarding with the Godfrey's and trouble with the Indians was always feared by the new arrivals. One night we heard a terrible hullabaloo and Mrs. Godfrey called, "For the Lord's sake come down, the Indians are here." All the boarders dashed out in scant costume, crying, "The Indians are upon us," but it turned out to be only the first charivari in St. Anthony.

In five years, St. Anthony had became a boomtown. But then, a wedding procession—celebrating with the banging of pots and pans, called charivari—was confused for an American Indian uprising. Pike's Purchase was a land and timber grab. It didn't force Dakota and Ojibwe removal but left that impression. Contemporaneous accounts required that myth to attract settlers. The *St. Anthony Falls Express* wrote about the future of the city on November 15, 1851: "And with the tide of immigration to our shores will come wealth and capital to improve the inexhaustible power of our water-fall,—giving employment to the surplus of labor." The city's development had begun. But wealth remained stratified until the rise of unionization in the late nineteenth and early twentieth centuries.

After years of anticipated industrial and commercial development, timbers floated down from the Rum River to St. Anthony. This led to unprecedented growth, the need for labor and diversification of employment.

Again, Kane illustrated the explosive growth of St. Anthony:

As the mills at the falls prospered, so did the community of St. Anthony. In 1848, when Steele bought the land an estimated three hundred persons lived in the town. By 1850, the population had more than doubled, and five years later St. Anthony had approximately three thousand people.

The Falls of St. Anthony were a natural engine for development. The falls provided seemingly endless power as settlers and then immigrants arrived. Then the city, no longer a village, of St. Anthony was born.

Again, the November 15, 1851 *Express* foretold the dilemma of competition for immigrant labor, capital and the future of the city:

This wave of immigration will flow; a failure to ratify the Treaties will have little effect in checking its resistless tide. And if we are not prepared to receive it, it will find its level in some other land, —Oregon, perchance, or Utah, or California, will receive in what Minnesota loses in an accession to its wealth by no means second in worth to all the gold mines in Christendom: a population of brave and industrious farmers and mechanics.

The paper lobbied for additional treaties securing more land, settlers and commerce for St. Anthony. For the American Indians in St. Anthony, the war already had been lost. The author of *Indians in Minnesota* wrote about the economic process: "By the 1840s, the fur market had collapsed, and government policies turned away from supporting the fur trade. Land was instead sought for minerals, timber, and farming. The era of initiating treaties to take title Indian land in the Midwestern and Western regions of the country began." Additional treaties awaited ratification in Washington to open the floodgates of immigration. When people settled in St. Anthony and the Upper Midwest, a regional power was born.

The Birth of St. Anthony

Now we pass along Main street, and here seems to be an unimproved space intervening between the upper and lower part of town—to the upper town, which certainly shines with prosperity, every thing looking new and clean. Here we come to the St. Charles hotel, a fine, spacious building, full of strangers. What a contrast within a few months! What a change since a year ago, when the stranger who visited St. Anthony could not obtain a dinner, unless through the compassion of some citizens he were invited to dine at some private house!
—J.W. Bond, *Minnesota and Its Resources, 1856*, describing St. Anthony's early years. The arrival of the St. Charles hotel (located at Marshall Street and Sixth Avenue Northeast) was, for Bond, a watershed in the transformation of the city from a hinterland into a boom town.

The climate is the principal boast of Minnesota. It is claimed to be "the healthiest in the world." The testimony of thousands of invalids, and the experience and statistics of twenty years, confirm this.
—*The Minnesota Guide*, J.F. Williams, editor, in 1869, promoted weather in the region. Before immunization provided protection against epidemic diseases, cold winters and mild summers were important in preventing the spread of disease. The climate was a major selling point in the early years of the city, especially in recruiting settlers from New England and the Middle States.

S t. Anthony gained life from the waterpower of the cataract. Inexpensive land and energy's promise promoted rapid development at the falls—and

required labor. Herein began the perpetual struggle between owner and workers in the fledgling city. The struggle recurred on the east bank, Upper Town in St. Anthony and, later, the East Side and Northeast Minneapolis.

The interaction between the established American settlers and the new immigrants caused difficulties and misunderstandings. But unlike the Ojibwe, Dakota and the fur traders who preceded the arrival of the pioneer settlers, the groups of immigrants who followed learned, with difficulty, to co-exist. But ethnic groups remained segregated in distinct neighborhoods.

After centuries of European contact and the rigid and racist nineteenth-century social hierarchy, American Indians were not considered a potential labor force for burgeoning industry. But labor was found elsewhere. With the British North American Act of July 1, 1867, the tap of immigrants from the British Isles had turned off. Germans and Scandinavians were recruited, and when that source dried up, Eastern Europeans began to immigrate.

Beliefs clouded the interaction between ethnic groups. Voyagers, fur traders and Frenchmen, and later Englishmen, married American Indian wives—e.g. Henry Sibley. In *Minnesota History* magazine, Bruce White reflected:

> *More and more Americans in the mid-nineteenth century believed that human beings could be categorized according to racial groups, not all of which had the same intelligence and capabilities. Those considered superior were described as Anglo-Saxon, Germanic, Caucasian—or, simply white. Indian people and blacks, as well as, on occasion, Irish, Italians, and others were thought to be inferior without a part to play in American society.*

Bond's quote at the beginning of the chapter illustrated the dichotomy in the city's early days. It existed between the proper New Englanders in Lower Town (south of modern-day Central Avenue and Second and Fourth Streets Southeast) and the ethnic groups who had arrived in Upper Town after 1856, located conveniently next to the steamboat landing north of Nicollet Island (near present-day Main Street and Third Avenue Northeast). White described the typical attitude of the day regarding the American Indian in St. Anthony as "savages, uncivilized, wandering people who made wasteful use of the land and were occasionally visited by a few traders, missionaries and daring adventurers." The Ojibwe and Dakota were removed by treaty; but some remained after settlement. Mrs. Silas Farnham, an early settler, described St. Anthony in 1849, "The Indians were always around, but we never minded them—always lookin' in the windows." As time passed, Upper

Town became increasingly ethnically diverse. During the platting of the city, Upper Town was then the newer section of St. Anthony—and later a section of Northeast Minneapolis.

THE CITY OF ST. ANTHONY FALLS

St. Anthony was born with the 1849 plat. William Marshall was hired by Steele and Pierre Bottineau. Bottineau, a Métis, owned a portion of the future Northeast Minneapolis. Marshall—an early shopkeeper, a future governor of Minnesota (1866–70), a regent at the University of Minnesota and a surveyor—created the first plat of St. Anthony: twelve and a half blocks along the river and five blocks deep. The arrangement of the streets and lots defied the Northwest Ordinance but asserted St. Anthony's identity as a river city, born of the Mississippi River. The streets' alignment ran parallel and perpendicular to the curve of the river. Northeast Minneapolis has streets orientated north/south and east/west, as seen in the Beltrami, Logan Park and Sheridan neighborhoods and farther east and west. The quirky plat defined St. Anthony. St. Anthony was the oldest part of the city, and the only portion where the streets followed the river.

On the original plat, Marshall wrote, "St. Anthony Falls." Steele disagreed. But it remained on the largest circulating newspaper's masthead, the *St. Anthony Falls Express*; at the post office; and as an entry in Warren Upham's *Minnesota Place Names*. Still, the name was too long Steele reasoned. St. Anthony would suffice, but since it was written on an original government document, it was difficult to change. The city's rapid growth brought additional settlers. St. Anthony had fewer syllables and was more euphonious. Eventually, it was the name that stuck. In 1849, William Cheever's plat, also known previously as "Cheeverstown," was added to the south and east—present-day Southeast Minneapolis. In 1850, the Steele and Roswell P. Russell addition was annexed, as well as the area that became Northeast, with the Bottineau and John Orth additions.

Capital was necessary for St. Anthony's rapid boom. Steele's claim was used as collateral to mortgage the sawmills and a dam on the east bank in 1849. Eastern financiers were utilized to sustain the development of St. Anthony. Richard Chute oversaw the falls. But Steele had financial problems. He owned the title to one of the greatest locations for building a great city but lacked the personal finances to maximize the industrial potential of his claim.

Richard Chute, from New York, represented East Coast financiers' interests and oversaw the St. Anthony Waterpower Company for Franklin Steele. *Courtesy of the Minneapolis Collection.*

Pierre Bottineau's (1817–95) background was the polar opposite of Steele's. Bottineau represented the Old Northwest, and he ran boats for the American Fur Company. A Métis with both Dakota and Ojibwe background, the French Canadian son of a fur trader father and Ojibwe mother, he commanded numerous languages. He was born near Pembina, just two miles from the Canadian border, in the Red River Colony and later lived in a town in North Dakota. The frontiersman was a prominent guide, interpreter and scout in the region who went on to found Osseo in 1852 on a claim called "Bottineau's Prairie." He founded Red Lake Falls in northwestern Minnesota in his final years.

Before arriving in St. Anthony, Bottineau was evicted from the Fort Snelling military reservation, where he and other French Canadians from the Red River Colony squatted. Bottineau claimed 320 acres north of the east bank and Nicollet Island, but the property went through many hands before he was successful. Land speculators laid claim to the prime piece of property—first, Sergeant Nathaniel Carpenter, Private Thomas Brown, Peter Quinn and, finally, S.J. Findley and Roswell P. Russell. On May 9, 1846, they deeded the claim to Bottineau. It was the first claim in the area that became present-day Northeast, including the St. Anthony West neighborhood. Bottineau settled with his Métis extended family, which included his brother-in-law Louis Des Jarlais; Joseph Reed; his two brothers, Severre and Charles; and the men's families. In addition, Bottineau "jumped" an early claim by Joseph Rondo of St. Paul.

Bottineau left an indelible mark on Northeast Minneapolis. The French Canadians who followed him and settled St. Anthony were the first wave of

immigrants. They would challenge the elite "Old-Stock Americans," or white Europeans, who had resided in America for several generations. Bottineau initiated this continuing process, but he didn't stay and watch it happen. Instead, his perpetual wanderlust led him to create other communities.

St. Anthony's overnight growth was decried by another minority in the nascent city—women. Few jobs besides homemaking were available to women, despite the need for labor. When the city was platted, James McMullen, an early settler, remembered buffaloes and American Indians wandering the streets. He recalled men before their families' arrival getting into trouble due to the lack of city services, "As there were absolutely no places of amusement, the men became great wags. One of the first things established by them was a police court."

His wife remembered, in a lumbering town, the horrible lack of cladding for homes. When sidewalk planks were laid down, "the sidewalk would disappear in the night." But an even more hilarious anecdote related the rowdiness of frontier politics, "In '49 or '50, the old black schoolhouse was the site of an election. I lived near enough to hear them yell, 'to Hell wit Henry Siblee [*sic*]—Hurrah for Louis Robert.'" Those not in agreement with the majority, in her account, were thrown out the door like a proverbial sack of potatoes.

St. Anthony flourished almost overnight, while the west side of the Mississippi River—eventually named Minneapolis—developed slowly. John H. Stevens founded Minneapolis after serving as Steele's clerk. Stevens encountered Steele's brother-in-law, Henry Sibley, after the Mexican War. Stevens had a claim in Texas but hoped Minnesota's climate would improve his ailing health.

Blegen wrote about Steele's foresight, "His calculating judgment led him in 1849 to suggest…that it might be good business to get a permit from the War Department to stake a military claim on the west bank, then part of the Fort Snelling military reservation." As Stevens wrote in his autobiography, "On the morning of the 10th of June, 1849 Mr. Steele came into his counting-room, in the rear of the sutler's store, and asked if I could spare the day to accompany him to the Falls of St. Anthony." Stevens averred, and his 160-acre claim was expeditiously accepted. Stevens agreed to serve as ferryboat captain. His house—the first in the future city of Minneapolis—was then constructed with the assistance of Captain John Tapper and Pierre Bottineau.

In his autobiography, John Stevens described the American Indians on both sides of the river. History impacted their presence in the fledgling cities.

Before the outbreak in 1862, they [the American Indians] *were often the source of much annoyance to the white settlers on the meadow lands, from their wandering habits, but the end of the Indian war of 1862 and 1863 mostly ended their visitations to their former hunting-grounds, the sites of their villages, and the graves of their fathers.*

The rapid growth of St. Anthony and Minneapolis necessitated a bridge across the Mississippi River. Completed in 1855, the suspension bridge was the first permanent span on the river that only could be crossed by paying a toll. The bridge perpetuated the regional boom as well as aided the interaction and development of the older side—St. Anthony. As the decades passed, St. Anthony became increasingly industrial. Housing boomed in south Minneapolis as result of the bridge and its replacements later in the century. Neighborhoods became more segregated as the connection between the "East" and "West Divisions" made transportation across the bridge—for those who could afford it—easier.

St. Anthony incorporated in 1855. Along with St. Paul and Stillwater, it was one of the three great cities in Minnesota Territory. Just three years earlier, the city was originally in Ramsey County but was redrawn as part of Hennepin County.

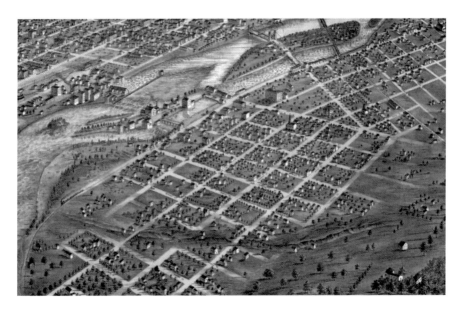

After the onset of the Civil War, St. Anthony continued, despite enduring the Panic of 1857 and the Dakota War. *Courtesy of the Minneapolis Collection.*

In 1856, Bond marveled at St. Anthony's growth, but the city had just begun. With the exception of the Panic of 1857 and the Civil War (1861–65), it expanded at a remarkable rate. Certainly, much of this development would not be to his liking. The old New Englanders continued to head government and industry into the twentieth century while the vast unskilled labor force worked built the new city. Incremental growth fueled immigration as the city asserted itself as a regional economic powerhouse. The city expanded in concentric rings from the falls—beyond the borders of pioneers and early immigrants' wildest dreams—as St. Anthony, Upper Town, the East Side and, later, Northeast Minneapolis developed.

PIONEER SETTLERS OF ST. ANTHONY

St. Anthony had a wealth of pioneer settlers. Beyond the founders and businessmen were a variety of citizens pivotal in the nascent city's establishment. In the nineteenth century, local histories included biographies, and here we examine just a few of the early settlers and, in one case, a visitor to St. Anthony.

The Fourth of July in St. Anthony is a tradition dating back to the first settlers. Although the celebration has changed over the years, the elements of the holiday were important to the community before St. Anthony became a city. As Helen Godfrey Berry—the daughter of Ard Godfrey, overseer of the first dam, millwright and first postmaster—recalled:

I would not omit my recollection of our first Fourth of July. It was either '49 or '50 and carried out with all patriotism. I went early…to touch the Liberty pole set up on the hill not far from the mills and near where was afterward built the Winslow Hotel. It was a genuine celebration. In my mind, somehow, like a dream of a birthday in spring, comes a faint picture of a number of pioneer mothers, in my mother's partly finished parlor. I rushed in after school and stood upon the threshold. I saw bright colors in stripes, and stars of blue that seemed [to] be in a quandary how to place and how many to use. Was this the first flag made in St. Anthony? Was it made in the old Godfrey house, or was I only dreaming? Anyway, it was a real celebration that came after. The Declaration of Independence was read, I think by J.W. North, a volunteer choir of our best singers—Mrs. Caleb Dorr, Mrs. North, and others—sang the patriotic hymns, Isaac Atwater,

Ard Godfrey was hired by Franklin Steele to construct the mill and the first dam. He was also the first postmaster of St. Anthony. *Courtesy of the Minneapolis Collection.*

Capt. John Rollins and others sat upon the platform and my father was marshall of the day.

On June 21, 1851, the *St. Anthony Falls Express* wrote about the Fourth of July: "At a meeting…it was determined to celebrate the seventy-fifth anniversary of our nation's independence in the village of St. Anthony in an appropriate and patriotic manner."

State and national events shaped the history of the fledgling boomtown of St. Anthony. They had a tremendous impact on its settlers. The Fourth of July was an annual celebration, but the Panic of 1857, the Dakota War (1861) and the Civil War (1861–65) were once-in-a-lifetime, cataclysmic events that were felt throughout pioneers' lives. The diary of Rufus Upton, provided by R.I. Holcombe in *Compendium of History and Biography of Minneapolis and Hennepin County, Minnesota*, said:

In June, I think—I succeeded J.M. Marshall and Wm. R. Marshall in the grocery business, which was carried on in a little store near Captain

Rollins's old house, on Main St, E.D. [East Division of Minneapolis]*;
I lived in the rear end of the building near the Pillsbury 'A' Mill, and
branched out into a general store of dry goods, clothing, boots and shoes,
iron, steel, nails, glass, and blacksmith's tools.*

Upton also recalled the Panic of 1857 in Lucy Leavenworth Wilder
Morris's oral history anthology *Old Rail Fence Corners*: "The destructive
financial distresses of 1857–58, which 'knocked on the head' the many
western interests. We had scarcely recovered from this period of hard times.
When the War of Rebellion came and interfered with all of our enterprises."
Rufus Upton and his brother, Moses, constructed a store out of brick in the
Federal style in 1855. Before the panic, the Upton block had transformed
with the boom and bust of St. Anthony.

Years later, the building served a heavy industrial use and was expanded
as the Union Iron Works was added in 1879. Later, it served as a warehouse
from 1930 onward. In 1878, the Saterlee and Salisbury Company
constructed an enormous mattress factory to the south on Main Street.
Lower Town had industrialized on the banks of the congested and polluted
workhorse known as the Mississippi River by the 1870s. The panic and the
Civil War had transformed Main Street from a major commercial street into
an industrial hub. Shopkeepers abandoned the river for Division Street (later
East Hennepin Avenue)

Anna Todd, who arrived 1856 in St. Anthony, confirmed Upton's
consternation about the Panic of 1857:

*Times were very, very hard in '57 and '58. We never saw any money and
to our Yankee minds this was the worst part of our new life. A friend had
been staying with us for months sharing what we had. One day he said
to my husband, "I'm here and I'm stranded, I can see no way to pay you
anything, but I can give you an old mare which I have up in the country."
He finally induced Mr. Todd to take her and almost immediately, we had a
chance to swap her for an Indian pony. A short time after, there was a call
for ponies at the fort and the pony was sold to the Government for $50.00
in gold. This seemed like a $1,000.00 would now.*

The Panic of 1857 left an indelible mark on St. Anthony. So did the
Dakota War. Before the war, St. Anthony's past was intertwined closely
with the Dakota, Ojibwe, Métis, fur traders and white settlers—this was
Bottineau's world. After the Dakota War, industry replaced fur trading,

and the American Indians were either removed or traveled west. The mills' construction sparked immigration—and the need for inexpensive unskilled labor. As historian Jocelyn Wills wrote, the Dakota War "permanently severed the fragile ties between Native and European-American cultures." With this, security spurred industrial and economic development near the falls. It also reinforced a persistent myth about St. Anthony and its surroundings—one that played out in countless boomtowns as the United States expanded westward. The myth moralized and justified the immeasurable injustices perpetrated against the American Indians. Bond repeated the racist and historically inaccurate myth. But it, nevertheless, was a significant pull factor for settlement. He wrote in *Minnesota and Its Resources*:

> *A very few years ago, and the present territory of Minnesota was a waste of woodland and of prairie, uninhabited save by the different hordes of savage tribes from time immemorial scattered through its expanse, with* [whom] *of later years a few white traders only intermingled.*

The myth of an empty plains open to white settlement encouraged the peopling of the region. While, without regret, the Dakota and the Ojibwe were sent to reservations, they continued to appear in advertising and place names in the region. But the American Indians were largely removed from St. Anthony—both physically and in settlers' consciences—and, later, the East Side and Northeast Minneapolis.

Early settlers bridged the gap between a bucolic past and urban future. As St. Anthony developed, Anna Hennes Huston comically reflected on her youth, "I moved to St. Anthony in 1854. I was only a tiny tot but used to go with my brother along a path by the river to find our cow. We usually found her in the basement of the university." St. Anthony recognized its past and knew that in the future would become a significant regional power. But what kind of a city did it want to, or would it, become?

John Wesley North (1815–90), a New York lawyer, was encouraged to settle in St. Anthony by Franklin Steele in 1849. He resided on Nicollet Island and later University Avenue with his young wife, Ann. North was both a militant abolitionist and a founding member of the Minnesota Republican Party. Steele stood in stark contrast to North: he was a Democrat like Sibley. But Steele needed settlers and eastern capital in his fledgling borough. North desired a New England town, one methodically and virtuously cultivated at the center of the Upper Midwest, and he succeeded by serving in the territorial legislature. Settlers arrived from the west, a state university was

promised for St. Anthony and the prohibition of alcohol consumption was considered. The couple's culture, intelligence and politics also attracted visitors to the tiny burgh, despite St. Anthony's isolation. Steamboat was the primary means of transportation on the rocky and poorly navigable Mississippi River between St. Paul and Minneapolis. The Norths were visited by Finnish-born Swedish-language novelist Frederika Bremer in 1850. She toured America to learn about democracy and even played Ann North's piano.

The Norths became disillusioned with St. Anthony. By 1855, it was not the staid New England City on the Hill that they had dreamed of. They moved on, founded the city of Northfield in that year and, in 1870, founded Riverside, California. But the Norths left behind a legacy that included the future University of Minnesota. They also contributed to the ongoing dialogue about St. Anthony's identity. What would the city become: a town of transplanted New Englanders or a bustling city with a diverse population? The latter won out due to the city's unbelievable growth in the ensuing decades. The Norths also posed another question in a free state: what was St. Anthony's position on the slavery and abolition debate? The complex question in antebellum St. Anthony was answered after a thirty-year-old slave arrived in 1860.

Interpretations of Eliza Winston's emancipation have been infected by the stain of racism. They reflected the individual historians and zeitgeist as much as the actual facts. The historiography of Eliza Winston's case in itself is worthy of a monograph. Besides Winston's court records, there are no extant primary source materials. But newspaper accounts and histories were written over the years—often through the lens of the climate of American race relations. There was, however, an insightful article in *Minnesota History* entitled "Eliza Winston and the Politics of Freedom in Minnesota, 1854–1860," written in 2000 by William Green. It is the definitive work on the Winston case.

Eliza Winston sought her freedom after arriving in St. Anthony. She was the caretaker for Norma, the daughter of Colonel Charles and Mary Christmas of Mississippi, for seven years. The August 24, 1860 court records state she was married to "a free man of color" who died in Liberia. Winston arrived with the Christmases the summer before the national election that prefigured the Civil War. At the time of the incident, the Christmas family visited, said Winston, "Mrs. Thorton's" on Lake Harriet. They had stayed earlier at the Winslow House, where Winston had packed "a good supply of clothing in [his] trunk, sufficient to last [him] two years."

The Winslow House was a luxury hotel. Constructed in the spring of 1857 for about $100,000, the six-story limestone structure was the focal

The six-story limestone luxury hotel, the Winslow House (left of center), was the focal point of St. Anthony for thirty years. *Courtesy of the Minneapolis Collection.*

point of St. Anthony for thirty years. At the hotel, Winston said, "After I got to St. Anthony, I got acquainted with a colored person and asked her if there were any persons who would help me in getting my freedom. I told her my whole story and she promised to speak with some persons about it."

During the summer, the hotel was a popular retreat for southern vacationers. The visitors' economic impact resulted in a bill legalizing slavery during summer months to be presented before the state legislature. The legislation was inspired by a petition from nine hundred residents of Stillwater, St. Paul and St. Anthony. It failed. But by all accounts, St. Anthony's position on slavery was split, though public opinion on the matter is difficult to discern given the vitriol on both sides. Furthermore, historians' interpretations were colored by race relations during their times—even Blegen believed, in 1963, just as the civil rights movement began to reshape America, "there was little abolitionism in the state." Events are strongly influenced by the times the historian lived in. And the historiography varies widely. Not even is the location where Winston

or the persons who freed her for habeus corpus agreed upon. Winston's testimony and Green's detailed and painstaking research are the best accounts. As he said, "August 21, 1860, abolitionist William D. Babbitt and Ariel S. Bigelow swore out a complaint for woman named Eliza Winston" at Lake Harriet. In Green's version, Winston was asked if she wanted her freedom. She agreed. But she was afraid to do so in the presence of Mary Christmas. As Winston said, "Whenever any one was seen coming, my mistress would send me into the woods at the back of the house."

Did someone instigate Winston to seek her freedom? Yes, said Green. Abolitionist and St. Anthony free black seamstress Emily Grey, "the colored person" mentioned by Winston, premeditated the plan for her freedom.

In Holcombe's version from 1914, Winston and the Christmas family are at Lake Harriet in south Minneapolis when "a posse" of thirty men arrived. Green concurred and stated the posse rode from the lake to the Hennepin County courthouse. Holcombe wrote of "the plan"—for all purposes a conspiracy hatched by Republican abolitionists William King, the editor of the *Minneapolis Atlas*; lawyer Francis Cornell; and pioneer abolitionist W.D. Babbitt. The Republicans were in political power then. King, Cornell, Babbitt and Judge Vandenburgh wanted to subvert the *Dred Scott v. Sandford* decision. The Supreme Court had ruled that slaves were not free in states where slavery was illegal. The abolitionists were, in modern parlance, "activists." They believed the law was unconscionable, and Vandenburgh refused to uphold it. The abolitionists' position was not unheard of in the state of Minnesota. Earlier that year, a slave was freed by the judiciary and again in Sauk Center, Minnesota, in October.

Holcombe claimed to understand the allegiances of slaves and the commitment of abolitionists when he said, "There were quite a number of other slaves at Minneapolis at the time of Eliza Winston's deliverance, but they loyally remained with their masters, and the abolitionists had no heart to try to effect their freedom." Holcombe's interpretation is viewed through the lens of America before World War I—an epoch when race relations had deteriorated to its nadir. Garraty and Carnes wrote:

> *The most horrible manifestation of the social malaise of the 1920s was the revival of the Ku Klux Klan. This new Klan, founded in 1915 by William J. Simmons, a preacher, admitted, only native-born, white Protestants. The distrust of foreigners, blacks, Catholics, and Jews implicit in this regulation explains why it flourished in the social climate that spawned religious fundamentalism, immigration restriction, and prohibition.*

However, in all versions of Winston's story, she went before Judge Charles Vandenburgh in the fourth judicial district in Minneapolis. She was granted her freedom in a matter of minutes. Again, the story is written from various points of view. All included Winston being whisked off to Babbitt's home. Then angry mobs of abolitionist and proslavery groups confronted each other. What is certain is that Winston escaped from St. Anthony, but with whom and where she went is unknown—again, there are countless interpretations. Before the mob arrived, Green wrote, she escaped with a "Professor Stone." Another mob gathered around Emily Grey and Ralph's (her African American husband) home.

In the Holcombe interpretation, "Before the Civil War broke out she voluntarily returned to Mrs. Christmas and presumably to slavery." The strangest version comes from Blegen in *Minnesota: A History of the State*. He outrageously stated, "Sentiment in this northern state was so strongly anti-abolitionist that a mob proposed to take Eliza back to 'her kind and generous master' and then to tar-and-feather the abolitionist who had befriended her." Green found no extant records of Winston after she received freedom, but she had an enduring impact on St. Anthony:

> *Eliza Winston left no record. Her assessment of Minnesota, as well as the subsequent events of her life, remain unknown. However, in a large sense, her story is less about herself than it is about the community she affected. By her single act she accelerated the inevitable collision between powerful and conflicting passions motivated by opportunity and morality. Her circumstances illuminated the underlying tensions in an antislave community that profited from slave money and, in doing so forced the community to see itself for what it was. Only the Civil War, declared six months after Winston's freedom, enabled the community to heal itself.*

Winston's life became a template open to speculation. However, historians frequently did not take into account that Winston sworn testimony before the court: "It was my own free choice and purpose to obtain my freedom."

Green also summarized the contemporary perspectives: "For Democrats, the Winston incident was an issue of respecting the private property of tourists." But for Republican Party members embarrassed by radicals, it was "a statement of principle rather than a legal directive." While for abolitionists, "Winston's freedom was a moral imperative."

St. Anthony underwent a cataclysmic change as industry developed on the riverfront. These laborers with their families were the basis of Northeast

Minneapolis. Paulina Starkloff was a bellwether of the immigration to come. She recalled, years later, in Morris's pioneer anthology:

> *My name was Paulina Lenschke. I was twelve years old when I came to Minneapolis in 1854. We intended to stay in St. Paul but were told that this was a better place, so came here and bought an acre and a half just where the house now stands, Main Street N.E. The town then was mostly northeast. The St. Charles hotel on Marshall Street, northeast, was just below us and so were most of the stores. Morgan's foundry and Orth's brewery were just on the other side of us. We paid $600.00 in gold for land and half of it was in my name, as my mother paid $350.00 that I had made myself.*

Starkloff received the money from her father. He disappeared in Australia prospecting gold and was never heard from again. After returning to her native Germany with her mother, they cashed the gold. Later, with the proceeds, they purchased their home in St. Anthony. German immigrants, especially after the failed revolutions of 1848, arrived in the United States and St. Anthony and provided labor for industrial development.

Early Industry in St. Anthony: Lumber Milling, Grain Milling and Brewing

Early industry in St. Anthony was driven by water power. The promise of its immense power drove lumber mills and floated logs down the Mississippi River. It also brought settlers and immigrants alike in search of employment.

Franklin Steele established the St. Anthony Boom Company in 1851. It was essential to sorting the logs going to the growing number of lumber companies. In the nineteenth century, the city was routinely one of the nation's leading lumber producers, especially in the Lower Town area. The original sawmill site was at the first dam, just south of Nicollet Island, and it was constructed in 1848. Two more sawmills were constructed in 1849. Saint Anthony boasted an output of 100, 000 board feet per day in 1855. By 1869, there were thirteen sawmills on the two sides of the river. But in 1870, the East Side sawmills were destroyed in a fire. In the aftermath, they were replaced by modern mills.

However, lumber production precipitously dropped off by the turn of the twentieth century as lumber interests moved west. Technology led the demise

The Northwestern Casket Company building was constructed in 1887. Shortly thereafter, the carriage house and the nearby factory were added. *Courtesy of the Minneapolis Collection.*

of the Lower Town milling district. The development of efficient steam power caused sawmills to move up the river to North Minneapolis. But even without sawmills, St. Anthony and Northeast Minneapolis became the center for allied industries related to lumber products, including Northwestern Casket Company, Levin Brothers Furniture and B.F. Nelson Paper Company.

Minneapolis and St. Anthony cooperated, once, in the development of water power at the falls in 1856 to 1857: they agreed on dam improvements. From then on, the relationship was contentious. The upstart yet deep-pocketed interests of Minneapolis battled the older but cash-poor St. Anthony's backers in a long game for regional riparian dominance. From the onset, although initially developing slower, the Minneapolis Water Power Company was led by Cadwallader Washburn's absentee vision. With his brother William D. Washburn on the west bank, Cadwallader invested in technological improvements on the west side of the falls.

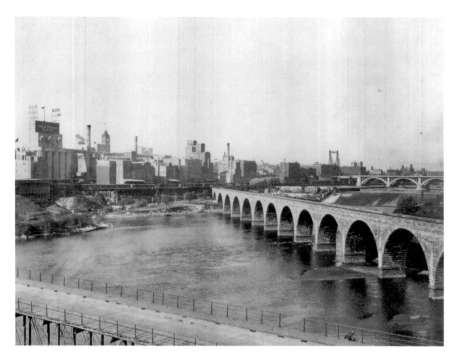

Cadwallader Washburn's business foresight led to the domination of the West Side Milling District in Minneapolis from 1880 to 1930. *Courtesy of the Minneapolis Collection.*

Richard Rogers built the first gristmill on the east bank. It was adjacent to the sawmill (between First and Second Streets Southeast) and was constructed with investment capital from Boston in 1851. With the available water power, in conjunction with the wheat farmers settling to the west and the advent of the railroad, St. Anthony and Minneapolis began to dominate the nation—and the world—in flour production. The two banks of the Mississippi River became known as the "Mill City." In 1880, twenty-seven flour mills produced two million barrels of flour per year. The city would remain the world's largest grain producer until 1930. But large-scale flour milling developed more gradually in St. Anthony at first as the great sawmill row of Lower Town declined. However, unlike Minneapolis, more diverse industry developed because of water power, for example, tool and furniture manufacturing, foundries and machine shops.

St. Anthony developed the nation's first permanent hydroelectric power plant after the second sawmill row had burned down on Hennepin Island west of Main Street Southeast in 1887. On the foundations, the Minneapolis General Electric Company built the nation's first hydro plant in 1894–95.

The Main Street Power Station, the second plant built on the site, was constructed in 1911.

Before Lower Town sunk into decline, small flour mills followed on Hennepin Island, such as the Island Flour Mill. Later, Lower Town mills included the North Star Mill (1871), the Phoenix Mill (1875) and eventually the massive Pillsbury A Mill (1881). The east bank's mill district was small compared to that of the west bank of the river, with two-dozen flour mills in 1890. But after consolidation, two firms dominated the region's milling.

John Pillsbury opened a hardware store in St. Anthony in 1855. It wasn't until 1869 that, with his nephews Fred and Charles, he bought a mill in Minneapolis. The Pillsbury clan had business acumen and prospered. They emerged as the largest flour milling company in St. Anthony. The Pillsbury A Mill was constructed with locally renowned architect LeRoy Buffington's architectural vision. W.F. Gunn assisted him by engineering the milling and factory equipment. The mill, completed in 1881, was not only a beautiful testament to the company but also a state-of-the-art factory. The walls of the immense limestone structure are an astonishing eight feet thick in places.

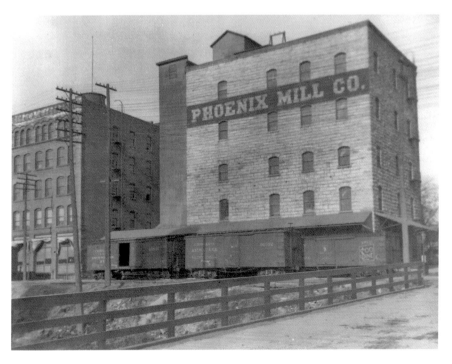

The old Lower Town mills began with the North Star Mill (1871), the Phoenix Mill (1875) and the massive Pillsbury A Mill (1881). *Courtesy of the Minneapolis Collection.*

Larry Millet, in *AIA Guide to the Twin Cities*, summarized the unbelievable scale of production at the mill:

> *In its peak years around 1905, the mill—divided into two identical sections—poured out nearly 3.5 million pounds of flour a day, using over 400 rollers for grinding hard spring wheat. Moving all the machinery were two water-powered turbines. Fed by a 400-foot-long underground canal from St. Anthony Falls, the turbines could generate a combined 2,400 horse power.*

The mill is a National Historic Landmark. The mill's success transformed Lower Town St. Anthony. As *Saint Anthony Falls Rediscovered* wrote, "The success of the mills like the Pillsbury 'A' Mill, once the largest mill of its kind in the world, doomed the beauty of the falls. Engineers were forced to cover the waterfall with first a wooden, and then a concrete apron, to control waterpower and erosion." Disasters worsened because of the use of water power with the mills' enormous growth.

Brewing was one of the earliest industries in St. Anthony. After a hard day of work, thirsty Upper Town pioneers needed beer. John Orth Brewing satisfied their needs within the heart of Northeast. From 1850 to 1976, the property bounded by the Mississippi River on the west, Broadway to the south and Marshall Street to the east was home to a several versions of the brewery.

John Orth was born in Alsace, France. The border territory was linguistically German. Likewise, he was of the same cultural affinity—beer was his drink of choice. He arrived with his wife, Mary, in 1850 and was, in many accounts, the first German in the St. Anthony. He was the second brewer in Minnesota after Anthony Yoerg of St. Paul. The early styles brewed by Orth in his original eighteen- by thirty-foot brewery were primarily ales. He had arrived before lager beer drinking was widespread in Minnesota Territory. Lagers were first brewed in the 1820s in Munich and Vienna but were not brought to America until John Wagner of Philadelphia brewed the beer style in 1840. Orth began brewing darker porters and ales for the New Englanders in the area. He did brew a few lagers even before a significant German community existed. In early editions of the city's newspaper, the *St. Anthony Falls Express*, he placed ads quirkily demeaning the beer from "below," or St. Paul: "I am now prepared to supply the citizens of the Territory with Ale and beer, which will be found equal—yes superior—to what is brought from below…Try my ale and beer and you will be convinced of the fact."

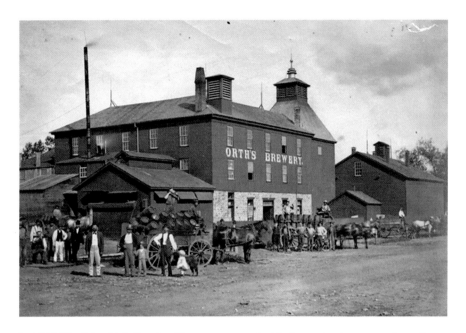

In 1890, The John Orth Brewing Company merged with three other brewers to form the Minneapolis Brewing Company—later known as the Grain Belt Brewing Company. *Courtesy of the Minneapolis Collection.*

Another major brewer emerged in early St. Anthony. The Gluek Brewing Company became a staple of Northeast lore. Before running Gluek's, Gottlieb Gluek worked for Orth for two years. The German immigrant then partnered with John Rank at the Mississippi Brewing Company (1857–62), which was renamed Gluek's. The story of brewing was ongoing in Northeast Minneapolis's rise, fall and renaissance—it is revisited throughout its history.

Lumber milling, flour milling and brewing were central to St. Anthony's development. As the city expanded and prospered, these industries, and especially their allied industries, would become the backbone of Northeast Minneapolis.

THE CONCEPT OF NORTHEAST

St. Anthony dominated the early history of the city of Minneapolis. The east side village had a fifteen-year head start on its cross-town rival in terms

of settlement. However, as the city expanded away from the river, old St. Anthony became less desirable than south Minneapolis, with its lakes, as the ideal residential place. But for the working class, a neighborhood surrounded by industry was a great place to live and work. Before the merger of St. Anthony and Minneapolis, the neighborhoods of the two cities were, like most cities in the United States during this time, segregated on ethnic and class lines. Neighborhoods emerged with distinct ethnic and occupational backgrounds reinforced by man-made affordances, such as railroad tracks, factories, rivers or roads.

Northeast Minneapolis: Minneapolis Historic Context Study, written in 1998, described the development of a distinct area. The survey stated:

> *While Old St. Anthony southeast of E. Hennepin acquired an early core of Yankee mill owners and professionals who persisted for a number of decades, the portion of St. Anthony northeast of E. Hennepin was largely a worker's enclave, first populated by Yankees, Irish, French Canadians, Germans and Swedes and then by large numbers of Poles and Eastern Europeans.*

These distinctions were apparent when the city began. Upper Town and Lower Town—as mentioned earlier—were viewed as distinct and nearly independent neighborhoods in St. Anthony. Surveying history and primary accounts, it's obvious that a rivalry began almost immediately. In his popular settlement and visitors' guide, Bond said in 1856 about Lower Town, "Her people are distinguished for their temperance, morality, industry and untiring energy of character." The city was already dividing. And it was on the east side of the river on ethnic lines.

As early as 1849, Dr. Lysander P. Foster, an early St. Anthony settler, opined in Morris's anthology, "In 1848 halfbreeds had gardens and raised famous vegetables up in what is now northeast Minneapolis." The Bottineaus were the earliest settlers to Northeast. With his large clan, he settled in the area before moving to modern-day Osseo in 1852. Despite the historically anachronistic descriptions given by Foster, at the time, they did not represent diversity but the status quo. Before settlement, white, Métis and American Indians traded and lived side by side but not always in peace. But with the arrival of settlers from the East, particularly New Englanders, they were outsiders. And as industry developed around Upper Town, the area became increasingly diverse—first German and Irish and then the gamut of Eastern European immigrants.

Lower Town was settled by lumbermen from the East. Especially common were Maine and New Hampshire as birthplaces. The Pillsbury clan, John and his nephews Charles and Fred, were later arrivals. The neighborhood was first characterized by sawmills and sobriety. Early prohibition efforts began there shortly after settlement when a chapter of Sons of Temperance organized. The May 31, 1851 issue of *St. Anthony Falls Express* listed the all-male organization that included Robert Cummings as an officer. He later developed the Maple Hill Cemetery in Northeast Minneapolis.

Lower Town was once a commercial strip with the Upton block and Martin and Morrison blocks at its center. Not surprisingly, John Martin owned a sawmill. His part of the eponymous building had four bay windows made with beautiful, white-dressed limestone in 1858. Frank Morrison thought the office was perfect, and on his adjoining property, he replicated Martin's property, only slightly smaller, with three bays constructed.

As time passed and additional industry developed, the concept of Lower Town and Upper Town disappeared. In time, the distinction became Northeast and Southeast Minneapolis, but both were located on the east bank of the river.

On the east bank of the river across from the northern Nicollet Island was the historic Upper Town. From the start, the settlers were more diverse than Lower Town and included the first Germans in the state. Germans brought beer and bars to the neighborhood. Out of this milieu, the original concept of Northeast Minneapolis was born—hardworking and hard-living, largely immigrant populations doing their best to get ahead in America and building Northeast, a place unlike any other in Minneapolis.

Northeast has had several names. First it was called St. Anthony—and more specifically as it grew, Upper Town—then the East Division, or East Side. As the city of Minneapolis flourished and looked away from the Mississippi River, it became the City of Lakes. But Northeast by any name was intimately tied to the river, even as industrialization caused increasing pollution.

"BLACK TUESDAY": THE EASTMAN TUNNEL COLLAPSE

The Eastman Tunnel collapse sealed the fate of St. Anthony—a civic merger with Minneapolis. The cataclysmic event shook the city to its knees, an exclamation point added to the area's economic malaise. But the disaster could have been worse without the intervention of the state and

federal governments in protecting the city's greatest resources and raison d'être—the cataract. With the industrial development of the mills, the falls' erosion only worsened, and in 1856, it was estimated the falls were receding around seven feet per year.

William Eastman arrived in St. Anthony after leaving a paper mill in New Hampshire. On September 17, 1865, he purchased Nicollet Islands' mortgage. Franklin Steele had defaulted on a $25,000 loan held by Hercules Dousman in 1861 and put the island up for sale. Steele's fortune had declined after he failed to develop the cataract's resources for financial gain while overextending himself to eastern creditors.

Steele resided then on the East Coast and rarely visited the city that he had founded. Instead, Richard Chute, the head of the St. Anthony Water Power Company, organized in 1856, supervised his interests. As *Saint Anthony Falls Rediscovered* stated:

> *The St. Anthony Water Power Company, almost from its very inception, was plagued by insufficient capital reserves and a divided management which plunged the firm into years of enervating legislation. Constantly in financial crisis, the East Side developers sought short-term gains rather than long-range improvements.*

Chute led a boondoggle by attempting to bring additional water power to the factories and mills on the east bank in 1864. When an 8-foot-high, 550-foot-long tunnel was dug under Fourth and Fifth Avenues Southeast, workers hit a large natural cave between Third and Fourth Avenues. The project failed. A portion of the tunnel and cave eroded and filled with water.

In 1865, the deed for Nicollet Island was drawn up for Eastman and sold. His partners, St. Paul businessman John Merriam and silent partner Amherst Wilder, discovered an enormous legal blunder. The deed had not excluded water power rights for Nicollet Island. At first, Chute refused to grant access to the water power. He, representing Steele and his financiers, was taken to court. The St. Anthony Water Power Company lost the legal battle and was forced to remove the dam. Meanwhile, Eastman and his investors attempted to sell the island to the Minneapolis Park Board in 1866. But the city, in a special election, refused the costly expense of purchasing the property for land.

With that option exhausted, work on the Eastman Tunnel did not begin until September 7, 1868. Excavating under Hennepin Island and the tip of Nicollet Island, it was hoped that the tailrace tunnel would dramatically improve east bank water power. In retrospect, this was a difficult task since,

as the *Landscapes of Minnesota* said, "Resistant Platteville limestone caps the falls, but the Glenwood shale and the St. Peter sandstone beneath the limestone are easily eroded." And that is what happened. On October 4, 1869, after digging two thousand feet from the falls through Hennepin and Nicollet Island, water leaks began to erode the sandstone. Within hours, a six-foot tunnel became ninety-feet wide and sixteen-and-a-half-feet deep. Parts of the limestone riverbed collapsed into a ferocious whirlpool. The tailrace of the tunnel collapsed less than one thousand feet from the falls. Something had to be done. The east side of the Falls of St. Anthony was at risk of being transformed into unnavigable rapids. The water-power source would be permanently lost.

A September 25, 1904 article in the *Minneapolis Tribune* tells the story. Businessmen and the Minneapolis Fire Department made attempts to stop the disaster. "George A. Brackett and others loaded a great crib filled with rocks, logs and heavy timbers and lowered it into the whirlpool, but the great crib was sucked out of sight in an instant and was never seen again." Repeated efforts failed to cease the erosion of the falls. Additional cribs—or in other accounts, "rafts of logs"—with the same materials as in the newspaper story

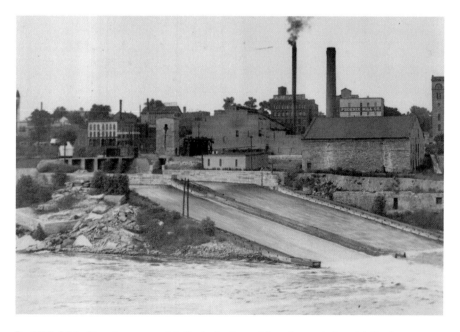

By 1870, Main Street's commercial district had transitioned to an industrial district. The rapid industrial expansion was powered by the Falls of St. Anthony. *Courtesy of the Minneapolis Collection.*

were sunk, but they, too, after brief success, failed to totally stabilize the falls. Finally, under the direction of Brackett, three cofferdams were built to divert water from the damaged area. Men worked day and night and, after the cofferdams were completed, stabilized the falls.

In the aftermath, a part of Hennepin Island, as well as the Summit Mill and warehouse, were lost forever to the river. An ongoing effort to save the falls commenced. In November 1869, the Army Corps of Engineers surveyed the damage. However, they did not have appropriations for improvements. Lobbying continued while St. Anthony, Minneapolis and the region's future was imperiled. Six breaks at the falls occurred in six years. The federal government recognized the possible economic cataclysm if the falls were not remedied and acted quickly but in a piecemeal manner. By 1870, Congress approved $500,000, but this was just the beginning of federal appropriations for protecting the cataract of such importance to the continued development of Minneapolis. In 1874, two low dams were constructed on the east and west side of the falls. By 1880, a new apron was completed.

The disaster easily could have ended water power at the Falls of St. Anthony—only one hundred feet upstream, near the southern tip of Nicollet Island, there is no protective layer of Platteville limestone. Instead, porous limestone lines the riverbed and would have replaced the falls with rapids. *Saint Anthony Falls Rediscovered* noted, "For a time, the falls themselves appeared to be on the verge of collapse—a calamity that would have destroyed the milling district on both sides of the river." It could have been worse, but the city of St. Anthony's days were numbered. As Wills observed, "The tunnel collapse foreordained the consolidation of Minneapolis and St. Anthony into one city."

THE MERGER OF THE ORIGINAL "TWIN CITIES": MINNEAPOLIS AND ST. ANTHONY

To civic leaders, St. Anthony's merger with Minneapolis was a fait accompli, but it was years in the making. Working people in the future Northeast met the merger with deference while Minneapolis industrialists planned for regional economic dominance.

From the perspective of Northeast pride in 1976, the paper "Northeast: A History" looked back at the merger:

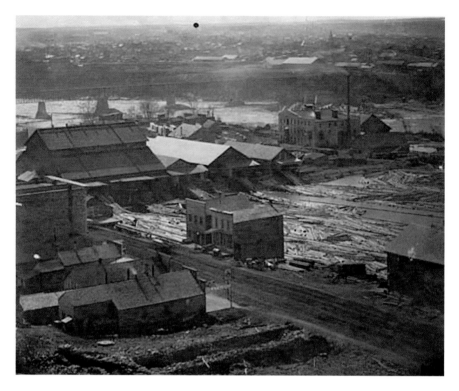

Main Street, old St. Anthony, as it appeared within a decade after the merger with Minneapolis, when the once commercial area industrialized. *Courtesy of the Minneapolis Collection.*

The influence of St. Anthony, spiritual and profane, is unmistakable in Northeast. When in 1872 Minneapolis "annexed" the East Side, Northeast practically went its way…annexed by the new city called Minneapolis, the Old City called St. Anthony or the East Side went to newer glory of its own—no longer a milling capitol, no longer a showplace of fancy and classy folks, and no longer a beauty spot in a natural wonderland.

The story of St. Anthony's merger began with Franklin Steele. Before the Eastman Tunnel collapse, real estate, immigrant and job recruiting pamphlets like the *Minnesota Guide* said, "In 1850 there were two or three hundred people in St. Anthony, and it grew rapidly until the Panic of 1857 checked it, since which, its progress has been more slow." When settlement propagandists question a city's future, then something is amiss—but it began years before. On March 19, 1866, a referendum in Minneapolis to annex St. Anthony failed by eighty-five votes, but the city agreed to relinquish part of its autonomy. In the same year, the city was included within the city limits of Minneapolis

as chartered by the Minnesota state legislature. The newly consolidated city was divided into two divisions—East (St. Anthony) and West (Minneapolis) with four wards on each side of the Mississippi River. Though St. Anthony's corporate identity was retained, the mayor, treasurer, comptroller and city justices were shared; however, street improvements, education and taxation remained independently controlled by the two divisions.

St. Anthony, despite its fifteen years advantage on Minneapolis, prepared for complete annexation. The St. Anthony Water Power Company led by Steele financially overextended itself. "Land speculation rather than...manufacturing improvements" was a poor economic development plan, argued Wills. She contrasted the paths that Minneapolis and St. Anthony followed in the development of both cities' greatest natural resource—the cataract.

The Minneapolis Mill Company, with deeper pockets under the leadership of absentee owner Cadwallader C. Washburn, brother and lawyer William D. Washburn and their cousin Dorilus Morrison, took a long-term plan. The group had a vision for the development of the West Side Milling District, and it was played out in the history of the area, although they did not live or participate in the fourth development period. As *Saint Anthony Falls Rediscovered* noted about the stages, "The four major periods [were] (1) initial commercial development, 1856–70; (2) expansion of flour milling, 1870–80; (3) consolidation of flour milling, 1880–1930; (4) decline of flour milling, 1930–65." Minneapolis Mill Company became the dominant flour milling company and involved itself in additional business interests, such as the railroad and the antecedent to the *Minneapolis Star-Tribune*, while entering contracts that preserved the falls and received dividends on investments.

The company also invested in New Process flour milling, with technical innovations such as "the middlings purifier" in 1871. Spring wheat grown in the Upper Midwest, despite having red, hard kernels, could then compete with eastern winter wheat. The new milling process made whiter and cleaner flour by using "high grinding," where the wheat kernel was broken while passing through the millstone and the hard bran center was separated out; then it passed through the separator, which removed "the light bran." New Process ended the problem of discoloration and the lack of gluten, necessary for dough's elasticity, and transformed the city's reputation. Before these technological innovations, Minneapolis was known for milling low-quality flour, but afterward, it made arguably the best. The companies capitalized on to the high quality of flour with ads for "Pillsbury Best" and Washburn-Crosby's "Gold Medal" flour. St. Anthony's finances were lacking from the start, and it sought investment capital from the East. But in doing so, it neglected to make improvements to the

water power. Besides the Pillsbury A Mill area, the then formerly Lower Town commercial district of St. Anthony became increasingly heavily industrialized.

Cadwallader Washburn's business decisions had incredible foresight. While sawmills continued turning a profit for the Minneapolis Water Power Company, he began the process of closing them down. He knew sawmills were not as financially lucrative and were furthermore an inefficient use of water power. As *Saint Anthony Falls Rediscovered* stated, "Convinced that sawmilling operations wasted waterpower, the Minneapolis Mill Company, between 1876 and 1880, purchased all the sawmills on the west side and, within a decade, phased them out of production." Washburn's legacy was the company he created, as noted once again in *Saint Anthony Falls Rediscovered*:

> *In 1879 he took three partners into the business and formed Washburn Crosby and Company. Although Washburn died three years later, the new company continued to set an innovative example with advances in quality control, product diversification, marketing, and advertising. In 1928 Washburn Crosby was reorganized as General Mills, Inc.*

Historically, milling was not as successful in St. Anthony. And this initiated the process of decline and dominance by its cross-river rival. After losing Nicollet Island to Hercules Dousman in 1861, Steele defaulted on the St. Anthony Water Power Company loans in 1871. A sheriff's auction was held while Steele remained in the East because of owed back taxes. But he did return for a carriage ride with his old friend Captain John Tapper in 1880. During the jaunt, he collapsed and died soon after. Despite financial mismanagement, Scott Anfinson argued St. Anthony's fate was the result of its geology:

> *The life blood of the mill district was the water pouring* [out of] *those gates, which had been developed very differently than the east side, which is sort of a hodge podge of development and it had no big power canal. That's why Minneapolis has the name Minneapolis, because of that power canal! The Saint Anthony side got a fifteen-year jump on settlement over Minneapolis, but why is it Minneapolis and not Saint Anthony when they had the original jump on the settlement? Well, the reason is that waterpower canal.*

Sheer demographics also led to the merger. Despite the head start, St. Anthony did not experience the continued population boom that Minneapolis had maintained. *Saint Anthony Falls Rediscovered* encapsulated the dilemma that the city faced:

In 1870 the city numbered 5,013 inhabitants, only a marginal increase over the 1857 census figure. Minneapolis during the same period quadrupled its population to 13,066 residents. As East Side population growth stagnated, the physicians, lawyers, and merchants of Lower Town began to abandon Main Street for more promising neighborhoods; several moved across the river to Minneapolis.

St. Anthony might not have decided at the ballot box yet, but the settlers and professionals who relocated their business before the merger had. Or as the *Saint Anthony Falls Rediscovered* mentioned, "When the voters of St. Anthony relinquished municipal autonomy and joined Minneapolis in 1872, they politically ratified an already established economic fact."

St. Anthony's merger was approved by the state legislature on February 28, 1872, but one city—Minneapolis—was not officially recognized until April 9. In that year, the new city of Minneapolis expanded its boundary east to H Street, later renamed Stinson Boulevard. St. Anthony was now part of Minneapolis, a city in competition with its downriver rival, St. Paul, for regional supremacy.

After the merger, St. Anthony became the East Division of Minneapolis with Southeast and Northeast Minneapolis as constituent parts. But Minneapolis had a succession of names during its settlement on the west bank of the Mississippi River. John Stevens, lacking a name in the first years, referred to the future city of Minneapolis as West St. Anthony. But, like several other names—especially since it lacked distinction from St. Anthony—it didn't stick. Downriver, rivals in St. Paul were led by editor James Madison Goodhue and the first newspaper in the territory. First issued on April 28, 1849, the *Minnesota Pioneer* repeatedly referred to the city they considered a lesser upstart as "All Saints." Repeatedly, Goodhue imposed the saints theme: St. Paul and then the St. Peter River (later the Minnesota River)—and angered some settlers. John Stevens recalled in his autobiography that All Saints was used in the city's first election. Regardless, the settlers preferred allusions to the East, such as the great water-powered city of Lowell, Massachusetts. Albion was another name, alluding to the Greek word for England.

As settlement claims became possible on the west side of the Falls of St. Anthony, early settlers pushed for a county seat there. With the Mendota Treaties signing by the Senate, three months later, a meeting was held to form the county seat. Holcombe wrote about the event:

Then the question of the name of the county's capitol [sic] was considered, "All Saints" was at once discarded; so was "Hennepin City," which [Isaac] Atwater and the St. Anthony Express had argued for. Chairman Alexander Moore suggested Albion, an ancient name of England. Commisioner [sic] Dean said the place was destined to be a great manufacturing site and proposed Lowell, for the city of factories in Massachusetts. Finally the name of Albion was agreed upon, and the clerk was instructed to use upon all official letters the name Albion as the county seat of Hennepin County.

So the name was decided—or was it? Charles Hoag had settled on the west side of the river in 1850 but was dissatisfied with the city's name. So, it turned out, were many members of the community on both sides of the river. The schoolteacher, formerly from Philadelphia, wrote to the November 5, 1852 *St. Anthony Express*. He suggested and even signed his letter to the newspaper with the nom de plume "Minnehapolis." He wanted the citizens of St. Anthony's assistance with the name and wrote, "We are accustomed, on this side of the river, to regard your paper as sort of exponent of public sentiment, and as a proper medium of public expression." He poked fun at "All Saints," saying it was "applicable to no more than two persons in the vicinity of the falls, and [a] doubtful application even to them." Then he wrote in the *Express*, "The name I propose 'Minnehapolis,' is derived from 'Minne-ha-ha,' 'laughing water,' with the Greek affix polis, a city, meaning 'laughing water city,' or 'city of the falls.'" The newspaper supported his recommendation. Editor George Bowman of the *Express* responded on November 12:

The name is an excellent one, and deserves much favor from the citizens of the capital of Hennepin. No other opinion could be chosen that would embody to the same extent the qualities desirable in a name. The h being silent, as our correspondent recommends, and as custom would make it, it is poetical and euphonious.

Minneapolis won out—eventually. But, first, Hoag in the slightly different guise of "Minnehapolis" wrote on December 3, in the *Express* that "Albion" was adopted for a short time.

The name Minneapolis, however, did not stick until 1855. *Saint Anthony Falls Rediscovered* detailed, "Twenty-one Minneapolis businessmen pooled their real estate interests and founded the 'Town of Minneapolis.'" The authors also wrote, the city was "eight square miles, neatly gridded into 210

blocks by over 60 intersecting streets." But they then jested, "Most of these thoroughfares were as yet figments of the surveyor's imagination."

The merger necessitated numerous changes for the two cities. While Minneapolis and St. Anthony might have immediately merged on paper, the East and West Divisions remained separate in other ways. The city's separate educational systems after the merger served as a fine example. It took until 1878 before the two school systems merged into one entity.

Another challenge was integrating the labyrinthine tangle of streets. Both sides of division of the city had repetition of names and numbers of streets. The curve of the river further undermined the coherence of the grid. In 1872, Franklin Cook combined the confusing collection of streets. He organized the street grid on both sides of the river by making them cohesive, consistent and understandable.

A persistent myth existed and continues to this day about the names of Northeast streets. The chronological North and South President Streets begin in the west with Washington Street after Sixth Street Northeast and end with Delano and Kennedy Streets (an east–west street) in the Mid City Industrial Park near Minneapolis's eastern border. But they were not established as a civics lesson to the city's most diverse ethnic neighborhoods. The wave of immigration had not yet arrived from Poland, Czechoslovakia, the Ukraine and Lebanon when the new street plan was unveiled. The street plan was not drawn with nativism, 100 percent Americanism or anti-hyphenism in mind—that despicable behavior was saved for the period before and after World War I.

To deal with the unprecedented rapid economic expansion of Minnesota, and particularly Northeast, the state established an immigration board in 1867. Members included Governor William Marshall, Henry Rogers and immigrant agent Hans Mattson. The board published recruiting pamphlets and books in English, German, French, Swedish, Norwegian, Welsh, Dutch and Danish. It rarely published pamphlets in the languages of the newest wave of immigrants who arrived from Eastern Europe after 1880 who worked the low-skill and heavy-labor jobs available in Northeast Minneapolis. The New England elite didn't expect them—they, unfortunately, didn't want them—but the immigrants arrived anyway. The immigrants made the best for themselves in America because they wanted better lives for their children. The merger only hastened the city's economic growth and caused Northeast Minneapolis to both become more independent and to be transformed into the manufacturing and industrial powerhouse of the city. Northeast Minneapolis found its niche, a position it would retain until long after World War II.

After the merger, St. Anthony, with Northeast Minneapolis, gained the working-class reputation that exists even today. St. Anthony, once a city competing with St. Paul and Stillwater for regional power, had been reduced to a decaying industrial zone. The transition from a commercial street to an industrial area began early with the St. Anthony Iron Works (75 Main Street Southeast) after the Civil War from 1865 to 1879 and the Barnard Brothers Furniture (308 Main Street Southeast) from 1853 to 1871. After the 1870s, the area further industrialized with the Union Iron Works, Crown Iron Works, Levin Brothers Furniture and Salisbury and Satterlee Company, a mattress firm. They were clustered in the vicinity of Main Street by 1900. When St. Anthony was annexed by Minneapolis, Northeast continued its rapid transformation into the city's hardworking blue-collar immigrant heart.

NORTHEAST

In the way of cataracts, it is decidedly the glory of our west and the northwest.
The pulse of the traveler seems to beat quicker as he feels himself approaching the
scene, where Father Louis Hennepin, was so carried away with admiration.
—J.W. Bond, Minnesota and Its Resources

On the land sloping down to the riverside between Marshall Street and the
Mississippi River, another residential district became the first American
neighborhood for many immigrants. Poles and other Slavic groups first settled
in Northeast in this low-lying area called "the Flats" on the Mississippi's
east bank opposite Nicollet and Boom Islands. In the Flats, the newly arriving
immigrants could find affordable housing in two and three story buildings that
served as rudimentary hotels. The long rectangular structures consisted of many
small rooms, and these bedrooms often had no windows because the buildings had
common walls. In some cases, owners rented the rooms using the hot bed system,
where customers paid for lodgings only during the hours they needed to sleep.
—Genny Zak Kieley,
Heart and Hard Work: Memories of "Nordeast" Minnepolis

The dichotomy of the idyllic cataract and the hard life on the Flats represented Northeast Minneapolis in the mid- to late nineteenth century. St. Anthony Falls rapidly transformed from pristine beauty to a dense industrial zone choking on pollution. The Flats were less than a mile upstream from the majestic falls. Zak Kieley wrote about one of a multitude

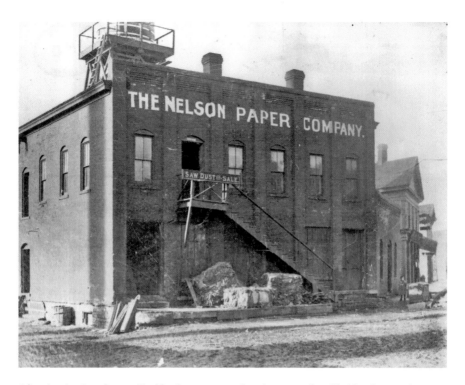

After the demise of sawmills, Northeast emerged as the center for allied lumber products like the B.F. Nelson Paper Company. *Courtesy of the Minneapolis Collection.*

of new immigrants' experiences in Northeast Minneapolis, where jobs were abundant and everyone could work.

Immigrants scrimped and saved. They founded enduring institutions: churches, schools, fraternal organizations and city services. In some cases, they reconstituted institutions while others were significantly modified from "the old country." City services largely conformed to the standards of New England and Middle States elites who ruled Minneapolis into the twentieth century.

In time, these institutions—as distinct as national churches—evolved to take on characteristics of their adopted land. Immigrants aged and remained in their communities. But immigrant's children were in limbo, trapped between the old country and America. Businesses and elites often viewed them as hyphenates—"German-Americans," "Polish-Americans," "Latvian-Americans." Every ethnicity in Northeast, they reasoned, were not "100% American." Israel Zangwill's "melting pot" failed. But Northeast's "salad bowl," or mosaic of multiculturalism, succeeded. Distinct ethnic groups adapted, worked together and found success in Northeast.

Northeast is defined by geography, crisscrossed by railroad tracks and industrial districts that predate zoning. *Twin Cities* architecture writer Larry Millett said:

> *Architecturally, what makes Northeast unique in Minneapolis is its intimate tangle of housing and industry. This is especially true in the neighborhood's older sections, where you may find houses on one side of the street and a grain elevator or factory on the other. Such casual commingling of disparate uses is frowned upon by modern zoning codes—the first of which was enacted in Minneapolis in 1924, well after most of Northeast Minneapolis developed—but it's always been a vital feature of the neighborhood's identity. Northeast also has many bars and restaurants, a circumstance stemming in part from an 1884 ordinance that limited where saloons could operate in Minneapolis. As it turned out, a good chunk of Northeast was left open to the temptation of alcohol, and the neighborhood thus became a prime destination for the city's thirsty multitudes.*

Northeast Minneapolis depended on water power for energy until the advent of electricity. The municipal, state and federal governments modified the Falls of St. Anthony to satisfy economic development. "Falls Preservation" and improvement were multifaceted and cost millions of dollars. On November 24, 1876, seven years after the Eastman Tunnel collapse, the trade paper the *Lumberman* said, "That something is being done for the preservation of St. Anthony Falls our readers generally are well aware, but that it is a matter of great engineering skill and a most stupendous undertaking has never entered their heads." The paper comically recognized the repairs necessary for the continued existence of sawmilling and allied industries and highlighted projects: "Completion of a Gigantic Concrete Dike 40 Feet High and 1,500 Feet Long, at a Cost of $200,000" and "Two Rolling Dams Being Constructed at a Cost of $22,000, and Will Be Completed by January First." *Saint Anthony Falls Rediscovered* claimed a 2,000-foot dike was necessary in 1981 and the Eastman Tunnel's collapse cost $1 million.

The explosive expansion of Northeast Minneapolis wouldn't have occurred without the improvements mentioned by the *Lumberman*. Industry, railroads, manufacturing and immigrant settlement were possible because of the power of the Falls of St. Anthony.

IMMIGRATION LITERATURE

Pamphlets, written in numerous languages, alerted immigrants to the favorable conditions of settlement in Minnesota. Written from a propagandistic perspective, the authors often stood to gain economically from immigration. Countless unskilled jobs were available. The greater the competitions among immigrants, the more wages were kept down. Shopkeepers printed and sold the pamphlets that attracted workers. With labor competition, there were greater profits for the businessmen and investors.

The *Minnesota Guide* waxed about—what else, weather. The pamphlet said: "The popular impression that the further north you go the colder it gets, is an erroneous one…Minnesota, owing to the large lakes, east and north of it…[is] warmer than Chicago 2½ degrees south of it, and equal to Southern Michigan, Central New York, and Massachusetts."

Other persuasive methods attracted immigrants. For English speakers, the idyllic beauty of Henry Wadsworth Longfellow's "The Song of Hiawatha" was used to encourage settlement. Sensationalistic newspaper accounts confused foolish immigrants and investors alike while entertaining readers like a modern day tabloid. These stories were common after the Civil War, but perhaps the most absurd example was reprinted in the winter of 1981–82 in the *Hennepin County History* in an article titled "Minneapolis: the 'Lowell' of the West." The *Daily Graphic* of New York City, on August 17, 1878, outrageously claimed that the Falls of St. Anthony were the largest in America at "82 feet tall." The article neglected Niagara Falls, which is 167 feet high and 1,000 feet wide on the United States' side.

Land agents encouraged immigration. Governments, natives and fellow immigrants attempted to cherry pick groups capable of assimilation. But, eventually, the tap of mass immigration opened to meet the needs of the rapidly expanding economy.

Hans Mattson was the most famous agent. He encouraged immigration from his home country, Sweden. To his advantage were major push factors. Sweden's population swelled as a result of immunization, peace and better nutrition. As a result, good land was scarce and young men questioned if they could farm beyond a subsistence level. For others, religious intolerance, even persecution, was a factor. Until 1858, the Swedish Lutheran Church was the official state church, and all other denominations were illegal. Even when religious dissent was legalized, social intolerance was the accepted norm. Those not embracing the national church were persecuted. Land agents had early impact in Northeast. Swedes settled first on the flats when a shoemaker from Skåne arrived in 1851.

St. Anthony: Pioneer Churches

Before mass immigration occurred in St. Anthony, churches were established. Pioneer settlers—largely from New England, the Middle States and occasionally the South—formed several Protestant parishes. The parishes quickly segregated ethnically, although a few Protestant churches were founded before these lines were drawn. Pioneer churches, with a few early exceptions, were on the East Side and later Southeast Minneapolis, east of Division Street (present-day Hennepin Avenue). Immigrant churches were located within the original St. Anthony plat and later sprinkled throughout Northeast after settlement. In the nineteenth century, American cities segregated businessmen and bosses from workers—the East Side was no exception.

Holy Trinity Episcopal Church's roots predate the city of St. Anthony. In 1838, Reverend Ezekiel Gilbert Gear was appointed the chaplain at Fort Snelling to meet soldiers' spiritual needs. But it wasn't until 1848 that he held services in St. Anthony. By October 30, 1850, a church was constructed between Second and Third Avenues (Northeast today) on land donated by Franklin Steele and Roswell P. Russell. As the city expanded and industrialized, the city's founders desired a new church. They relocated from an area increasingly industrial and poverty stricken.

Holy Trinity's new church was constructed up the hill (at Fourth Street and Southeast Fourth Avenue) above the industrializing Mississippi River. English-born architect William Causdale built the church in 1873, a masterpiece of local materials in the Gothic style, made with gray Platteville limestone and finished with yellow Mankato-Kasota stone trim. In 1890, an addition doubled the space for the growing congregation. Over the years, members included Henry T. Welles, St. Anthony's first mayor, and William Watts Folwell, the first president of the University of Minnesota. In 1944, the church merged with St. Timothy's Episcopal parish. St. George's Greek Orthodox Church later purchased the church.

First Congregational Church held services on November 16, 1851. Charles Secombe of St. Anthony and Reverend Richard Hall of Point Douglas, Wisconsin, led the first congregational denomination in Minnesota Territory. The small wood frame building was "pledged" as the future University of Minnesota in the vicinity of Chute Square. The congregation then moved in the vicinity of Northeast Fourth Street and East Hennepin Avenue. But St. Anthony's growth necessitated another move, and a church was constructed near present-day Marcy School and Holmes Park (the corner of Fifth Street

and Third Avenue Southeast). Dedicated on June 28, 1874, it burnt down in less than twelve years. Warren Hayes, a respected local church architect, was hired. He created a beauty constructed with brownstone, with a corner tower and thin columns that distinguished the church when it was completed in 1888. It remains a landmark with its immense steeple visible throughout the neighborhood.

St. Anthony Andrew Presbyterian Church organized even before First Congregational Church. Reverend Edward Neill preached every other Sunday at the Falls of St. Anthony during the winter of 1849–50. This was the genesis of a church that continues to the present. Prominent St. Anthony citizens served as elders: Richard Chute of the St. Anthony Water Power Company and later General Horatio Van Cleve. The Civil War veteran and his suffragist wife, Charlotte, filled the pews with a brood of twelve children while residing within blocks of the church. The august elders swelled the congregation's numbers. During its first decade, services were in a commercial building on Main Street—Edward's Hall in Lower Town St. Anthony. The church attempted a "union" with the congregational church, but the effort quickly failed.

Andrew Presbyterian, as seen in this picture from the 1960s, was a scaled-down reproduction of St. Giles Church in Edinburgh, Scotland. *Courtesy of the Minneapolis Collection.*

In 1861, the First Presbyterian Church received a gift of $1,000 and a church bell. Catherine Andrew's three daughters from New York City made the contribution for their late mother. The Minnesota state legislature renamed the church "Andrew Presbyterian Church" in her honor in January 1861. In Neill's history, church construction was completed on April 14, 1862, at the Second Street and Fourth Avenue Southeast location. The wood-frame church relocated to its present-day Fourth Street and Eighth Avenue Southeast location in December 1870. With financial support, once again, from the Andrew family, the new gray limestone church was constructed on the site in 1890. A scaled-down reproduction of St. Giles Church built in Edinburgh, Scotland, in the fourteenth century, the massive Gothic-style structure with windows, bays, turrets and a bell tower transported viewers to another time. Sadly, Horatio Van Cleve's funeral was the first service in the new church on April 24, 1891.

Andrew Presbyterian merged with Riverside Church from the Cedar-Riverside neighborhood in 1966. The church was renamed Andrew-Riverside United Presbyterian Church. In 2001, a wall collapsed, and the building was irreparable. The lot was vacant for years before student apartments were constructed on the site with the church on the ground floor.

When the founders of St. Anthony arrived, they almost immediately formed churches. Immigrants soon followed with a seemingly endless array of faiths and built the city, working in the flour mills, sawmills and factories of pioneer businessmen.

IMMIGRANT CHURCHES

Churches were an integral institution where immigrants' ethnicity and religion overlapped. They were intimately linked to their daily lives, culture and identity. This was particularly true in Northeast Minneapolis.

Nancy S. Doerfler wrote in *Heart and Hard Work*, "More than any other institution, the churches of Northeast Minneapolis reflect the rich heritage and diversity of Northeast's ethnic communities." As Wolniewicz observed, "The dates of the establishment of ethnic churches in Northeast indicates that the period of greatest immigration occurred between 1870 and 1914, the Germans and Scandinavians coming somewhat earlier than the people from the South and East Europe."

The landscape's transformation occurred in cities across the country. As Minneapolis's population swelled from 46,867 in 1880 to 164,738 a decade

later, immigration was the reason. As *Northeast Minneapolis: Minneapolis Historic Context Study* noted:

> *The 251 percent population increase experienced in Minneapolis in the decade of the 1880s included thousands of European immigrants. Their greatest numbers reached Northeast Minneapolis between 1870 and 1914. Northeast Minneapolis' initial labor force was comprised of primarily native-born Americans and French-Canadians, but the late 19th century was characterized by a substantial settlement of Germans, Scandinavians, Poles, and Ukrainians as well as other European groups, including a small number of Italians. The immigrants arranged themselves in the often non-contiguous areas of residential land around the rails and factories and adjacent to the oldest settled portion nearest the river.*

Immediately after settlement, the immigrants began the process of establishing their own churches, and they did it on a remarkable scale—one worthy of the Guinness Book of World Records.

On Monroe and Madison Streets between Thirteenth and Fifteenth Streets, four churches were constructed on one block: Emanuel Evangelical Lutheran, Elim Swedish Baptist, St. Peter's Lutheran and Immanuel Lutheran (Strong Tower Parish). These were the churches' original identities. The parishes were constructed circa 1900. Ebbe Westergren said in *Snoose Boulevard and the Golden Mile*, for Sweden's Kalmer Läns Museum, "the greatest effort to preserve the use of Swedish was made in church services and Sunday school." Churches also represented the diversity of faiths in the immigrants' adopted home and frequently changed hands and served new parishioners. During this time, two churches were constructed because of infighting among Norwegian immigrant populations—St. Peter's and Immanuel's.

Emanuel Lutheran is an enormous Gothic Revival–style building across from Logan Park. It is the first and grandest of the four. The Swedes, far more numerous in south Minneapolis, had a presence in Northeast Minneapolis. Swedes immigrated after the 1868–69 crop failure, and some eventually settled in Northeast. Tired of traveling across the river for church services after working in the flour and lumber mills and breweries, the Swedes constructed their own church. First, they worshipped at First Street between Central Avenue and First Avenue Northeast. It was closer to home than "Our Savior" (Washington Avenue and Tenth Street South) but proved insufficient. In 1892, land was purchased for a new church that opened in 1899.

First Ward Park, later Logan Park, provided athletic and educational opportunities for immigrant children. It continues to meet the needs of its diverse neighborhood. *Courtesy of the Minneapolis Collection.*

Keith Dyrud, in *They Chose Minnesota*, described the importance of the church and other meeting places for immigrants: "Although men used the saloons of Northeast Minneapolis as social centers and women visited in each others' homes, all gathered in their chosen churches." The overwhelmingly unskilled but hardworking new arrivals craved an institutional connection to their past. But they wouldn't have crossed the ocean without favorable, even profitable, circumstances in the United States. The "new" immigration began earlier and at a more rapid pace in Northeast because of the overnight industrial boom and the need for labor. Garraty and Carnes wrote about the transatlantic economic development that shaped immigration:

> *Beginning in the 1880s, the spreading effects of industrialization in Europe caused a shift in the sources of immigration from northern and western to southern and eastern sections of the Continent. In 1882, 789,000 immigrants entered the United States; more than 350,000 came*

from Great Britain and Germany, only 32,000 from Italy, and less than 17,000 from Russia. In 1907—the all-time peak year, with 1,285,000 immigrants—Great Britain and Germany supplied fewer than half the number they had 25 years earlier, whereas Russia and Italy were supplying 11 times as many as then.

The new immigrants sought to reestablish old institutions. Despite poverty, the new immigrants earned money and made Northeast home. They built the central institution in their lives and communities—churches.

St. Anthony was the site of the first permanent churches. St. Anthony of Padua was constructed on a future address in Northeast (813 Main Street Northeast) and led by Father Augustine Ravoux. Pierre Bottineau donated fourteen lots of land for the French Canadian Catholic church in 1849. It was dedicated with the financial assistance of Bishop Joseph Cretin in 1851. To meet the needs of a growing parish, a second church was built in between 1857 and 1861. Later, it included the state's first parochial school, the Sisters of St. Joseph. But once again, the church was too small. As Roman Catholics immigrated from Ireland and Germany

Pierre Bottineau donated the land for St. Anthony of Padua, organized by French Canadians and the first Catholic church in St. Anthony. *Courtesy of the Minneapolis Collection.*

in the 1850s, they raised money for their own parishes. The Irish quickly overwhelmed the French Catholic in numbers.

In 1877, the French Catholics established Our Lady of Lourdes Catholic Church. The minimalist, Greek Revival–style First Universalist Church constructed of local limestone in 1857 was massively modified to satisfy Roman Catholic architectural tastes. An apse, transept, steeples, front

Our Lady of Lourdes was constructed as the First Universalist Church (1857) but was significantly modified when French Canadian Catholics purchased it in 1877. *Courtesy of Sherman Wick.*

tower and bell tower transformed the once staid structure into the French Provincia style with Romanesque architectural add-ons. In the 1880s, a tiny French Second Empire mansard roof was added at the rear of the sacristy. The combination of architectural elements created a beautiful church and the oldest continuously used church in the city of Minneapolis.

St. Boniface was the first German Catholic church in then St. Anthony. Germans immigrated to the state escaping political turmoil and religious intolerance after the failed revolutions of 1848. They began attending church at St. Anthony of Padua, but in time, and as their flock grew, they built a parish and named it in honor of the patron saint of the German people: St. Boniface. The Anglo-Saxon had brought Catholicism to the Frankish Empire in the eighth century. For centuries, his sarcophagus in Fulda, Germany, has remained a pilgrimage site for the devout.

The original St. Boniface, the second Roman Catholic Church in St. Anthony, was constructed in 1858. The second St. Boniface was built under Father Wirth's leadership in 1878. The church boasted 2,500 members by 1910. The present-day church was constructed by St. Paul's Charles Hausler, who studied with the father of American modern architecture Louis Sullivan. The 1929 church in the Byzantine Revival style sits on the 1899 foundation.

Polish Roman Catholic churches are sprinkled throughout Northeast Minneapolis. Holy Cross was the earliest. The first Polish immigrants were composed mostly of Galicians, from what was then the Austro-Hungarian Habsburg Empire, who arrived in the late 1860s. The Russians and Prussians also divided Poland's lands between 1795 and 1905. This resulted in a great immigration of Poles to America, and Northeast Minneapolis became the primary destination in the Upper Midwest. In the early years, Poles attended either St. Anthony of Padua or St. Boniface.

Over the years, three Holy Cross churches were constructed. The first was constructed in 1886, but only the third, built in 1928, satisfied the congregation's needs at 1621 University Avenue Northeast. Though its exterior is brick, the interior contains stained glass, statues, paintings and marble columns—everything that told the Polish immigrants they'd succeeded, if only for the duration of Sunday Mass. Over the years, additional Polish Catholic churches were constructed in Northeast to meet the spiritual needs of the burgeoning community, including St. Hedwig's, Sacred Heart and All Saints.

Slovaks first arrived in 1875 and settled in Bohemian Flats. On the Minneapolis side of the Mississippi River, across from the University of Minnesota, they built makeshift shanties similar to St. Paul's Lower

Levee and Swede Hollow. In greater numbers in the 1880s and 1890s, they worked in the mills and foundries of St. Anthony and Northeast, where they established communities.

The Slovaks were of exceedingly diverse religious backgrounds. Slovak culture and history expert M. Mark Stolarik in *They Chose Minnesota* wrote: "The Reformation and Counter Reformation of the 16th and 17th century left Slovakia with four major faiths. By 1930 their relative sizes within Slovakia were: Roman Catholic 72%, Lutheran 12%, Greek Catholics 6% (most of whom were Rusyns) and Calvinists 4%." Northeast Minneapolis was a good fit for the Slovak community who had worshipped in a variety of churches throughout Minneapolis. Slovak Lutherans lived in south Minneapolis with the Scandinavians of the same faith, and Roman Catholics attended Polish churches. But the Greek Catholics were dissatisfied with the options for practicing their faith.

Sts. Cyril and Methodius epitomized the unique history that is Northeast. The parish was named after the ninth-century brother saints known as the "Apostles to the Slavs" from the Byzantine Empire. They were born in Thessalonica, Macedonia (present-day Greece) and converted the Slavs in Macedonia, the Balkans and Moravia—which included the Slovaks who had settled central Europe before AD 500. Conquered by the tenth-century Magyars, an ethnicity today associated with modern-day Hungary, the non-Slavic western Asian and Finn-Ugric language speakers isolated the Slovaks from the Czechs, fellow western Slavs. They were persecuted under Magyar domination and eventually were incorporated into the Ottoman Turkish Empire and later the Habsburg Empire in the 1520s.

When it was time to form a Slovak parish, two saint names were too much for Archbishop John Ireland. Stolarik wrote that he allowed the church "to leave the Polish congregation and form their own Roman Catholic Slovak national parish." However, as Nancy S. Doerfler wrote in the chapter "A Church on Every Corner," from *Heart and Hard Work*, "The delegation proposed naming the congregation for the apostles to the Slovaks, Saints Cyril and Methodius, but the bishop felt one name would be sufficient. So, the Church of St. Cyril incorporated in February 1891." In 1885, parishioners purchased the land for a national church. Ireland appointed Father John Ladislas Zavadan as parish priest—a Slovakian Franciscan. But the priest and parishioners quarreled, as Stolarik wrote:

Slovak immigrants, accustomed to a system by which the noble who erected a church controlled the appointment of its priest, assumed that

Located in the heart of former Little Poland, Sts. Cyril and Methodius Catholic Church, built in 1917, is Northeast's Slovak parish. *Courtesy of Sherman Wick.*

> *since they paid for the church in the new country, they had the same right. The Irish hierarchy of the American Catholic church disagreed. Financial problems and disagreements over Americanization and language use ensued until the congregation in 1926 received a priest who had been raised in the community.*

In 1917, the second church—the present St. Cyril's—was completed for $85,000 at Thirteenth Avenue and Third Street Northeast. It was known only as St. Cyril's, unlike other Moravian/Slovak parishes throughout the world—e.g. Skopje, Macedonia; Bulgaria; Slovakia; Chicago; and Michigan.

The East Slavs', or Rusyns (also spelled Rusins), religious beliefs are diverse and complex. Dyrud wrote, "In the century from the 1870s to the 1970s an estimated 500,000 to 600,000 East Slavic people who referred to themselves as Ruthenians, Rusins, Ukrainians, or Rusyns immigrated to the United States from eastern Europe." He also stated 5,000 to 10,000 settled in Minnesota. They transcended national boundaries, but their roots were in Kiev, modern-day Ukraine, where the Rus originated and spawned the

Russians, Ukrainians, Byelorussians and the Rusyns. Dyrud described the difficulty of pinning down ethnicity: "The main difficulty in discussing East Slavic peoples occurs in distinguishing the various groups among them. Complexity is the outstanding feature in the history of eastern Europe, not least in the area where East Slavs lived." Wolniewicz diagnosed another problem for Rusyns: "Census figures usually give country of origin data only for countries existing at the time of the census. Countries, however, may begin or stop existing, and their boundaries may change radically." As Wolniewicz wrote, "The Slavic groups of Northeast, [mostly] originate within 150 miles of Przemysl, Poland." Nationality was a confusing and tangled skein that was difficult to determine. "An immigrant from Sub-Carpathian Russia (Ruthenia) who was born in 1865 would have seen his homeland change hands five times by the time he was eighty."

The Ruthenians, or Rusyns, were from the Carpathian Mountains. In Poland, Slovakia, Serbia, Croatia, Romania and the Ukraine, they had resided in mountain villages and endured poverty and high illiteracy rates. In Northeast, they worked in rail yards, flour mills and sawmills after first attending German and Polish parishes. In 1886, a committee purchased property at Seventeenth Avenue and Northeast Fifth Street, where parishioner carpenters built a wooden church—St. Mary's Greek and Catholic Church in 1888. It was dedicated by Rusyns from villages in modern-day eastern Slovakia, then a portion of the Austro-Hungarian Empire. The Hungarian bishop of Presov sent Father Alexis Toth in 1889, and he held services on Thanksgiving Day. Toth had married, a common practice among Byzantine Rite priests, but was a widower when he arrived. Lacking financial support for the parish, Toth opened the community's first grocery store. Three weeks later, church services commenced. Toth visited Archbishop Ireland, from whom his church sought support. Doerfler wrote:

> *Archbishop John Ireland denied Father Toth permission. Ireland also refused to acknowledge the legitimacy of the Byzantine Church in his diocese and ordered St. Mary's Catholics to attend the Polish Roman Catholic Church. At this point, the Slavs parted company with the Roman Catholic Diocese of St. Paul, and Bishop Vladimir Sokolovsky welcomed the parish members into the Russian Orthodox Diocese.*

After this rejection, the church converted to Russian (Eastern) Orthodoxy. Archbishop Ireland became known as "the Father of the Orthodox Church in America." Paul Petrovich Zaichenko was sent from San Francisco by

the Russian Orthodox Diocese of Alaska and the Aleutian Islands in October of 1892. He wrote, "There was not a single man from Russia in the city of Minneapolis." But the Russian government could not refuse the orthodox proselytes and, in 1906, sent St. Tikhon and then Archbishop Tikhon Belavin. He consecrated St. Mary's Orthodox Cathedral as the first Russian Orthodox seminary in the United States. St. Mary's defection to Russian Orthodoxy was followed by over one hundred Greek Catholic congregations nationally who were also alienated by the Roman Catholic Church. St. Mary's remained financially favored by the imperial Russian government—the church received an annual $1,100 stipend from 1892 until the Russian Revolution in 1917.

St. John the Baptist Eastern Rite Catholic Church was an international reaction to St. Mary's defection. Stirring for an Eastern (or Byzantine) Rite Catholic church began in Hungary, where government officials were troubled. Rusyns returned from Northeast Minneapolis to their native village, Becherov, where successful conversions were made to Russian Orthodoxy. Furthermore, St. Mary's Reading Room provided newspapers and other information about the need for Russian Orthodox Rusyns in Hungary to allow Russian annexation of their homeland. In 1902, Andor Hodabay, a papal representative, lobbied for a Byzantine Rite church in the United States. While working for the Hungarian government and the Greek Catholic church, he approached Pope Pius X. Pius approved the church. Father Sotor Ortinsky became the first Byzantine Rite bishop in the United States. John Ireland wanted to halt the conversion to Russian Orthodoxy. He supported a Byzantine Rite church but with a celibate parish priest to avoid scandal. Symbolically, John the Baptist Eastern Rite Catholic Church (Twenty-second Avenue and Northeast Third Street) celebrated Mass on Thanksgiving Day 1907, only eighteen years after Father Toth and Ireland's conflict over St. Mary's.

St. Constantine's Ukrainian Catholic Church is another Rusyn Byzantine Rite church. The restrained onion dome structure, made of brick and tiles, was established in 1913 (University Avenue and Fifth Street). Ireland, once again, admitted the church following the precedent for clergy's celibacy at St. John the Baptist. The Byzantine Rite in East Slav tradition is a complex amalgam of a faith. Dyrud described the denomination: "Byzantine Rite Catholic church, called at the time the Greek Catholic or Uniate church…combined Eastern Orthodox ritual and practice with recognition of the pope in Rome as its head."

This group of Rusyns had attended St. John the Baptist Greek Catholic Church. The parishioners included intellectuals who immigrated after

participating in the Ukrainian independence movement (1910–17), unlike earlier immigrants from Subcarpathia—a depression near the Carpathian Mountains that borders present-day Ukraine, Romania, the Czech Republic, Poland and Austria. Dyrud wrote about the immigrant's differences: "The earlier settlers in Northeast Minneapolis had immigrated principally from Subcarpathia and considered themselves Rusins or Russians. The intellectuals, as well as other later arrivals, were largely from Galicia, and they increasingly identified themselves as Ukrainians." The parish founded the Ukrainian Educational Home, later rechristened the Ukrainian Culture Center.

St. Michael's Ukrainian Orthodox Church (505 Northeast Fourth Street) was built by in 1925. Ukrainian immigrants, dissatisfied with church services, formed the parish, arguing the other Greek Catholic churches were too Latinized and controlled by the Archdiocese of St. Paul and Minneapolis. This elicited not only a local but also a national response. Ukrainian Orthodox churches created independent or autocephalous churches disconnected from the ecclesiastic hierarchy. This angered both Russian and American church leaders. Autocephalous local leaders wanted Ukrainian culture as a central thrust, which they believed was absent at the other Northeast Minneapolis churches. After the creation of the Ukrainian Soviet Socialist Republic in December 1922, the Ukraine was absorbed into the Union of Soviet Socialist Republics. In response to the Soviet Union's attack, several community members desired a political church.

St. George's Greek Orthodox Church began services in 1922 (at 900 Fifth Street Southeast). The church relocated to the former Holy Trinity Protestant Church (316 Fourth Avenue Southeast) in 1950. It later merged with St. Michael's and formed St. Michael's and St. George's Ukrainian Orthodox Church.

In the 1850s, Italian immigrants settled in Minnesota but, unlike in most American industrial cities, in small numbers. Before settling in Northeast, Italians had a series of churches. Originally, they worshiped south of downtown Minneapolis at Immaculate Conception, now the site of the Basilica of St. Mary's. Then they created the first Our Lady of Mount Carmel at a former German Lutheran church on Main Street Northeast and Seventh Avenue Northeast in 1910, which was later sold to the Lebanese Maronite community. The church was too far from the Italians' primary settlement, Maple Hill, also known as "Little Italy" or "Dogtown" (later Beltrami Park). They replaced the Swedes who had dominated the area but, having financially established themselves in America, moved to newer

neighborhoods. The Italians also found employment in jobs formerly held by Swedes and Irish at the Soo Line Railroad at Shoreham Yards (Central Avenue and Twenty-eighth Street Northeast) and at Pillsbury. Church services were held at the Margaret Berry House until 1938. The Italians then purchased the second Our Lady of Mount Carmel Catholic Church. Here, the parishioners celebrated Italian feast days in the streets, until Interstate 35 West was constructed.

The Lebanese settled in Ward One of Northeast Minneapolis. Originally known as Syrians, they proudly associated with Lebanon following independence in 1946. Viviane Doche, in *Cedars by the Mississippi: The Lebanese Americans in the Twin Cities*, said, "The immigrants from Lebanon who settled in Minneapolis and St. Paul were fairly homogenous in background." Doerfler expanded:

> *The first middle-Eastern immigrants to Minnesota were the Syrians. They began to arrive in Northeast Minneapolis in the 1880s from Bjdarfel, Batroun, Jdabra, and other villages south of Tripoli and settled near Marshall and Main Streets. A large portion of the immigrants came from small villages in the Mount Lebanon district, a coastal region between the port cities of Beirut and Tripoli. After the area gained independence as the country of Lebanon in 1946, a renewed national consciousness spurred immigrants from the part of the country to think of themselves as Lebanese instead of Syrian.*

The Eastern Rite Catholic Lebanese, an ethnic group with small numbers, at first, held services in a private home (311 Main Street Northeast). In 1903, it was converted into a church and led by itinerant priest Father Antoun Sleiman. In 1895, there were thirty Lebanese immigrants who listed 123 Main Street as their residence, where they rented rooms and worked as peddlers. Once again, in 1905, the entire Lebanese population of fifty-one lived at shopkeeper Mike Henne's new address. The Lebanese saved money and prospered in the grocery business. In 1919, they purchased the abandoned original Our Lady of Mount Carmel (625 Main Street Northeast) from the Italians and Reverend Emmanuel El-Khoury served during this transition (1916–21). In 1939, the old Everett School was renovated into a church, rectory and recreation center at Sixth and University Avenues Northeast. On the same site, the new St. Maron's Catholic Church was completed in 1948. The fifth church incorporated the altar, chapel, sanctuary and stained-glass windows of the previous church.

St. Maron's was named in honor of the fourth-century hermit and priest. He proselytized on the Orontes River in present-day Lebanon to the descendants of the Phoenicians, who were Mediterranean mariner-merchants. After converting to Christianity, the adherents were persecuted and escaped to the mountains of Lebanon. The liturgy of Maronite's is in Syriac, a sister language of Aramaic—the language of Jesus. The Maronites

A renovated Everett School became St. Maron's Catholic in 1939. The new church was built in 1948 and another in 1999. *Courtesy of Sherman Wick.*

practiced the Antiochian Rite, the liturgy of the Patriarchate of the ancient Syrian city on the Orontes River in modern-day Turkey as opposed to the Roman or Byzantine Rites.

As ethnic groups "made it" in Northeast, in some cases, they relocated. Unlike today, the area was a dirty and industrial place—especially the ramshackle shanties on the flats by the Mississippi River, west of Marshall Street and between Third and Eighth Avenues Northeast. After finding financial success, immigrants moved up to the hills to Windom Park, Audubon Park or even the suburbs. As ethnic homogeneity also broke down over generations, so did the use of native languages in churches. As Westergren wrote, by 1945, in Swedish churches, "all regular service were conducted in English." As she said, "With World War I, things started to change. The United States was at war with parts of Europe. Organizations, private and governmental, campaigned for Americanization."

Holiday services ads in the *Minneapolis Argus* on December 24, 1959, illustrated the churches' demographic shift. Elim Swedish Baptist Church was an exempler: Christmas services included an "All Swedish Julotta" at 6:00 a.m. with a Swedish choir led by the extremely Swedish-named Nels Stjemstrom. During the same time, Emanuel Lutheran had transitioned into a multi-ethnic parish—with a very German American named pastor, William Siegel. By Easter 1970, Elim Baptist in an *Argus* advertisement included Swedish American surnames but also the German American Joseph Tewinkel as minister of music and Robert Guelich as interim pastor.

Salem Mission Church demonstrated the evolution of one particular church. Swedish immigrants established the church as a mission church. Later, they moved to Jefferson Street and 13th Avenue near Logan Park in 1881 but quickly relocated to 18½ Street and Central Avenue in 1901. In 1971, they settled in the northern suburb of New Brighton and became the Salem Covenant Church.

The Swedish immigrant community was an example, perhaps an especially transient one, of an ethnic group's movement as it prospered. As all ethnic groups aged in Northeast, they frequently relocated. In some cases—as with the Swedes—religious homogeneity broke down while in others, such as that of the Lebanese, it remained largely intact.

RAILROADS

The railroads were an essential industry in the development of St. Anthony and Northeast. Trains brought immigrant labor to Northeast Minneapolis and were one of the largest employers. For recently arrived immigrants, the railroads offered a variety of jobs to catapult them into the working or even middle class. Moreover, the railroads improved and expedited transportation, which in turn allowed for greater volume of products and the development of allied manufacturing industries in the vicinity of rail lines.

St. Anthony waited impatiently for the arrival of railroads. Steamboats slowly navigated the Mississippi River near the Falls of St. Anthony with extreme difficulty. Investors, speculators and politicians understood railroads would transform the region and lobbied Congress for their development. In 1857–58, twenty railroads had been chartered in Minnesota Territory when the Panic of 1857 hit, followed a few years later by the Civil War, which brought progress to a complete stop.

On June 28, 1862, the William Crooks, the first train in Minnesota, traveled between St. Paul and St. Anthony. On the ten-mile route, three daily trains linked the cities, except on Sundays. The St. Paul and Pacific Railroad, a short line, connected the two cities but avoided Minneapolis on the west side of the Mississippi River. The railroad's arrival caused excitement throughout the state. As the July 3 *St. Cloud Democrat* reported:

> *An important event in the history of Minnesota transpired yesterday. The first division of the St. Paul and Pacific railroad is finished, and trains have commenced to run from St. Paul to St. Anthony! Let it be recorded for the benefit of the future historian of the vast Northwest, that on the 28th day of June, 1862, the first link in the great chain of railroads which will, in the course of a few years, spread all over this State from the valley of the Mississippi to the Red River of the North, and from Lake Superior to the Iowa boundary line, was completed and a passenger train started in the direction of Puget Sound!*

The railroad's introduction was a transformative event. Northeast's remarkable industrial growth in the late nineteenth century would not have occurred without it.

The Mississippi River's navigation remained an ongoing battle. Despite serving as the power source and impetus for the area's development, the Falls of St. Anthony were difficult waters for shipping. Railroads provided

an improved means of transportation. The railroads' burgeoning development was noted on January 20, 1888, in the trade newspaper the *Lumberman*. In the article "Interurban Navigation," it commented about the river, "Quite an elaborate survey of the Mississippi river channel between Minneapolis and St. Paul has recently been made under the direction of the general government, with a view to determining the mooted question of the possibility of making the river navigable up to or near the Falls of St. Anthony." The writer listed the improvements and expenses required: dredging, $12,000; removal of boulders and debris, $60,000; lock one, $900,325; and lock two, $1,349,235. This was only the beginning of expenses. Each decade there were more bills for improving river navigation, but the railroads increasingly became a quicker and cheaper option for shipping. Northeast benefited from abundant railroads and immigrant labor to keep them running.

When immigrants arrived in Northeast, railroads were then a common place of employment. By 1900, with four rail lines, numerous options existed for workers both skilled and unskilled. *Northeast Minneapolis: Minneapolis Historic Context Study* stated the reason for plentiful railroad jobs: "The routing of several railroads across the northeast side of Minneapolis ensured its future as an industrial area, and reflected markets as far as Puget Sound and the Atlantic."

After the 1893 Minneapolis fire, the Wisconsin Central Railroad provided additional jobs with its yards and roundhouse on Boom Island. The yards were conveniently located near immigrant homes and businesses. The channel around Boom Island was industrialized and gradually filled in by the railroad. By the late nineteenth century, it wasn't an island anymore.

The Soo Line was an important employer in Northeast. It originated because of Minneapolis millers' and manufacturers' dependence on Chicago, St. Paul and eastern railroads for shipping rates. This greatly affected profits and, indirectly, employment—when the Minneapolis firms profited, more employees were hired. John S. Pillsbury, Thomas Lowry and William D. Washburn cooperated to create a rail line bypassing the Chicago-based lines—they named it the Minneapolis, Sault Ste. Marie and Atlantic Railway. It was shortened to Soo (as in Sault Ste. Marie) in 1888—a route that avoided St. Paul and Chicago and made profits as Minneapolis ascended to become the economic power of "the American Northwest." Incorporation papers were filed in Wisconsin in 1883 for the rail line that linked Minneapolis flour milling interests with the Great Lakes and customers in the East.

The Soo Line constructed the enormous 230-acre Shoreham Yards at Twenty-seventh and Central Avenues in the 1880s. On the site were yards, maintenance and repair shops. During boom years, over one thousand people were employed at the only shop in the Twin Cities capable of constructing an entire train from parts. The arrival of Thomas Lowry's Twin City Rapid Transit allowed employees to travel on the streetcar line to Shoreham Yards by 1891. And new employees would be needed when Shoreham Yards was greatly expanded in 1913. The construction included a tool house, woodworking shop, blacksmith shop addition, storeroom and more. The daily *Finance and Commerce of the Twin Cities* wrote about the expansion:

Soo Line Railroad opened Shoreham Yards in the 1880s and employed over one thousand Northeasters in its maintenance, yards and shops during its peak years. *Courtesy of the Minneapolis Collection.*

> *The Soo Line will put nearly $400,000 into enlargement and improvement of its Shoreham shops and the announcement that the company will begin the work March 15 is the most important development for years relative to the New Boston industrial district of Northeast Minneapolis, and is of great importance to the city as a whole. Where 1,300 skilled workmen are now employed and 2,000 men in all making an annual payroll of magnitude, the company will make such enlargement as will permit an eventual material increasing of the working force.*

The Soo Line is currently part of the Canadian Pacific Railway. Shoreham Yards was demolished in 1995.

FIRE DEPARTMENT

The fire department dates back to the inception of St. Anthony. The all-volunteer group began as "Al Stone's Fire Company" in 1851. Al Stone, a Maine native from Lower Town, led it. But the modern fire department was decades in the making. Overnight industrial development and extensive wood frame buildings made the likelihood of fire a persistent and imminent possibility.

The volunteer department continued at the Cummings and Brotts' office in Lower Town but was not officially organized until 1857. By 1858, three fire companies existed in St. Anthony: the Cataract Engine Company in Lower Town, the Independent Hook and Ladder Company at Fourth and Main Streets Northeast and the Minnesota Engine Company in Upper Town.

Immigrants were critical members in the early St. Anthony and later East Side and Northeast Minneapolis fire departments. Germania Engine Company Number Two was organized on November 3, 1858, in an old school on Second Street Northeast. In the late nineteenth century, rosters of fire stations had diverse "nativity" of German, Irish, Swedish, Norwegian and Scottish firefighters.

With the merger of Minneapolis and St. Anthony in 1872, the east and west sides retained their own fire department buildings and equipment. Improvements included the Fire Alarm Telegraph System—a system of fireboxes that responded quickly, by late nineteenth century standards, and alerted stations. It was installed in the West Division in 1875 and in the East Division in 1877.

The city's greatest disaster occurred in the west side milling area. On May 2, 1878, a dust explosion at the Washburn A Mill, then the largest flour mill in the world, leveled two blocks of mills and resulted in eighteen fatalities. The event was the catalyst for modernizing the fire department. By July, Minneapolis had created a permanent fire department. But by today's standards, it was miniscule with only twenty paid firefighters spread over twenty stations.

Augustine Costello wrote, in *The History of the Fire and Police Departments of Minneapolis*, "Minneapolis as an intelligent, progressive city has many things to be proud of, but no one thing is of greater importance or more highly appreciated than the fire department." The firemen of the city had many reasons for pride in their service. Unfortunately, a few years later, disaster would strike again with the fire of 1893. Still, a couple years before he had written about the department: "It bears the reputation of being the best

for its size in this country." Minneapolis's rapid growth and the lack of city planning, zoning and building codes challenged the fire department when the great conflagration occurred.

POLICE DEPARTMENT

The police department in St. Anthony and later Minneapolis developed more slowly. Into the twentieth century, the role of the police force evolved rapidly to meet the needs of a modern city.

The St. Anthony Police Department shares minor resemblance to the modern force. After incorporation, Benjamin Brown was elected marshal in the spring of 1855. A police ordinance passed on May 31, 1858, and another marshal, J.A. Armstrong, was appointed by the mayor. The marshal had similar duties to a sheriff in the Old West with limitless police power and questionable political relationships in the then four wards of the city established in 1857. He commanded constables and two justices of the peace who sentenced criminals. Rufus Baldwin bluntly said, in *The History of the City of Minneapolis*, edited by Isaac Atwater, the marshal had "almost unlimited power." In Alix J. Muller's *History of the Police & Fire Departments of the Twin Cities*, Frank B. Mead wrote:

> *He was empowered and it was made his duty to execute all writs or other processes issued by the city justice, to collect by execution or otherwise all fines, forfeitures and penalties, to diligently inquire into and report to the city attorney all violations of the ordinances, criminal laws of the territory and breaches of the peace; to ferret out all suspicious and disorderly houses; to arrest with or without warrant any person found intoxicated in the streets of the city.*

On and on ad infinitum went the list of offenses—"swearing," "pilfering," "robbing," "quarreling" and "threatening," to name a few. The law permitted overzealous marshals with extensive police powers; fortunately, no reports of such activity exist. Moreover, the law empowered aldermen to make arrests and corroborate with the police force—both were significant conflicts of interest. Corrupt aldermen could easily shake down citizens on trumped-up charges under the threat of arrest.

The police department was created after the merger with Minneapolis in 1872. The mayor appointed the police chief in 1890, and the police

department's ranks swelled with 217 officers and 147 patrolmen on the force. Police practices were in their infancy at the turn of the century. Mead discussed "the Bertillon System for the identification of Criminals." The state-of-the-art modern policing employed biometrics, or anthropometry, which detractors would today call phrenology. The pseudo-science measured the head (both length and width) and the middle finger as factors in determining suspects' criminality. The French system developed by Alphonse Bertillon was then touted as the first scientific system for identifying criminals. It was replaced by a reliable and scientifically accurate system—fingerprinting.

Costello euphorically wrote from his position as Minneapolis's city director:

> *The present incomparable Fire and Police departments of Minneapolis, although widely divergent as regards their duties and functions, are nevertheless twin guardians of the public and social fabric of this young giant city of the great Northwest. Without them, civilized society could not exist.*

More than a dozen years before his wanton criminal activity would destroy Minneapolis's reputation, Costello wrote about an address delivered by Mayor Amos Alonzo "Doc" Ames. Ironically, he lauded the police department:

> *Mayor Ames delivered his inaugural address, April 12, 1887, wherein, he said that he referred with pride to the police force of the city, and took pleasure in stating that in his opinion it had no superior in the United States as regards efficiency and discipline.*

Mayor Ames would engage in rampant corruption with the police department's aid. The corruption was so significant, noted muckraker journalist Lincoln Steffens, who would write a chapter in his book *The Shame of the Cities* entitled "The Shame of Minneapolis." After corruption was swept away, the second police precinct—located on Central Avenue—served the Northeast community with dedication. The East Side station was where numerous children of immigrants found careers in public service.

EDUCATION

When St. Anthony was established, schools were one of the first institutions. Once the pioneer settlers had built homes and stocked food for the winter, their

attention turned to education. The first settlers arrived from New England and the Middle States, where education set them apart. Ahead of national trends, educators organized a school board by legislation passed into law in 1860. As Garraty and Carnes said about American education in the 1870s:

> *The history of American education reflects after about 1870 the impact of social and economic change. Horace Mann, Henry Barnard, and others had laid the foundation for state-supported school systems, but most of these systems became compulsory only after the Civil War, when the growth of the cities provided the concentration of population and financial resources for economical mass education.*

Atwater's history hyperbolically stated, "No city in the Northwest, and perhaps it would be safe to say in the United States, can boast of a more perfect system of public schools, than that of Minneapolis."

In the relative wilderness of Minnesota Territory, settlers attempted to re-create their educational heritage. On June 1, 1849, Miss Elizabeth "Electa" Backus was the first teacher at a little frame shanty near Second Street and Second Avenue Southeast. Soon, another school opened on University and Second Avenues Southeast, followed by the first school in Northeast, Everett School (on University Avenue between Sixth and Seventh Avenues Northeast) in 1851. Dr. Lysander P. Foster remembered his education in Backus's classroom:

> *The first school I went to as boy of fourteen, was on Marshall Street Northeast, between Fourth and Sixth Avenues. I was taught by Miss Backus. There were two white boys and seven half-breed Bottineaus. It was taught much like kindergarten of to-day—object lessons, as the seven half-breeds spoke only French and Miss Backus only English. Mc-Guffy's Reader was the only textbook.*

Though his language is salty and colloquial, one thing was clear: St. Anthony and the East Side and Northeast Minneapolis were dedicated to educating children.

In St. Anthony and later Northeast Minneapolis, education was of fundamental importance to the community. Neill described, "The educational system of Minneapolis is justly a source of satisfaction and pride to the citizens. It consists of public graded schools, providing a course of instruction preparatory to the University, private schools, supplementary to these, and finally to the University

and theological seminaries." Neill wrote that the Minneapolis public schools, in 1882, were divided into primary (grades one through three), intermediate (grades four through five), grammar (grades six through eight) and high school. St. Anthony "secured" sites for primary and intermediate schools in 1865 and voted on locations for public schools from 1867 to 1872.

Elementary schools radiated out into the neighborhoods on the East Side in the nineteenth and twentieth centuries. Northeast Minneapolis and Southeast Minneapolis have several schools with over one hundred years of history. Their names have changed—whether common, primary, grammar or elementary schools—as much as the style of instruction and the number of students in classrooms. But they remain an essential link between the residents and the community that they serve.

By 1890, Northeast Minneapolis had four public elementary schools: Prescott (1884), Holland (1886), Schiller (1890) and Webster (1880). The original elementary school (Summer Street and Monroe Street Northeast) was named after Massachusetts senator Daniel Webster. The school moved

Prescott Elementary opened in 1884 and expanded its campus three times by 1931 to meet the needs of Northeast's growing population of school-age children. *Courtesy of the Minneapolis Collection.*

east a handful of blocks in 1974 to 425 Fifth Street Northeast but closed in 2006. The Minneapolis public schools will reopen Webster as pre-kindergarten to second grade school in the fall of 2015. An additional class will be added each year until the school goes up to fifth grade.

Pierce Elementary School opened in a former church on Fillmore Street Northeast between Spring and Summer Streets in 1896. The school relocated to a new building on Broadway Street and Fillmore Street Northeast in 1900, where it educated a diverse student body. The building closed in 1966; it burned down in 1969.

The number of Northeast Minneapolis elementary schools swelled as first- and second-generation immigrant children became school age. In the early and mid-twentieth century, portable buildings and classrooms were used to accommodate the booming population. Two examples were Cavell Elementary (Thirty-fifth Avenue and Tyler Street Northeast) from 1918 to 1923 and Cary Elementary School (2105 Thirty-third Avenue Northeast) from 1924 to 1948. During this time, Van Cleve Elementary was at Lowry Avenue and Jefferson Street Northeast from 1894 to 1941. Holland Elementary originally opened between Fifteenth and Seventeenth Street Northeast in 1886 but moved to nearby 1707 Washington Street Northeast in 1969. In 1884, Prescott Elementary School opened at 1030 Lowry Avenue Northeast with additions in 1901, 1909 and 1931; the two-story Lowry Elementary was at Twenty-ninth Avenue and Lincoln Street next to Audubon Park and was open from 1915 to 1977. The school was named after the local lawyer and businessman Thomas Lowry. He successfully transformed the streetcar lines that later extended to the entire Twin Cities as the Twin Cities Rapid Transit (TCRT). John S. Pillsbury Elementary, named after the Minnesota governor and University of Minnesota regent, was constructed in 1909. Additions were added in 1912 and 1923 for the mushrooming enrollment; 410 students attended in 1952 but there were 541 in 1967.

Marcy Elementary School's historic roots are as the Fourth Ward School. In 1872, a school was constructed within the East Division of Minneapolis (Ninth Avenue and Fourth Street Southeast) and later named after the United States secretary of state William Marcy. In 1908, the school moved to a 1.26-acre site at 711 Eleventh Avenue Southeast. The old Fourth Ward/Marcy School became the Arnold School in 1912 and later changed its name to Trudeau in 1921, when it served as a school for children recovering from illness, especially tuberculosis. It took its name from the father of "open air" tuberculosis schools—Dr. Edward Livingston Trudeau. The school was later demolished and became Marcy Park. Marcy, because of declining enrollment, closed in

Holland Elementary originally opened in 1886 and was located between Fifteenth and Seventeenth Streets Northeast but moved to Washington Street Northeast in 1969. *Courtesy of the Minneapolis Collection.*

1978, as did the Holmes Elementary School in 1981. Marcy then existed as a pilot "open school" program at various facilities. In 1992, it moved to Holmes Park (415 Fourth Avenue Southeast), where it continues to flourish as Marcy Open School.

Waite Park Elementary is a massive suburban-style one-story building that was constructed in 1950. In the northernmost part of the district, it is situated on 6.2 acres and surrounded by land devoted to athletics. It is in the last neighborhood to be developed in Northeast Minneapolis, and the predominantly single-family homes were constructed after 1940.

High schools evolved with the needs of the community in St. Anthony, the East Side and Northeast. East High School opened when graduation was still uncommon. The high school was the first on the East Side of the Mississippi River. Its predecessors were not high schools but served a variety

of educational missions as the Third Ward, Central and, finally, Winthrop School in 1878. East High was there between 1899 and 1927; thereafter, it was converted into Boy's Vocational. It was sold in 1950, but part of the structure remained. Until the last decade, it was behind the East Gate Shopping Mall. It was demolished and Cobalt Condos opened in 2006.

As the city expanded, two high schools replaced East High. Edison High School was the first in Northeast Minneapolis. After the Civil War, kindergarten through twelfth grade education evolved from optional to compulsory. As Garraty and Carnes said:

> *After the Civil War, steady growth and improvement* [in education] *took place. Attendance in the public schools increased from 6.8 in 1870 to 15.5 million in 1900. A typical elementary school graduate, at least in the cities, could count on having studied, besides the traditional "three R's," history, geography, a bit of science, drawing, and physical training. But fewer than half a million of these graduates went on to high school; secondary education was still assumed to be only for those with special abilities and youths whose families were well off.*

The educational landscape transformed further in the decades thereafter. But graduation remained an incredible achievement, especially for the children of immigrant families. West High English teacher E. Dudley Parsons wrote in *The Story of Minneapolis*, "Nearly 50,000 pupils are now enrolled in various grades [in the Minneapolis School district], and [of] that nearly 1,000 of these graduate from the *five* high schools every year—a larger number in proportion to the total enrollment than in almost any city in the United States." A new high school served the Northeast community less than a decade later.

On September 5, 1922, Northeast High School opened. It was later renamed Edison High School (Twenty-second Avenue and Northeast Monroe Street) and cost $80,000. The three-story masonry building on 6.94 acres was known for sports. Under the leadership of Pete Guzy—a star athlete at East High School in football, basketball and baseball—the school was a perennial athletic powerhouse. In baseball, he pitched and hit the East High School Cardinals to City Conference Championships in 1921 and 1922. While he was the coach of the Edison football team from 1935 until 1966, the Tommies won or tied six times for the city conference title. With immigrant children's success on the athletic field, they found success in life.

The second East Side school high school was Marshall High (1313 Northeast Fifth Avenue) in Southeast Minneapolis, a couple of blocks from the University of Minnesota campus. The school, which opened in 1924,

Northeast High School, later renamed Thomas Edison High School, opened in the fall of 1922 and provided educational opportunities for the children of immigrants. *Courtesy of the Minneapolis Collection.*

was named after the Supreme Court chief justice and Secretary of State John Marshall. The University of Minnesota started a teaching laboratory high school at Peik Hall, but it was consolidated with Marshall High to form Marshall-U in 1968. Marshall-U closed in 1982.

Parochial schools are an important part of St. Anthony's and Northeast's history. For religious minorities, these schools were necessary to preserve culture and avoid discrimination. Numerous Catholic parishes provided schools until after World War II.

DeLaSalle was established as a boy's school in 1900. The school's success necessitated additions on the ruins of the William King Mansion and the Eastman Flats row houses on Nicollet Island. Affiliated with the Roman Catholic Christian Brothers Order, it was founded in 1680 by Jean-Baptiste de La Salle

in France. It was the first school organized lay-based—that is, no clergy, only lay brothers—Catholic order with children as the focus. Before opening a school in Minneapolis, the Christian Brothers had a large imprint in St. Paul. Cretin High was named after Joseph Cretin—the St. Paul Diocese's first bishop. The archdiocese of St. Paul and Minneapolis desired a Christian Brothers school in Minneapolis. Irish American businessman Anthony Kelly willed $10,000 for DeLaSalle while church leaders financed the balance. The school's early ups and later downs piggybacked with Nicollet Island's urban decline. In the 1960s, students fled to suburban Catholic schools Benilde High School (St. Louis Park) and Archbishop Grace High School (later Totino-Grace), which opened in Fridley in 1966. But DeLaSalle would recover. DeLaSalle graduates have been crucial in the redevelopment of Nicollet Island, old St. Anthony and the Mississippi riverfront since the 1970s.

The Baldwin School was the preparatory school precursor to Macalester College. In December 1853, Reverend Edward D. Neill (1823–93), a prominent Presbyterian minister from Philadelphia, opened the school in St. Paul. He had served as territorial superintendent of public schools for territorial governor Alexander Ramsey from 1851 to 1853. The private preparatory school was then the largest institution for educational purposes in Minnesota Territory but closed during the Civil War when Neill served as a chaplain. He returned from Europe in 1872 and relocated the school to the vacant Winslow House. Charles Macalester of Philadelphia bequeathed the property for the school. An act of the Minnesota state legislature, Macalester College was organized with the Baldwin Institution as a preparatory school in 1874. Neill served as president of Macalester (1873–74) and as a history and literature professor. In 1881, he wrote about the "East Division of Minneapolis" college: "It is the intention to dispose of the present edifice, and build in the suburb between Minneapolis and St. Paul, as soon as possible." In 1885, with Presbyterian Church's financial assistance, he relocated Macalester to Snelling and Grand Avenues in St. Paul.

The "State University," another higher education institution, had roots in St. Anthony. It has endured, albeit after relocating to the abutting neighborhood. The sprawling land-grant University of Minnesota–Twin Cities began as a preparatory school before statehood.

On February 25, 1851, the charter was signed by the territorial legislature for "a state university" at or near the Falls of St. Anthony. Being home to the University of Minnesota was an important accomplishment for St. Anthony and conferred it regional status, alongside St. Paul, the state capitol, and Stillwater, the state prison. Civic boosters secured the university through intense lobbying. The university's greatest champions were Judge

Isaac Atwater, John North and William R. Marshall, who also served in the first territorial legislature. Of course, Franklin Steele played a pivotal role by donating the land for the university. As of June 1851, North, in the *St. Anthony Falls Express*, sought "subscriptions" in weekly ads from boosters who pledged monetary donations to the university. The original university was a two-story wood-frame building near the corner of University and Central Avenues Southeast, and of course, the boosters Atwater, Marshall, North and Steele were on the first board of regents.

The University of Minnesota's preparatory school commenced with a class of twenty-five. Women were permitted, but like the Baldwin Institution, classes were segregated by sexes. Carrie Stratton, a student, recalled, "In the fall of that first year, I entered school, which was an academy in a building on University Avenue opposite the present East High School. This school was the nucleus of the State University and presided over by Mr. E.W. Merrill." Merrill of Middleton College in Connecticut headed the school until it was destroyed by fire in 1864.

The preparatory school developed slowly as the University of Minnesota's postsecondary mission remained on hold. The proximity to the falls' business district was a concern. Then Steele's financial and legal issues forced the board of regents to find another site in 1856. They purchased twenty-seven acres from Paul George and Calvin Tuttle, who also donated a portion of the land. In his history, Atwater said, "It had been decided that site offered by Mr. Steele was entirely unsuitable, both on account of the limited quantity of land, and its close proximity to the business centre of the city." In 1857, Old Main was completed, but then the Panic of 1857 struck, followed by the Civil War. During the Civil War, the school closed due to insufficient funding. But with John Pillsbury's financial help, it reopened in 1867 after nearly ten years' vacancy. The institution served, finally—and has ever since—as a college.

In 1869, the first president of the University of Minnesota was hired. William Watts Folwell (1833–29), a Hobart College graduate who had taught math at Kenyon College in Ohio, transformed the institution from a college with one building to a bustling state university. He also wrote the four-volume collection *A History of Minnesota*, the first comprehensive history of the state, and served as president of the Minnesota Historical Society (1924–27). Folwell's legacy was the expansion of "the U of M" or simply "U." The East Side, later Southeast Minneapolis, was dominated by the world-renowned state university, with its world-class research in many academic disciplines. But the university's history began in St. Anthony.

CHARITABLE ORGANIZATION

Before government social welfare programs were established, charitable organizations were a necessity in Northeast. When the elderly, infirm and poor required care, religious and secular organizations met their needs. As communities of distinct ethnic neighborhoods from devout religious backgrounds and belief systems, the first place to go for relief was the local parish. But in some cases, other specific organizations were necessary. Residents felt the cyclical pendulum swing of the economy, which placed them at risk. Before the Social Security Act (1935), the elderly were society's largest demographic group victimized by poverty.

The Union Home for the Aged was the brainchild of Emily Holmquist and the Swedish Methodist and Episcopal churches. As a part of "the Women's Relief Society," it was organized by a group of largely Christian women of Swedish heritage in Northeast Minneapolis on February 23,

The Norwegian Lutheran Rescue Home, the Swedish Methodist and Episcopal Churches' Union Home for the Aged and other settlement houses were necessary immigrant charitable organizations. One way they helped was with childcare. *Courtesy of the Minneapolis Collection.*

1906. Holmquist noticed an enormous plantation-like building for sale on Lowry Avenue on the bluff west of Johnson Street. The women cobbled together money to purchase the property to serve the elderly. Their persistent efforts were rewarded when Prince Bertil of Sweden visited the home in 1948.

The Little Sisters of the Poor is an international organization. Organized in France in 1792, it had an enduring impact in Northeast Minneapolis. The local order, mostly French and Irish in the early years, placed faith in St. Joseph to provide clothing, food and nursing supplies. The building's first phase was constructed for $50,000 in 1895 with safety for the elderly the major concern. It served the community as the Little Sisters of the Poor St. Joseph Home for the Aged until 1977. In eighty-two years, over four thousand men and women had received care at the facility.

Journalist and memoirist Brenda Ueland described a January 21, 1944 visit. In a *Minneapolis Times* article, she said it was a "yellow brick structure, melancholy and picturesque. It lies athwart Second St. N.E. A few blocks away, there is the dirty grey Mississippi among railroad yards, and warehouses." Ueland painted a bleak picture of the neighborhood, but the nuns served the patients with dedication and respect—and all through their love of God.

The building was renovated in 1979. It was an early building rehabilitation in Northeast and became the Stone Square Apartments. It was carved into fifty-two separate rentals. The carriage house was converted into rental town homes, and St. Joseph's Chapel became a community room. But the building's institutional exterior cannot hide the past from the present.

SETTLEMENT HOUSES

Settlement houses were an international movement. Progressive, idealistic college graduates from wealthy families dealt with "slum problems." As Garraty and Carnes said, "These were community centers located in poor districts that provided guidance and services to all who would use them." Toynbee Hall in London, England, in the 1880s established the pattern, followed by Jane Addams' Hull House in Chicago (1889), Robert Wood's South End House in Boston (1892) and Lillian Wald's Henry Street Settlement House in New York (1893). By the turn of the century, there were over one hundred settlement houses in America. Uncharacteristically,

one of the Northeast settlement homes was run by Catholic women. Before establishing a settlement house, the Catholic Church had lost members to Protestant dominations.

A few critics dismissed settlement houses, according to Garraty and Carnes, as "devices to socialize the unruly poor." In settlement houses, immigrant children were taught about American society and their adopted culture. At the turn of the century, two neighborhood houses developed in Northeast.

Nationally, the settlement house movement had many accomplishments. But its activities occasionally bordered on paternalism. The introduction to *They Chose Minnesota* recognized abuses:

> *The social settlement movement and the newly spawned philosophy of social work, both products of the Progressive reform era, were responses to an "industrialism, which created a large working class and brought about an influx of immigrants with numerous problems of assimilation." The movement focused especially upon recently arrived immigrants, striving to achieve what one author called "100 per cent Americanism and 100 per cent conformity."*

The goals of local settlement houses were not as outlandish, or for that matter, impossible. In true Northeast style, settlement houses were pragmatic in their goals—helping immigrant children succeed in school and, later, American society.

In the late nineteenth century, the Minneapolis Settlement House movement began, spurred by a growing immigrant population. The May 26, 1905 *Minneapolis Journal* summarized the settlement houses' goals: to "strengthen family life," create "a feeling of neighborliness," develop "indigenous leadership" and integrate local neighborhoods into the larger community.

The Margaret Berry House was organized by the Minneapolis League of Catholic Women. It served children from Poland, Russia, Italy, France, the Ukraine and Lithuania at 339 Buchanan Street Northeast. Members of the National Federation of Settlements staffed it. The Berry House moved to Pierce Street Northeast in 1915. It expanded in 1922 and served neighborhood children through athletics programs, healthcare and home classes for decades.

The Northeast Neighborhood House (NENH) opened on January 20, 1915, at 1929 Northeast Second Street. Before NENH, services were provided at Open Door Congregational Church, where the Emmanuel Sunday School Mission was held at Drummond Hall. But the community's needs were too great at the turn of the century. The Pan-Slavic neighborhood of Polish, Russian, Slovak and Ukrainian immigrants had the city's highest levels of poverty and

Northeast Neighborhood House provided myriad services for immigrants and other underserved populations in Northeast Minneapolis, including education, childcare and work training. *Courtesy of the Minneapolis Collection.*

illiteracy. The neighborhood's diversity even surprised state officials when the dictatorial Commission for Public Safety, under state law, required registration of "aliens," or immigrants without naturalization papers, a common practice in the late nineteenth and early twentieth centuries. During one day in 1918, nineteen nationalities registered at NENH.

Initially, NENH caused suspicion among neighborhood kids. In "Northeast: A History," a former visitor recalled, "The house was ignored at first, the immigrants suspicious of the gratuities." Poor children unaccustomed to lavish handouts called NENH "the nut house," eventually a term of affection for the unimaginable free amenities provided.

The Northeast Neighborhood House was run by Robbins Gilman. Before serving as head worker at New York City University's settlement house, he was a New York banker and bondsman. After marrying Catheryne Cooke in 1914, the couple relocated to Minneapolis and managed the Northeast Neighborhood House until 1948. While Catheryne ran the women's and children's programs, her greatest impact was the organization of the Women's Cooperative Committee, incorporated in 1918 as the Women's

Cooperative Alliance. The alliance promoted social welfare activities in the Twin Cities while conducting extensive research into movies, volunteer courts, social hygiene, recreation, public entertainment, sexual offenses against women and children, prostitution, venereal diseases and obscene literature.

Gilman was a very hands-on director, bringing on youth workers to develop a variety of programs and sports teams. He was responsible for starting an employment bureau, providing women services and focusing on youth empowerment while protecting workers from sweatshops. Under his direction, Miss Wood's School for Kindergarten teachers opened a demonstration kindergarten at the site, as well as a dental clinic and gym.

After Gilman's retirement in 1948, Lester Scheaffer became head worker. During his tenure, he developed many youth-orientated programs at NENH, including a new poolroom and a variety of youth club groups for children and youth of all ages. The Goldbricks, a Northeast community services group for youth, was founded in 1949. In 1950, Camp Bovey opened in Gordon, Wisconsin, and remains a

While veterans observed Flag Day after World War I, Neighbor Day—started by Northeast Neighborhood House—celebrated Northeast Minneapolis's rich ethnic diversity. *Courtesy of the Minneapolis Collection.*

popular campsite for neighborhood children who participate in NENH-sponsored fundraisers and volunteer opportunities to finance camp.

When the immigrant population ascended out of poverty, NENH and the Margaret Barry House merged. East Side Neighborhood Services (ESNS) was created. Margaret Berry House closed in 1973, but its mission continues as ESNS, providing pre-kindergarten screening and educational and health services.

Northeast settlement houses created incredible American stories. One occurred during the nativism and "100 percent Americanism" efforts of World War I at NENH. In a program to champion the area's diversity while stressing the universality among all children in Northeast, a celebration was held. "Northeast: A History" states:

> *Customs and traditions of neighborhood ethnic groups were celebrated beginning in 1918. Many ethnic groups were brought together for a folk festival which became known as Neighbor Day, and which continued to be celebrated for a number of years on Flag Day. In 1976, its 61st anniversary year, the agency was to celebrate the cultural diversity of the neighborhood with its "Nation of Nations" forum, a lecture series on the Poles, Russians, Slovaks and Ukrainians, funded by the Minnesota Humanities Commission.*

LODGES, CLUBS AND FRATERNAL ORGANIZATIONS

Since the city's inception, lodges, clubs and fraternal organizations have existed in St. Anthony. The *St. Anthony Falls Express*, on June 4, 1852, listed a few pioneer organizations: "We have in our town a Lodge of Masons, one of Odd Fellows, and a Club of Temperance Watchmen. They are all in a flourishing and vigorous state." In the nineteenth century, fraternal or benefit organizations were dedicated to nearly every cause and avocation while in the twentieth century, they branched out to serve eclectic ethnic concerns.

Clubs ranged from bicycle, singing and art focuses to organizations involved in civic engagement of all kinds. Minneapolis had exotically named organizations in the 1880s such as the "Knights of Pythias," "Knights of Honor" and "Druids." In the history books of the epoch, members are listed encyclopedically, like in a phone book. In the decades after the advent of Jacksonian democracy in the 1830s, Americans, and the people

of St. Anthony, were joiners. By necessity, as citizens in a democracy, they became involved in a multitude of organizations. The East Side and later Northeast Minneapolis flourished and hosted a gamut of prominent national fraternal organizations—the American Legion, Lion's Club, Kiwanis Club, etc.

In *Old Rail Fence Corners*, Helen Godfrey Berry recalled her father, Ard, and the first Cataract Masonic Lodge:

> *In our house was organized the first Masonic Lodge. I remember it perfectly well. My mother had arranged the house in such perfect order we children felt something unusual was to happen...I couldn't understand why we couldn't even peep through the key-hole. I saw Mr. John H. Stevens and Mr. Isaac Atwater pass into the parlor where they spent the evening with my father.*

The Sons of Temperance–Cataract Number Two organized in St. Anthony in 1850. The *St. Anthony Falls Express* reported influential citizens' struggle for a dry city. In a January 3, 1852 article, the paper chronicled Maine's efforts to restrict "drinking houses," and in response, it received several supportive letters to the editor. The organization celebrated its first anniversary on May 31, 1851. The *Express* wrote, "The Sons have a very flourishing society here, and made a most imposing appearance in the procession, clothed in the regalia of their order."

Lodges also organized on ethnic lines in St. Anthony. The first Minneapolis Turn Verein had twenty-five members in 1862, led by Adam Kegel. Nationally, the Turners then boasted fifteen thousand members. When German states were divided during the Napoleonic Wars, Turnvater Friedrich Jahn created the gymnastics group. Participation by the organization went beyond athletics. Neill quoted the group's literature:

> *We advocate and strive after the development of a popular government on a genuine and humane popular basis. Every attempt at a restriction of religious toleration, as well as all abridgements of human rights, which oppose perfection and building up of our liberal institutions, will on this account be firmly resisted by us.*

The Turn Verein, or Turners union, on Sixth Avenue was one of several in Minneapolis. It was located a few blocks south of the dense German neighborhood, north of Broadway between Marshall Street and the Mississippi River.

In the twentieth century, eclectic ethnic organizations like the Mother's Club of St. Mary's Russian Orthodox Church (members of which are pictured) reached out to serve their community. *Courtesy of the Minneapolis Collection.*

The Knights of Pythias organized with a specific mission. Pythias was a Greek legend who espoused "trust and loyalty." Members formed a "mutual benefit" organization for purchasing life insurance. Before employer-based pensions, these organizations were common. Lodges existed in St. Anthony, the Eureka Lodge–Germania Lodge Number Four, organized on July 10, 1871. The charter members' surnames were Oswald, Boehme and Conrad, indicating the lodge's German ethnicity.

Slovak men organized the St. Cyril and Methodius Society, which excluded women. Following the example of Cleveland Slovak women, local women formed the First National Slovak Ladies' Union in 1892. Named Saint Mary's Lodge, it became the third branch in the nation.

The Russian American Club was founded at St. Mary's Russian Orthodox Greek Catholic Church in 1922. The group was involved in a large slate of cultural and charitable activities. During World War II, the group worked with the national American Red Cross. Moreover, it published a cookbook

of authentic Russian recipes and held youth organizations for preserving their cultural heritage.

The Ukrainians organized Sitch at St. Constantine's Ukrainian Catholic Church in 1934. A branch member in the Society of St. Mary, the group was involved in ballet and Ukrainian choruses.

The Poles had two prominent social clubs in the twentieth century. The Polish White Eagle Association (PWEA) had practical origins. In 1906, it was organized with three objectives: promoting Polish unity, loyalty to the adopted homeland and life insurance policies for members. The PWEA had as many as three thousand members at its height.

The Polanie Club, in contrast, was formed by young women in 1926. It promoted all things Polish: dance, music, drama and language. The name honored agricultural heritage: "Polanie" meant "people of the prairie." The middle-class women, Frank Renkiewicz wrote in *They Chose Minnesota*, were a "bridge between the ethnic neighborhood and the larger world." In the 1930s, the group led American-born students on trips to Poland, but World War II and the cold war halted the group's cultural immersions. An enduring legacy, wrote Renkiewicz, was "a successful series of publications based on popular Polish folk culture and Polish-American life." The Polanie collection is archived at the Minneapolis Central Library in the James K. Hosmer Special Collections.

The Sons of Norway once had a Northeast Minneapolis chapter. The lodge was located on in the Dovre Building (Central Avenue and Twenty-third Street) from 1921 to 1970. The building was sold after the Northeast Norwegian population aged or relocated while the south Minneapolis location was retained. It was later purchased and rechristened Latvia House.

The Latvians, descendants of Baltic peoples, opposed the USSR's territorial annexation after World War II. Latvia, with 25,500 square miles, was the largest of the then Soviet Baltic Republics. The Latvians were oppressed and escaped to the West, first to Poland and Germany and later to the United States. After other cultural houses proved insufficient, they opened Latvia House in 1970. It served the community with plays, dances and concerts. The relatively small Latvian community had an active social life, which included the Latvian Youth Theatre, the Latvian Women's Society and the Latvian Youth Organization. As the population aged, they resided farther away from Latvia House. Maija Zaeska of Delano, Minnesota, said about the organization in the *Northeaster* in 2006, it "was important to them because as refugees who were forced from their homeland, it gave them a place to celebrate their culture and heritage." The Latvian House was sold

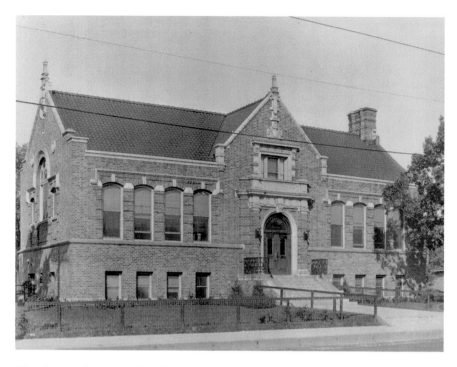

Libraries were important educational institutions in Northeast. The Central Avenue branch of the Minneapolis Public Library system was located in the heart of New Boston. *Courtesy of the Minneapolis Collection.*

to Meerwais Azizi, an immigrant from Afghanistan, in 2006, who had rented the lower floor for Crescent Moon Bakery. He purchased the property while the Latvians rented a ballroom upstairs.

LIQUOR PATROL LIMITS

Minneapolis's development, especially Northeast's, was shaped by Liquor Patrol Limits (LPLs). A city ordinance from 1884 limited the location of saloons and where alcohol could be purchased and consumed. In an era before automobiles, many patrolmen walked their beats in the LPLs that were established on both the east and west banks of the Mississippi River. The LPL included the Cedar-Riverside neighborhood in south Minneapolis, with a burgeoning Scandinavian immigrant population, and large sections of Northeast Minneapolis, with the heaviest concentration of poor immigrants.

Following the river from Sixth Avenue Southeast to Twenty-ninth Avenue Northeast, within the limits were numerous churches and schools.

In the 1880s, native New England elites, in conjunction with Scandinavian immigrants, codified the LPLs against Irish, Germans and Poles, who had a cultural affinity for alcohol consumption. Similar to zoning laws in principle, the limits excluded drinking from the neighborhoods, except the poorest ethnic neighborhoods, where the city's wayward sons could escape and drink in relative anonymity, like grandson of Mayor George A. Pillsbury, Carleton Pillsbury, who died from the affects of alcoholism in 1910. George Pillsbury, whose son Charles A. co-founded the Pillsbury Flour Company, was the architect of the LPLs. In 1914, Holcombe lavishly praised Pillsbury:

> *There is a legally established "patrol limit" confined to a small business portion of the city, beyond which the sale of liquor is not permitted. This is what George A. Pillsbury did while Mayor of Minneapolis. In every other large city of the country into which the traveler goes he finds saloons—scattered anywhere and everywhere according to the whim and means of the brewer or saloon keeper.*

Holcombe's glee is tempered by reality.

Minneapolis limited liquor's availability but concentrated it in other sections of the city—primarily Northeast. In 1959, Mitchell Baran wrote a letter to the editor to the *Minneapolis Argus* entitled "Dumping Ground for Liquor." Baran said:

> *Is the third ward to become the dumping ground for Skid Row and Lower Loop liquor licenses? Already a move has been made to slip another liquor place into Northeast Minneapolis at 2420 Marshall N.E. under the guise of a restaurant. This was the unanimous approval given by the city council on October 30th to the transfer of the Casanova Bar license (43 S. 4th St.) to the Northeast address.*

The LPLs contributed to the enduring mythology of Northeast, even after it was eliminated in a 1974 referendum. But the world's oldest profession's history here began earlier.

PROSTITUTION

In Minneapolis, within the Liquor Patrol Limits, red-light districts existed from 1860 to 1910. The vice districts were segregated sections of the municipality. Houston, El Paso and New Orleans had similar districts where the city government, judges and the police departments were complicit in and profited from prostitution. Main Street Southeast was one of three historic red-light districts, and it extended into Northeast Minneapolis.

Prostitution was conditionally permitted in the Main Street red-light district, where madams and prostitutes paid monthly fines to the local courthouse to remain in business from 1870 to 1904. Without established districts, city officials feared a proliferation of vices. Before the telephone and the advent of "call girls," they correctly predicted crackdowns would lead to prostitution's rampant spread. Penny A. Petersen, in her insightful book *Minneapolis Madams: The Lost History of Prostitution on the Riverfront,* wrote, "Minneapolis was hardly the first or only city to impose a system of regular fines on madams and prostitutes that, in effect licensed the sex trade." Eight brothels lined Main Street in 1895. The notorious madams—Mattie St. Clair, Nettie Conley and Jennie Jones—were shrewd businesswomen who owned property, often on both sides of the river and in multiple red-light districts. Sadly, due to the lack of opportunity afforded immigrants and divorced women in the late nineteenth century, many women turned to prostitution because it was a financially lucrative occupation.

The social stigma of prostitution was often an unshakably horrible stain. In 1875, the Sisterhood of Bethany, a Protestant-based organization, was established. Charlotte Van Cleve and Harriet

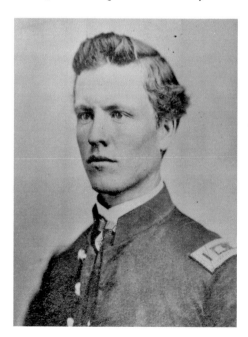

A young Albert Alonzo "Doc" Ames, later recognized nationally by muckraking journalist Lincoln Steffens as one of the most corrupt mayors in America. *Courtesy of the Minneapolis Collection.*

Walker, the wife of local lumberman and philanthropist Thomas Walker, led the group. They found early success pulling prostitutes off the streets and out of bordellos and finding them gainful employment. But women estranged or without family were permitted few economic opportunities. Many were forced to return to the trade for financial reasons.

Prostitution reached its nadir in the corrupt administration of Doc Ames. The mayor exploited city government for his own corrupt ends. Illegal activities lined his pockets, including prostitution. After the 1900 election, the victorious mayor installed his brother as police chief. Immediately, he extorted protection money, opened saloons, gambling dens and recruited criminals for committing robberies. Ames deviated from prior municipal, police and court precedent in his interactions with madams and prostitutes alike. During Ames's administration, prostitutes were required to make $100 monthly payments and pay $5 to $20 for monthly doctor's visits. Young muckraking journalist Lincoln Steffens examined municipal corruption in five cities. In his exposé for *McClure's* magazine, "The Shame of Minneapolis," he said of Ames in 1903:

> *Ames was sunshine not to the sick and destitute only. To the vicious and depraved also he was a comfort. If a man was a hard drinker, the good Doctor cheered him up with another drink; if he had stolen something, the Doctor helped to get him off.*

But "Doc" Ames—not surprisingly, given the brazen corruption of his administration—soon came to his political end. On the lam, he was captured in Indiana, extradited to Minnesota and sentenced to the Stillwater State Prison in 1903. Ames was convicted by the testimony of a prostitute whom he had bribed. The Main Street red-light district closed a year later. James Haynes, a reform-minded mayor, promised prostitution's demise by April 1, 1904. The deadline was not met. Within a few weeks, however, tacitly legal bordellos closed on the East Side, but it took another five years on the West Side.

THE INDUSTRIAL EXPOSITION BUILDING

The Industrial Exposition Building was an enormous structure, even by today's standards. It was constructed on the former site of the Winslow House that had been demolished in 1886. The building garnered national attention for the Republican National Convention in 1892. It quickly

became an economic white elephant because it was too expensive for the city to maintain.

The Industrial Exposition Building was an attempt by city leaders to halt the decline of Main Street in St. Anthony. *Saint Anthony Falls Rediscovered* wrote:

> *As late as the 1880s, the city fathers still hoped the area* [St. Anthony] *could be developed as a major civic center. Acting on this hope, they raised over $250,000 in private subscriptions to build an exposition building designed to house a permanent version of what had become a staple attraction at nineteenth-century world fairs—a working display of the latest industrial machinery. They also hoped the building's large hall would attract major meetings to the city.*

When the building was completed, it was the largest building in the Twin Cities. The structure cost $250,000 in private money and was located above Main Street Southeast and extended to present-day Bank Street Southeast and Central Avenue. The Renaissance-inspired building also included elements of Gothic and French Renaissance styles and was designed by architects Isaac Hodgson and son. Immense in scale—356 feet long, 336 feet wide and 80 feet high with a 260-foot tower—it integrated elements of the past with contemporary times. For example, there were masonry walls, but metal supports buttressed the building.

The Industrial Exposition Building was constructed when industrial fairs were popular across the country. Minneapolis lost its state fair to St. Paul (later Falcon Heights) in 1885. Chicago, Cincinnati and other cities annually staged expositions that lasted six weeks.

The first exposition was a gala event on August 23, 1886. Archbishop John Ireland gave the invocation. But the highlight of the evening occurred when Mrs. Grover Cleveland pressed a telegraph button 1,600 miles away at Prospect House in the Adirondacks of New York. The *St. Paul Daily Globe* wrote about the event:

> *In an instant the whirr of wheels announced that the Exposition was on. At that moment Miss Daisy Middleton pulled the cord attached to the five-chimed whistle that stands in the court and its clarion tones sounded the signal to the cannoneers, who discharged the ordnance in front of the building. A crash of music followed from the Mexican band and the overture from William Tell brought the entire audience to their feet.*

But the building's size remained a problem, and the community found it a difficult burden to maintain with so few events. Expositions continued through 1890. In 1892, it had one last hurrah.

THE 1892 REPUBLICAN NATIONAL CONVENTION

The Republican National Convention was then the largest event in the Upper Midwest's history. The city's inept handling of conventioneers, in part, resulted in a major political party convention not returning to the Twin Cities until the 2008 Republican Convention in St. Paul.

The city prepared for the 1892 convention while lacking the infrastructure for such an event. Without satisfactory hotel space for delegates, Republican Party officials and the press resorted to makeshift cots assembled at the University of Minnesota's armory. Lumber mill workers jested about the paucity of lodging for delegates and the quarters at the lumber camp. The *Lumberman* purveyed the perspective of plenty of Northeast Minneapolis workingmen:

> *The lumber camp built near the Republican National convention hall will be one of the features of life in Minneapolis next week. The ridicule heaped upon it by the correspondents of some of the eastern papers promises to make it one of the popular resorts. There are a good many worse places to board, as there is no necessity of informing the readers of THE LUMBERMAN, than a lumber camp and the uninitiated may go further and fare worse than the lumber camp of which B.F. Nelson, the president of the Manufacturers' association will be the presiding genius.*

After the construction of the Industrial Exposition Building, Minneapolis civic leaders considered the lumber camps, lumber yards and shanties at the Flats on First Avenue Northeast an eyesore. And then there were the provisional homes of the recent immigrants who worked at B.F. Nelson, John Orth Brewing and other industries. In 1890, the buildings were cleared and the immigrants moved north of Forth Street Northeast. The convention had missed out on the lumber camps at their most sprawling. Sawmills and flour mills were novelties to the attendees at the convention. The twelve-thousand-seat exposition building witnessed the typical political party maneuverings. Governor William McKinley of Ohio was elected permanent chairman of

The 1892 Republican National Convention was held at the Industrial Exposition Building, Minneapolis's last attempt to make St. Anthony a commercial district once again. *Courtesy of the Minneapolis Collection.*

the Platform Committee before ascending to the United States presidency in 1896. After typical party infighting, Benjamin Harrison was renominated over James G. Blaine for president before losing in the fall to Democrat Grover Cleveland.

African Americans also appealed with grievances to the convention. Chief among them was lynching, and a fast and prayer were held in protest on May 31. Frederick Douglass and Susan B. Anthony attended as non-delegates, and the convention greeted Douglass with "much applause." An illustration appeared in the June 8 *St. Paul Daily Globe*. The Republican platform postured politically with a strong condemnation of lynching with 116 African American delegates (13 percent) in attendance but did not plan on further legislative policy.

The Industrial Exposition Building declared bankruptcy in 1895. The once grand palace played a succession of roles in keeping with working-class Northeast Minneapolis. In 1903, Marion Savage, owner of the horse Dan Patch, had a mail-order business—the International Stock Food Company. In the 1930s, the building housed a merchandise warehouse featuring roller-skating clerks filling orders. But thereafter, the building's decline continued. A Coca Cola Bottling Company plant opened in 1946

and demolished the massive building except the tower. A Coke bottle was gauchely painted on the side before the plant closed in the 1980s. It was replaced by condos.

NEW BOSTON

Today, New Boston is rarely uttered in Northeast Minneapolis. The name is used in a recent mixed-use commercial and apartment complex but is otherwise nearly forgotten. New Boston is a developer's name for the residential strip from the railroad bridge at Central Avenue north of Forteenth Avenue Northeast to Lowry Avenue. Over decades, the business district centered on Twenty-fourth and Twenty-fifth Streets expanded in both directions into formerly residential areas.

At the turn of the twentieth century, Central Avenue had begun its transition from a mixed-use street to the primary Northeast business district. *Courtesy of the Minneapolis Collection.*

New Boston began as a new residential district in Northeast Minneapolis. Old Main Street transformed into an industrial zone and became a bastion of vice and squalor after the 1870s. New Boston ascended as Main Street fell. *Saint Anthony Rediscovered* stated, "Although a few large manufacturing plants, like the Pillsbury 'A' Mill...remained in operation, many of the old factory structures became low rent warehouses. For the next four decades, Main Street was a blighted area."

With the arrival of streetcars, the nearby business district of the Central Avenue and East Hennepin triangle eclipsed old St. Anthony. As *Saint Anthony Falls Rediscovered* said, "During the period from 1875 to 1905, the area slowly but steadily evolved into the East Side's major business center." The business corridor was where the East Side, both Northeast and Southeast, geographically intersected and shopped. Horsecar services, introduced in the 1880s, firmly established the area. But it, too, began to decline, and New Boston replaced it as Northeast's primary business district. With the completion of the Third Avenue Bridge in 1917, Central Avenue became the major thoroughfare for automobiles from downtown.

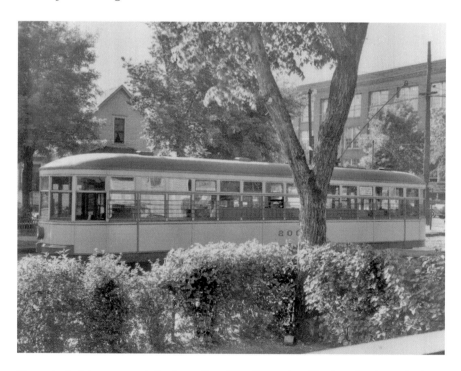

The arrival of the streetcar helped transform New Boston into Northeast's primary business district while old St. Anthony continued its decline into industrial blight. *Courtesy of the Minneapolis Collection.*

In the early twentieth century, residents with the economic means relocated to the north on Central Avenue. Social and financial status hinged on escaping the industrial pollution of "the valley" and old St. Anthony and Sheridan neighborhoods for Windom and Audubon Park on "the hill." Those who made it had succeeded in America. Proud "hill" parents bragged about their children traveling by streetcars while the "valley" children walked to school.

New Boston's early boosters included Henry Beard. He developed properties between 1885 and 1892. John D. Blake, the Chute Brothers and H.H. Smith were also major developers in the area. Another was Ezra Farnsworth. Farnsworth was born in Boston in 1843 and served in the Civil War. When he retured to the East after the war, his wife's declining health required relocation. He first settled in Stevens County, but farming did not satisfy him. About Farnsworth, Holcombe wrote, "He came to Minneapolis in 1881, and soon had more than three hundred lots and thirty-five or forty houses on Central Avenue." Farnsworth also was a primary real estate agent around Lake of the Isles in south Minneapolis. Holcombe summed up his contribution: "Mr. Farnsworth is recognized as one of the builders of the city of Minneapolis."

Portius Calvin Deming was an important developer who also served as the Minneapolis Park Board commissioner. Elms lined Central Avenue, and "Elmwood" was another name given to the neighborhood. "Northeast: A History," described New Boston from the perspective of 1976:

> *Central Avenue was made to bridge the vast railroad networks under Broadway and to reach industriously toward Lowry Avenue Northeast, which bridged the Mississippi to the west and into North Minneapolis. And there, perhaps a long mile from the city's Columbia Heights boundary, was declared a settlement called New Boston which helped make upper Central Avenue Northeast what it is today—the commercial heartline of a rare residential community with neighborhoods still distinguishably French, Irish, Swedish, Norwegian, Finnish, Danish, German, Ukrainian, Slovak, Russian, Italian, Lebanese—and Pole—and a bit Wasp [sic] as well as Catholic.*

Philip T. Johnson, in the same edition, made the observation, "Even before the turn of the century, Central Avenue was destined to become the most important business street in northeast Minneapolis." Before moving farther north, Germans and Scandinavian residents dominated the area around Lowry and Central Avenues in the early twentieth century.

But into the 1960s and 1970s, New Boston declined like East Hennepin Avenue and Main Street had before. The Arion Theater closed. Minar

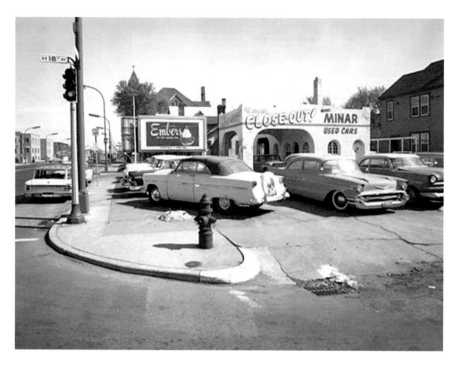

Minar Ford sold cars in Northeast Minneapolis until the 1970s when sadly, like many people and businesses, it moved to the northern suburbs. *Courtesy of the Minneapolis Collection.*

Ford closed and moved to New Brighton, where it eventually dropped the original name and all association with Northeast Minneapolis while taking the suburb's name. New Boston would rise again but with an unimaginable new diversity.

THE MINNEAPOLIS FIRE OF 1893

The greatest fire in the city's history occurred in old St. Anthony and Northeast Minneapolis. Urban development's rapid pace resulted in slapdash wood-frame buildings. Conflagrations occurred and regularly leveled cities: the Great Chicago Fire (1871) raged for three days and three hundred perished. A lack of proper fire codes and city planning, plus overcrowding and rapid urban growth, in boomtowns was a recipe for disaster. Fires were commonplace tragic events and the fodder for sensationalism in newspapers—while this boosted circulation, it has clouded the historical record.

On August 13, Minneapolis's worst fire began. The *St. Paul Daily News* reported, "The fire broke out in a stable...of the Cedar Lake Ice Company on Nicollet Island, about 1:30 P.M." The conflagration jumped the channel to Boom Island and fed off the lumber mills. Fanned by a southerly wind, it engulfed the lumber mills of Northeast and eventually crossed Broadway Street. Accounts disagree whether there were two fires or one giant inferno. Regardless, the areas around East Hennepin Avenue, Nicollet Island and the Northeast Minneapolis lumber milling district were destroyed. The fire raged from the Mississippi River to Sixth and Fifteenth Avenues Northeast. The poorest residents were victimized. The August 14 *St. Paul Daily Globe* reported:

> *The east bank of the river, between the Plymouth avenue and the 20th avenue bridges is occupied by shanties belonging to Bohemian and Polish squatters. As the fire crept up the river from Boom Island the Polanders and the Bohemians in this district moved their furniture out of the houses. The women sat down to watch it while the men hurriedly ran over for conveyances to take them to places of safety.*

The *Minneapolis Tribune* sensationalized the event with the headline, "Fire Bugs at Work." It gave a flimsy rumor as the cause of the conflagration. The paper also reported victims took refuge on Marshall Street Northeast: "The scene presented last night at the Turner Hall...would have excited the pity of the most callous and indifferent heart." The paper also claimed only two fire hydrants existed on Nicollet Island—a claim, if true, that surely rankled contemporary progressive politicians.

Joseph Zalusky examined the fire in *Hennepin County History* magazine in 1960:

> *There are still many old timers among us who remember when Minneapolis—then a city of 185,700 people—was visited by a terrible conflagration: the most widespread in its history and one entailing money loss of over one million dollars.*

Damage reports varied slightly and, in a few sensationalistic accounts, exceptionally. But the destruction of twenty city blocks, 150 buildings and hundreds of families left homeless is an accurate and common estimate.

The *New York Times* distorted the fire's damage, especially financially. The headline "Licked Up by Flames" set the tone. The paper ridiculously claimed that there was $2 million in property damage, two hundred homes

The Nicollet Island Inn was constructed before the fire of 1893 as Island Sash and Door Works and later served as a Salvation Army. *Courtesy of Sherman Wick.*

were destroyed and 1,500 people were left homeless. The *Times*, however, identified the source of the fire: "Nearly all the structures in the neighborhood were made of wood and dry as tinder." The blaze extended north to the Minneapolis Brewing Company, damaging property in the outbuildings on the south side. The *Times* proffered a plausible yet terrifying claim—after the wind changed direction at the brewery, the fire jumped the river to the west side. Fortunately, it burned out.

There were no casualties, except Thomas Faloon of Twenty-ninth Avenue Northeast. He suffered a stress-related heart attack and died. In the aftermath, Nicollet Island's mansions were abandoned. The Minneapolis fire of 1893 motivated reformists, and preventing conflagrations became a small plank in a large Progressive platform.

Unfortunately, prohibition was a larger plank. The Progressive crusade against alcohol consumption clashed with the identity of Northeast Minneapolis—moreover, it went to the neighborhood's cultural core.

THE CHANGING FACE OF NORTHEAST

*The first ward in Northeast Minneapolis—home to Minneapolis Brewing
Company, Gluek and Hennepin Brewing Co.—had forty saloons, but even more
worrying to some civic leaders was the fact that brewing companies owned a total
of 132 lots in the ward, including many prime corner locations and a number
of vacant lots. The brewing companies were blamed for the reluctance of other
businesses to move in because of the lack of prime corner lots, the lack of money to
keep the neighborhood in good repair, and the general depreciation of property value
in the ward. However, many observers wondered if any effective action would ever
be taken by the city, as the license fees paid by the breweries amounted to almost
$400,000 annually for the city coffers. The loss of this revenue and the property
taxes paid by the breweries would cause severe budgetary strain for the city.*
—Doug Hoverson, writing circa 1900, *Land of Amber Waters: the
History of Brewing in Minnesota*

A t the end of the nineteenth century, Northeast ebbed and flowed
with the growth and stagnation of the economy. During economic
downturns, unskilled immigrant laborers felt the greatest hardship. The
Progressive movement, with wings in the Republican and the Democratic
Parties, desired reform of the American political process. A few ambitious
initiatives included regulating big business, labor practices, food regulation
and political corruption. The prohibition of alcohol proved popular with
numerous political contingents but not in Northeast. Brewing companies
prepared as municipal, state and national political leaders incrementally

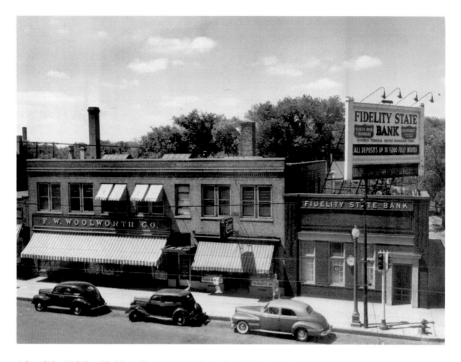

After World War II, New Boston continued as Northeast's most vibrant business district, unaware of the changes that would come in the following decades. *Courtesy of the Minneapolis Collection.*

moved toward the Eighteenth Amendment ratification. The ramifications were felt through the Depression until after the election of President Franklin Delano Roosevelt and the subsequent passage of the Twenty-first Amendment.

After World War II, first at a seemingly glacial speed, Northeast declined. The national suburbanization trend commenced. Northeast followed precipitously as industry and employment abandoned the area. Close-knit communities were cut off by freeway construction. But Northeast pulled through and reinvented itself.

THE NOBLE EXPERIMENT

Minneapolis breweries consolidated to fend off national competition in 1890. American breweries closed because of competition. A recognizable

flagship beer was a requisite response as breweries struggled to increase market share. Moreover, British businessmen attempted hostile takeovers of the immensely profitable American brewing companies that they coveted for investment opportunities.

Minneapolis breweries merged or closed because of competition and consolidation. Gluek Brewing and a few others are notable exceptions. Olson and Johnson, a Swedish Northeast brewery at Jefferson and Spring Streets, closed circa 1877, shortly after opening. Apparently, lager's dominance dissuaded drinkers from imbibing "weiss" beer, or low alcohol wheat beer.

Despite the transition to larger breweries, one small brewery continued for years. Doctor Peter Lauritzen, the founder of the Swedish Movement Cure Institute, owned a brewery. He advocated not only diet and exercise but also beer for improving health. As Hoverson wrote, "It was common in late Victorian times to tout beer and malt products for their digestive properties." His intoxicating product, however, was sold in beer bottles instead of "malt tonic bottles." The Lauritzen Malt Company (1900 Third Street Northeast) brewed beer from 1903 until 1909. After receiving bad publicity—it caused patients using the product to become drunk—Lauritzen moved to the Purity Brewing Company (1907–20) in south Minneapolis. Lauritzen continued brewing without the founder under a different name, Hennepin Brewing Company, in 1910. The company closed with Prohibition, ending a strange chapter in Northeast brewing history.

The Minneapolis Brewing Company was result of the merger of four of the five largest brewers in the city. The Germania, Noerenberg, Heinrich and Orth breweries formed Minneapolis Brewing and, in doing so, were able to consolidate the four breweries' saloons. Before Prohibition, breweries were allowed vertical integration—brewing, distributing, serving and owning bars. Together, the four breweries decided to continue operations on the site of an expanded John Orth Brewing Company. As beer historian Hoverson said, "The new brewery designed by August Maritzen of Chicago, was and is one of the landmarks of Northeast Minneapolis." The consolidated brewery also developed its flagship beer—Grain Belt beer. Within years, it was emblazoned on every container released by the brewery.

Gluek Brewing Company was the city's second-largest brewer on the eve of Prohibition. The brewery was also located on Marshall Street in Northeast Minneapolis. It was beloved by Northeast drinkers, despite refusing the national industry trend to advertise. Minneapolis Brewing Company had tremendous success with Grain Belt Premium. The brewery also had distribution advantages outside the city. Despite its significantly smaller brewery, Gluek's

owned 86 saloons within Minneapolis, in comparison to the 131 owned by Minneapolis Brewing Company in 1908. Moreover, "The first ward in Northeast Minneapolis—home to Minneapolis Brewing Company, Gluek, and Hennepin Brewing Co.—had forty saloons, but even more worrying to some civic leaders…132 lots," summarized Hoverson from a *Minneapolis Journal* exposé.

The passage of the Eighteenth Amendment on January 17, 1920, ushered in Prohibition. Northeast Minneapolis breweries needed a substitute for beer. The answer for the Minnesota Brewing Company was Golden Grain Juice (1920–29), a near beer. The passage of the Twenty-first Amendment ended Prohibition on December 5, 1933. At the stroke of midnight, Gluek resumed beer distribution, but Minnesota Brewing had to wait while it completed a renovation that would significantly increase beer production.

Prohibition had altered the brewing industry. Vertical integration was gone. Brewery consolidation continued, and competition increased in the battle for the lowest prices while beer's quality was sacrificed. After Prohibition, four breweries existed in the Twin Cities: Schmidt and Hamm's in St. Paul and Minneapolis Brewing Company and Gluek's Brewing in Northeast. Enormous advertising budgets caused cutthroat competition and more market consolidation.

The national beer wars were on. Northeast's economic livelihood and reputation hung in the balance. These enormous national breweries' trajectories influenced the direction of upstart brewers decades later.

WORLD WAR I AND THE DEPRESSION

World War I caused ethnic tension in Northeast Minneapolis. The residents were Americans first and foremost, but immigrants also sympathized with their home country. The Great War formed antithetical political alliances between the United States and European empires like Russia, Austria-Hungary, Germany and the Ottoman Turks. Trans-generational endemic oppression caused immigrants to resettle in America. In the United States, former archenemies were allies during the Great War and vice versa. Confusion reigned in the immigrant population when the United States fought the Central European powers.

The East Slav immigrants were an exempler. Compared to other ethnic groups in Northeast Minneapolis, the East Slavs were a small group. The

ethnicity loyalties were as confusing and complex as the variety of churches they attended. Loyalties were often based on the location of an immigrant's village. Dyrud wrote:

> The outbreak of World War I had a decided impact on East Slavs in the United States. At the war's outset in 1914 the United States remained neutral, but the East Slav loyalties were divided between Germany and Austria-Hungary on one side and Russia, which was allied with France and Great Britain, on the other. The Subcarpathian Rusins who wished their homeland to be free of the Hungarian yoke openly supported Russia. Most Russian Orthodox Rusins from both Subcarpathia and Galicia also supported Russia and its allies. The leaders of the Ukrainian movement, however, were ambivalent. In general they leaned towards Austria-Hungary, since Russian attitude clearly indicated that a victorious Russia would annex at least Galicia and would not tolerate an independent Ukraine.

Other ethnicities in Northeast had loyalties concurrent with America during World War I; nonetheless, they were accused of disloyalty. Immigrants in Northeast followed the example of their East Slav neighbors. As Dyrud said, "For the most part, the average East Slav in Minnesota tried to keep a low profile both before and after America entered the war."

Within a decade, another set of problems plagued Northeast—the Depression. The worst financial crisis in American history was felt hard, especially for those already struggling to get by. It also provided opportunities for those willing to break the law.

During the Depression, crime was rampant in the United States. National headlines resulted from a Northeast Minneapolis bank heist. The Third National Bank Robbery was the greatest crime in Northeast Minneapolis. It occurred at the triangle where East Hennepin and Central Avenues intersect.

The Karpis-Barker gang were guests in St. Paul under O'Connor's system. Police chief John O'Connor welcomed gangsters if they refrained from crime within the city limits. Notorious criminals John Dillinger, "Babyface" Nelson, Leon Gleckman, Ma Barker and Alvin "Creepy" Karpis, FBI chief J. Edgar Hoover's public enemy number one, used St. Paul as a hideout.

The Barker-Karpis gang robbed the bank on December 16, 1932. Paul Maccabee, in *John Dillinger Slept Here*, described the crime:

> The robbery was among the most violent of the Barker-Karpis gang's escapades, leaving two policemen and one innocent bystander dead, and it

Alvin "Creepy" Karpis hung out in St. Paul as a guest of the O'Conner system while he committed crimes in Minneapolis. *Courtesy of the Minneapolis Collection.*

proved that innocent citizens could be victims of the gangsters harbored in St. Paul.

Veteran Minneapolis policemen Ira Evans and Leo Gorski died in a gunfight at the bank. Oscar Erickson, a Swedish American bystander, was killed during the gang's escape in St. Paul. The three senseless deaths caused St. Paul to question the O'Connor system. In Minneapolis, it was revealed that mayoral candidate Ralph Van Lear was bribed by Karpis ($4,000) and Fred Barker ($6,500) so that the police would not interfere in the robbery. Obviously, Van Lear was corrupt but lacked the political connections that he had guaranteed the gangsters.

The Third Northwestern Bank Robbery was emblematic of the Depression. People lived in hard times, and some used corrupt ways, like robbery, to get ahead, with catastrophic results. There was no Robin Hood, only three dead innocent men and grieving families.

LABOR AND UNIONS

Beginning in the nineteenth century, working people's lives, both locally and nationally, were greatly improved by the labor movement. Minneapolis was recognized as an employer-friendly rather than an employee-friendly city before the Teamsters Strike in 1934. Later, following national trends, public sector trade unions were unacceptable for the police, fire department and postal workers until the enactment of state legislation.

Working-class people have called Northeast home since its inception. While some experienced unionization in Europe, an organized labor movement was slow to take hold. The July 1, 1887 *Lumberman* chronicled industrial development:

> *A considerable manufacturing center is growing up in the neighborhood of the point where Monroe street crosses the Manitoba and Northern Pacific railroad tracks in Northeast Minneapolis. The Minneapolis Casket company* [sic] *are building extensive buildings and the sash, door and blind manufactury* [sic] *of Lunquist, Anderson & Co. is being steadily extended.*

Manufacturing and industry's rapid emergence inspired unionization in Northeast Minneapolis, but the conservative businessmen of the Citizens Alliance controlled the ruling New England elite and thwarted these efforts. Still, there were pockets of progressivism. Before finding national notoriety as the most corrupt mayor in the city's history, Mayor Albert Ames was a reformer. The *Lumberman* said, "Mayor Ames, of Minneapolis, addressed a meeting of laboring men...he said that he believed in strikes."

Albert Strong led the Citizens Alliance for thirty years. A committee of businessmen concerned with "closed shops" established the organization in 1903. Iric Nathanson said, in *Minneapolis in the 20ᵗʰ Century*, "For the next three decades, the alliance dedicated itself to maintaining the 'open shop,' where workers did not need to join a union when employed by one of the city's major industries or businesses." The Citizens Alliance—in familiar contemporary tactic—claimed unionization robbed liberty from workers by denying them employment. After the 1934 Minneapolis Teamsters Strike and the general strike that followed, the alliance was broken.

Thereafter, union halls and membership characterized Northeast Minneapolis. The increased wages and benefits of workers improved the area. "Northeast: A History" stated, "This has been known for many

years as a labor ward and many laboring men were elected aldermen from this area." He said Alderman Alfred E. Voelker "presented himself as a socialist." In, fact, Alfred Voelker and Charles Johnson were socialist aldermen in 1912. In 1916, Thomas Van Lear, another socialist—and like the aldermen, a machinist—was elected mayor of Minneapolis. Union and management's struggle began with the 1900–01 machinist strike and the rise of the Citizens Alliance. Van Lear practiced what David Paul Nord, in *Minnesota History*, called "pragmatic socialism." Nord wrote, "The municipal platforms adopted during these years by the Socialist party stressed local issues, such as public ownership of utilities, home rule, and improved city services." But with World War I, Van Lear alienated the party by supporting the draft. He lost mayoral elections in 1918 and 1921. Afterward, the socialists' contingent moved to the Farmer-Labor Party.

However, voters did approve a watered-down version of home rule on November 2, 1920. The United States Constitution guarantees the right to amend charters. Minnesota was only the fourth state to approve home rule for municipalities. In 1903, six home rule charters failed at the ballot box. Van Lear's pragmatism extended to home rule, where he took the middle path. Before, home rule had been viewed as a Citizens Alliance proposal, but ineffective government was worse. He supported the compromised version of home rule. Eventually, so did the city electorate.

Relations between business, unions, the public and government were fractious. Most notably, local journalist Eva McDonald Valesh investigated management's abuse of workers, particularly women. Undercover, she experienced the degradation of working women in the late nineteenth and early twentieth centuries. Her tireless efforts exposed factories' and mills' abuses for the *St. Paul Globe* and other publications.

The Minneapolis Fire Department union was accepted by the city council in 1925. Inroads were incrementally established for public sector unionization. The August 28 *Minneapolis Labor Review* headlined with "Council Gives Fireman Vote of Confidence." The article stated, "Confidence in the purposes and intentions of City Fire Fighters union No. 82 was voted by the city council."

Government employees' rights to organize, strike, bargain and arbitrate remain contentious but are legally recognized in most states. In the 1960s, they gained wider acceptance, but recently, Wisconsin challenged public sector employees' right to collective bargaining. Historically, unions avoided government employees. Civil service jobs were controlled by political patronage, where spoils, including employment, were distributed after winning elections.

Despite this, employees of the United States Post Office organized. The National Association of Letter Carriers formed in 1889 and, by the mid-'60s, had 175,000 members. Postal clerks formed several unions in the 1890s. The disparate workers united in 1961 and formed the United Federation of Postal Clerks, which, with further mergers, became the American Postal Workers Union (APWU) in 1971. Finally in the 1960s, states passed laws that recognized public sector unions that were upheld by the courts.

Working people have an enduring history in Northeast. It continues with the scattering of union halls for organizations like the Minneapolis Police Officers Federation, Minneapolis Fire Fighters and the American Postal Workers Union, to name a few. Union halls are within walking distance of local bars, conveniently located to celebrate after contractual victories by unions, putting money in the pockets of workers and benefiting their children. This has been, and continues to be, the American dream for Northeasters and working people across America.

LITTLE POLAND

Little Poland epitomized historic Northeast Minneapolis between 1870 and 1914. An actual neighborhood with boundaries never existed, but Little Poland, or sometimes "Little Warsaw," was the heart of a business district situated around Thirteenth and University Avenues Northeast.

Northeast Minneapolis then followed national urban immigration patterns, which segregated ethnic neighborhoods. The Poles were the largest immigrant group from Eastern Europe, and largely unskilled laborers lacking English skills settled first near the Mississippi River and the rail yards. This poverty-stricken area was sometimes referred to as "lower Northeast." Frank Rog spent his youth in the area. He was a star athlete at Edison High and the University of Minnesota. In his memoir *Let Me Be Frank*, he recalled his Polish immigrant father with six kids who worked at the B.F. Nelson paper mill, "I was told by my next-door neighbor that Papa was by far the hardest working man they had at the mill—and that place hired hundreds of people." Rog's story was typical; hard work was the only tool out of poverty for immigrants. And Little Poland was the place to go when they needed to escape.

Little Poland was farther inland from the river's poverty and pollution. The Polish business district offered escape with its shops and countless bars. A

venue for entertainment was the Ritz Theater (1928), designed by renowned Twin Cities theater architects Jack Liebenberg and Seeman Kaplan.

When Poles saved enough money to relocate, they purchased homes away from the Flats. Especially after the first few decades of the twentieth century, Polish families moved to California Street and Grand Street Northeast north of Lowry Avenue, previously a German neighborhood. Zak Kieley recalled her neighborhood as a child in the '50s: "Just about everyone on our block came from Poland." Slavic neighborhoods remained, too. As Wolniewicz observed in 1973:

> *Two factors probably account for the persistence of these Slavic neighborhoods. First, the area has been losing population, and those having the greatest tendency to remain seem to be older people who have stronger ethnic ties. Second, after World War II the area received new Polish, Slovak, and Ukrainian immigrants who settled first in this region.*

Beyond Little Poland, other nationalities reconstituted neighborhoods. As communities aged and earned enough money, they moved to newer neighborhoods. Still, Kieley recalled the Northeast of her youth: "Divided by railroad tracks and industrial districts, Northeast eventually consisted of twenty or thirty distinct communities representing different cultures."

Little Poland was an ethnic district. For decades, there were numerous distinct ethnic enclaves: Germans near Broadway Street and Grain Belt Brewing; "Russian Boulevard," around Fourth Street Northeast; "Little Moscow," east of University Avenue and south of Thirty-seventh Avenue Northeast; and a diverse amalgam of Latvians, Estonians, Lebanese and Armenians that was located in the vicinity of Marshall and Main Streets Northeast.

MAPLE HILL

Maple Hill experienced dramatic ethnic demographic changes during its history. Located west of Central Avenue, it is now named Beltrami Park. The area began as a cemetery, then as a Swedish neighborhood and eventually as Minneapolis's Italian neighborhood.

Robert W. Cummings was a member of the first St. Anthony city council who staked a claim to sixteen acres, which became the basis for Maple Hill. St. Anthony had only one graveyard, since abandoned, at

Beltrami Park served as the primary Italian neighborhood in Minneapolis. Our Lady of Mount Carmel met the spiritual needs, while Delmonico's met the nutritional needs. *Courtesy of the Minneapolis Collection.*

Fifth Avenue and Eighth Street Southeast. Maple Hill Cemetery was dedicated on the present site of Beltrami Park on February 20, 1857. Early pioneers and Civil War veterans were interred there, but in 1890, burials stopped. The city health department closed the cemetery because of lack of maintenance and vandalism. An estimated 5,000 people were already interred at the site. The nondenominational cemetery soon fell further into disrepair and, by all accounts, became an eyesore. Civic leaders and residents called for action. In 1894, city engineers disinterred 1,321 bodies and eighty-two monuments of the estimated 5,000 buried and relocated them to Lakewood and Hillside Cemeteries. Still, vandals continued to desecrate the former cemetery, which culminated with a gang of men with horses and wagons at night removing broken tombstones and debris in 1906. Under citywide pressure, the Minneapolis Park Board bought the land in 1908. An improvement association spent $12,000 for restoration and fencing in part of the area. In 1914, Holcombe wrote that Alderman Frank Castner (1905–09) "was instrumental in having

the old and unattractive Maple Hill cemetery converted into the present Maple Hill Park."

But vandalism continued in 1916. Aldermen and citizens organized in opposition to the park; however, added amenities gradually transformed the former cemetery. The park is the final resting place for many of St. Anthony's early settlers. While monuments mark its past, its early history is still hidden below the surface. In 1973, after torrential rains, pioneer Janet Sleigh's gravestone remnants were exposed.

Maple Hill's residential development was not as controversial. "Swede Alley" was the residents' name for the area around Pierce and Broadway Streets. "Dogtown" was another name for the general vicinity east of Central Avenue and south of Broadway Street. Historically, Minneapolis Scandinavian immigrants are commonly associated with Cedar-Riverside and "Snoose Boulevard." The name came from the tobacco, called *snus*, that Swedes spat in their local neighborhoods; similar areas existed in several American cities at this time. While Scandinavians settled throughout south Minneapolis, some also lived in "the Flats" in Swede Alley. John G. Rice, in *They Chose Minnesota*, described the community: "Another large Scandinavian settlement grew up in Northeast Minneapolis, where a concentration of flour mills, breweries, foundries, railroad repair shops, and small industries led to the development of a distinctive blue-collar community."

Immigration agents played a crucial role in recruiting workers. The *North* was dedicated to finding Scandinavians to fill these positions. The Minneapolis weekly newspaper's president was Hans Mattson, the greatest land agent of his day. The settlers were described in a July 24, 1889 article:

And it is this spirit of the old colonizing Viking which has made some of the western states, notably Wisconsin, Minnesota and Dakota, what they are today. While this noble spirit has made the Scandinavian emigrant more valuable to the country than any other class and himself more independent, the same has always subjected him to more hardships and privations during the first years of his settlement than would otherwise have been the case. But it has made him the better American citizen.

As geographer David Lanegran noted in the anthology "Swedish Neighborhoods of the Twin Cities" from *Swedes in the Twin Cities: Immigrant Life and Minnesota's Urban Frontier*:

Blue-collar Swedes lived near the industrial zone of Northeast Minneapolis. This area, more commonly known for its Slavic population, was home to Swedes from the 1880s until World War II. Many second- and third-generation Swedes still reside in the old neighborhood or have moved to northern suburbs. Swedes also dominated the Maple-Hill–Columbia neighborhoods and the area south of Broadway called Dogtown. Neither of these areas housed many Scandinavians after 1950.

In addition, Norwegians resided on "Norwegian Hill," a community near the highest point of the city, centered on Fillmore and Thirty-first Avenues. Westergren reported that 70 percent of the Swedes in the Twin Cities resided in Minneapolis by 1910, but concentrations relocated to south Minneapolis. Wherever they lived, the Swedes, like virtually all immigrant groups, preferred a community where their language was spoken.

In the then predominantly Swedish Maple Hill neighborhood, only 18 Italians resided in 1905. Within fifteen years, a dramatic demographic shift occurred. "By 1920 about 40% of the 766 Italians in Minneapolis were concentrated in this small area," wrote Rudolph J. Vecoli in *They Chose Minnesota*. Maple Hill's Italians emigrated from the *mezzogiorno*, or southern Italy—especially the Abruzzi, Puglia, Campania and Calabria regions in the south. Italians worked in the railroads as laborers and opened businesses serving the community. A self-sufficient neighborhood thrived, with Our Lady of Mount Carmel Catholic Church at its center. Wolniewicz described a factor in the neighborhood's decline: "Six years ago eastern Dogtown was an Italian neighborhood, but several blocks were demolished to make way for a super highway." In 1948, Maple Hill was renamed Beltrami Park after Giacomo Beltrami, the Italian explorer. Beltrami was the source of neighborhood pride and washed away Maple Hill's past.

Jim and Rose Totino were another source of pride for Northeast's Italian American community. After opening a humble pizzas to-go store (523 Central Avenue) in 1951, they quickly expanded into a sit-down restaurant. The couple constructed a frozen pizza factory in 1962 that was purchased by the Pillsbury Company for $22 million in 1975. Rose was named a corporate vice-president—a notable first for a woman. Grandson Steve Elwell purchased the restaurant in 1987. It relocated to Mounds View in 2007 and closed in 2011.

NEWSPAPERS

Newspapers informed St. Anthony, the East Side and Northeast Minneapolis. Since European settlement, the community has evolved with its papers.

The *St. Anthony Express* was founded on May 31, 1851, and edited by Judge Isaac Atwater, an early settler and Minnesota Supreme Court justice who purchased his partner's shares in the paper in 1852. During a partisan era, the Whig newspaper was published weekly on Saturdays in its first six years. The paper grappled with the *St. Paul Pioneer* about the Hennepin County seat's name—eventually Minneapolis. The *Express* contained early civic leaders' ads: the North and Atwater law practice; John H. Stevens's store, "wholesale and retail"; and Pierre Bottineau offered the real estate that became Northeast Minneapolis, "A large Number of Village Lots for sale, which he will sell cheap for cash."

St. Anthony and Minneapolis newspapers recognized early trade unionism. On December 30, 1856, printers organized the oldest union in Minnesota Territory in St. Paul. Two years later, St. Anthony and Minneapolis organized a chapter of the National Typographical Union.

For decades, St. Anthony newspapers were in a state of flux. The *Falls Evening News* was first printed on September 28, 1856. An early victim to the Civil War, it closed in April 1861. The weekly *Northwestern Democrat* was another partisan paper first issued on July 13, 1853. John North, Dr. Vickers Fell and William Marshall founded the *Minnesota Republican* in St. Anthony. It was first published on October 5, 1854, with C.G. Ames as editor, but it merged with *State News* in 1858 and then with the *State Atlas* in 1863.

After the merger, Minneapolis was the center for journalism. However, newspapers had roots in St. Anthony. Colonel William King published his first weekly *State Atlas* on May 28, 1859. King was a fascinating man: an abolitionist, Republican, donor of King's Highway in south Minneapolis and the owner of a mansion on Nicollet Island (since demolished). In 1867, the *State Atlas* and the *Daily Chronicle* consolidated as the *Tribune* (the ancestor of the *Star-Tribune*). It was financed by milling industry titans William D. Washburn, Dorilus Morrison and John Pillsbury, with King receiving a small portion of the ownership.

The *East Side Argus* (1890–1926) was devoted to detailed coverage of the Northeast community. Lewis Duemke (1887–1932), the Minnesota senator and civic leader, served as publisher from 1911 to 1932. His son, Bruce, held this position for decades. Later renamed the *Minneapolis Argus* (1957–71) and published weekly on Thursdays, it boasted, "The *Argus* is the nation's largest

community newspaper" and was located in the heart of New Boston (2333–35 Central Avenue Northeast). In 1959, before consolidation, it claimed circulation in "Southeast, Northeast and South Minneapolis." In 1971, the Sun Newspaper Company, a community newspapers chain, bought the *Argus* and renamed it the *Sun Argus*. The paper continued but lacked focus, particularly on the Northeast community. Stories, particularly high school sports, concentrated on the northern suburbs and became a focal point as residents continued relocating to the northern suburbs, especially Fridley, Columbia Heights, New Brighton and Spring Lake Park. Not surprisingly, the paper's demise was near. Gene O'Brien wrote on January 3, 1979, in "Viewpoints," "Readers of Sun Newspapers can look forward to newspapers that will win their and *advertisers'* [emphasis added] support." But the *Argus* was true to its legacy of superb news stories about Northeast in the last issue's lead story. American Wrestling Association (AWA) promoter Wally Karbo was featured on September 26, 1979, and said, "I have been very fortunate and I thank the good Lord. You tell me in what other business can a Polish kid from Northeast meet seven Presidents of the United States and make friends all over the world."

After the *Argus* failed to serve the community and eventually closed, Northeast businesses and community members clamored for a new newspaper. The *Northeaster* filled the *Argus*'s void, with some overlap, beginning in 1978. The bi-monthly paper expanded beyond Northeast proper and added circulation in St. Anthony, Hilltop and Columbia Heights in 1983. Kerry and Margo Ashmore ran various aspects of the publication over the years. In 2014, Kerry Ashmore, also a local musician and Renaissance man, died. But the *Northeaster* continues to report the critical local beat, even as most neighborhood newspapers have closed in the last decade.

URBAN AND INDUSTRIAL DECLINE

The Mississipi Riverfront became increasingly inhospitable in the twentieth century. It was avoided by everyone—well, almost everyone. "The river was our playground. It was terribly polluted," said Rog, who served as mayor of Roseville, Minnesota (1987–91). As a teenager during the late 1930s and early '40s, he embraced the dichotomy—the river was fun place for adventure but horribly dangerous. Unwittingly, Rog was at the forefront, a ragamuffin who didn't turn his back to the river. The city fathers and businessmen neglected

the falls, the source of the city's existence, and looked to the south, the City of Lakes, for recreation. And why wouldn't they? The Mississippi riverfront was a polluted cesspool. But others recognized something was there, something in the region's heritage, something worth reclaiming and preserving.

The process of building the greatest city between Chicago and Denver resulted in the natural beauty of the river being lost. Unbelievable scenes occurred on the riverfront before World War II. As Rog said, "Frequently we saw bodies floating down the river. Almost always they were men's bodies, although sometimes we found bags below the dam that had babies in them." It was a horrible sign of the desperation on the riverfront. But Northeast Minneapolis remained attached to the river. "Northeast: A History" states, "The river was Northeast's swimming hole, where immigrant kids swam, and fishing hole, where even grownups cast lines, and early skating rink."

Rog's veneration of the river persisted from a pragmatic perspective while the unsightliness and inherent danger terrified the vast majority. Ann Calvert, "the community and economic planning coordinator" of city projects on the river in the 1980s and '90s, stated, "I grew up in northeast Minneapolis, and, over the years, we'd take the bus across the river. I was vaguely aware of the

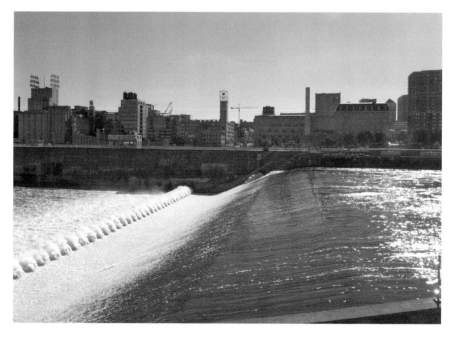

The falls' natural beauty was obscured by first a wooden and later a concrete apron to stop the erosion of the limestone sheath. *Courtesy of Sherman Wick.*

river, but like many people, when I was growing up, the river wasn't a place you went." Scott Anfinson was an important advocate for the redevelopment of the Mississippi River. He recalled going on a date while he was a University of Minnesota student to Fuji-Ya Japanese Restaurant, which owner Reiko Weston had constructed on the ruins of the Columbia Flour Mill and Bassett Sawmill. He felt "like my eyes were blind to everything else over there. The history, I really wasn't interested in." Anfinson summarized the situation: "The industrial death of the central riverfront in the 1960s and 1970s left the heart of Minneapolis a wasteland. The abandoned buildings and vacant lots were avoided by citizens and visitors alike."

The Upper Harbor project brought an end to a century plus of waterpower. In 1963, on the west side of St. Anthony, the Minneapolis Mill Power Company canal power was turned off. The 1,900-foot Stone Arch Bridge was modified and two steel trusses replaced the original twenty catenary arches. The wooden apron was replaced with poured concrete to further protect the falls. Navigation was improved, but the era of water power ended.

Up the river, Minneapolis Brewing and Gluek's followed the trajectory of Northeast Minneapolis in the '50s, '60s and '70s. During the era, the breweries remained focal points of Northeast. Hoverson wrote:

> *Minneapolis Brewing became one of the major cultural anchors of "nordeast" Minneapolis, starting in the late 1950s. The brewery undertook a major beautification campaign that included developing two parks and capped it off, literally, by placing on top of the brewhouse a reproduction of the Victorian-era weather vane that adorned its peak. Grain Belt Park, featuring a fountain from the brewery's well of "perfect brewing water," was dedicated in the summer of 1963 and immediately became a focus of social life in the neighborhood.*

Industry declined while residents relocated to the suburbs. Still, the neighborhood appreciated the amenities of the local brewer even after they had gone national. In 1967, Minnesota Brewing Company became Grain Belt Brewing while establishing a national brand; it was reasoned that Minneapolis's name lacked the national reputation that Milwaukee had for brewing. Marketers convinced the company to rebrand with the name of its flagship beer: Grain Belt.

Meanwhile, Gluek Brewing closed after one hundred years in Northeast. For decades, contract breweries brewed the beer, but it was never again made at 2000 Marshall Street Northeast. Gluek's brewing capacity was then

The Grain Belt Brewing Company five years before businessman Irwin Jacobs bought the company only to close it in 1976. *Courtesy of the Minneapolis Collection.*

too small to compete. After G. Heileman Brewing Company of La Crosse, Wisconsin, purchased the company in 1964, the American brewing industry's consolidation continued. The historic brewery was torn down and replaced by a box factory in 1966. Later, the mansion and part of the brewery's two acres on the Mississippi River were transformed into Gluek Park.

Grain Belt Brewing remained a neighborhood landmark during the 1960s. Having lost one of its other historic breweries—and the jobs—Grain Belt remained essential to residents' daily lives. As Hoverson said, "Many longtime residents still remember going to the park to see the tame deer on a Sunday after mass." But national competition proved too much for Grain Belt, which lost the battle of the cheap, thin, tasteless, yellow beers. Businessman Irwin Jacobs bought the Grain Belt Brewing Company in 1975. Within a year, they closed. Brewing ceased on the site for the first time since John Orth had arrived in 1850. The closure was unfathomable to longtime residents of Northeast. "Northeast: A History" placed the breweries' demise in the context of 1976:

> *The community has outlasted its nationally-known breweries, Gluek's and Grain Belt, whose double demise brought sorrow and suffering to hundreds whose livelihoods were lost with those enterprises—just as Northeast*

survived the passing of its sawmills and lumber factories and a millwork industry that gave it life at the start.

Northeast reached a turning point as industry was on the move, and railroad jobs disappeared in the 1970s. But there were signs of a revitalized Northeast.

St. Anthony West was an early example. "Northeast: A History," provides context:

> *A broad boulevard with a grassed and curbed median divider, is brand-new Main Street Mall, lined with houses in the $70,000 class—where just several years ago stood narrow frame boxes on crowded small lots in a pocket of industrial smog, belched black by a 19[th] century factory for tar paper and asphalt roofing tabs—a factory ordered out of town a year ago to be replaced by a greensward and a parkway and a river vista and downtown skyline view that had not been seen the past 100 years!*

Northeast's decline and renewal were non-linear. Even when Northeast had reached its nadir, there was occasionally evidence of a comeback. "Northeast: A History" provides a colorful example from the urban/suburban divide that existed in 1976:

> *Last Year, a Northeast couple that had moved to rich New Brighton, a new suburb of American executives and managers and their families superimposed upon an old farming village to the northeast of Northeast, suddenly sold their snowmobile and suburban sumptuousness and elegance on a silent street—and moved back to the old neighborhood on Quincy street in the urban-renewal project called St. Anthony West.*

The story is borderline comical now but not in an era when everyone was leaving the city—not just in Minneapolis but also throughout the nation.

Northeast felt fear. Multiple successful generations of Northeast families questioned the neighborhood's vitality. Had it declined too far to recover? Fortunately, a movement was underway to preserve and renew the area.

NICOLLET ISLAND

Nicollet Island always had an unusual status in Northeast Minneapolis. Unlike the rest of the city, directions are not emblazoned as a suffix on the forty-eight-acre island's street signs—except East and West Island Avenues, recent names in the city's long history. Despite its pre-industrial natural beauty, it became heavily industrialized. Later, it devolved into mixed-use dilapidation with industrial and residential zones, with DeLaSalle High School at the center of the island.

Urban revitalization of the worst kind occurred in downtown Minneapolis—historic landmarks and derelict properties alike were clear-cut from the 1950s to the '60s. Bridge Square and the Gateway District's skid row were destroyed, and in the process, society's most vulnerable were evicted from downtown. Resident and renovator John Chafee described Nicollet Island in the 1970s: "The Gateway Urban Renewal Project had displaced all of the old hard timers from the Gateway District, and the whole area had been flattened and turned into parking lots, so Hennepin Avenue on the Island was a skid row." With nowhere else to go, homeless, transients, wounded veterans and chronic alcoholics lived on Nicollet Island.

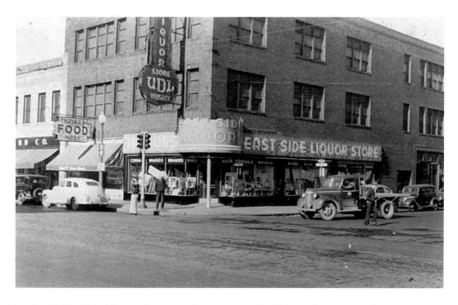

In the 1960s, East Hennepin was a vital commercial district. It wasn't until the new millennium that the area recovered from decades of urban decline. *Courtesy of the Minneapolis Collection.*

The Gopher Pattern Works building in 1967, six years before Hennepin Avenue was widened, eliminating several of Nicollet Island's skid row buildings. *Courtesy of the Minneapolis Collection.*

Dilapidated dwellings were overcrowded. Classic architectural masterpieces were carved into substandard rentals such as the Grove Street Flats (1877). The four-story row houses were "part of W.W. Eastman's plan to span Nicollet Island with fashionable townhouses," wrote *Saint Anthony Falls Rediscovered*. Once a beautiful piece of architecture composed of native limestone, its French Second Empire–style mansard roof was collapsing. The building contained eighty units. Grove Street Flats neighbors once included William King, Joel Bassett and Charles Loring. Until 1900, when the Grove Street Flats began subdividing, the island was a fashionable neighborhood. After World War II, the building was broken up into a rooming house. With the destruction of the Gateway District, the city's most disadvantaged citizens streamed in from across the river. The building was condemned in 1971 only to be rescued by John Kerwin, who renovated it from 1982 to 1984. The units were reduced to eighteen. The island's skid row buildings were, with a few exceptions, demolished when Hennepin Avenue was widened in 1973.

Plans were made for the redevelopment of the Minneapolis riverfront. "Mississippi/Minneapolis," first published in 1972, was crucial in codifying a plan. Deputy Mayor Janet Hively, during Donald Fraser's administration,

As much of the rest of Minneapolis gradually declinded in the 1960s, Nicollet Island and old St. Anthony struggled to remain commercially viable. *Courtesy of the Minneapolis Collection.*

assisted in the development and later implementation of the plan. "Much the city would benefit if it turned its face toward the river…[Boom Island] was a whole other set of decisions. It was really a massive landfill," Hively said. Something had to be done—a beautiful former island on the Mississippi River was an industrial wasteland. But "Mississippi/Minneapolis," like other government plans, was decades in the making.

Nicollet Island's skid row inspired planning and more planning. Al Hofstede, a Northeast native, served in many roles. He was alderman from the Third Ward (1968–70), chairman of the Metropolitan Council (1971–73) and Minneapolis mayor (1974–75, 1978–79). Redevelopment on the east and west banks of the Mississippi River and Nicollet Island were his biggest decisions. Density of housing developments was a crucial component. A decision was needed: either high density on Nicollet Island or high density on the two banks of the Mississippi River. After years of deliberation, the city chose low density for Nicollet Island, and Hofstede was instrumental in the decision.

The Minneapolis Park Board wanted to convert the entire island into a park, which called for the removal of the residential neighborhood to the north. Most other government agencies disagreed. The struggle for

Urban renewal demolished the Gateway District and Bridge Square, sending the city's most vulnerable populations to East Hennepin to create a new skid row. *Courtesy of the Minneapolis Collection.*

the island's future continued for decades. In the '70s, Hofstede strained to imagine the island's future when it was "the unhealthiest place you've ever seen. I thought they [the Grove Street Flats] would be torn down, but they were, obviously, rehabbed. We had donkeys on the island and we had all this stuff." The neighborhood was spared. And it inspired further renovation in St. Anthony and Northeast.

Skid row disappeared, but there were still many questions about Nicollet Island and also about the riverfront—the Falls of St. Anthony, long ignored, reasserted itself. It was far from the pristine beauty of nature in the past as industry declined. Former Minnesota Historical Society executive director Nina Archabel first visited the riverfront within months of General Mills' relocation to suburban Golden Valley in 1965. She observed, "My memory of that place is of an incredibly cold, abandoned place where nothing was happening, but where, clearly, something *had* happened that was really big but it was all gone."

Gradually, preservation of the river and its landmarks found support in city government. The elimination of the skid row on Nicollet Island and the eventual rehabilitation and preservation of the housing were ongoing efforts of agencies and groups. But sometimes individuals almost single-

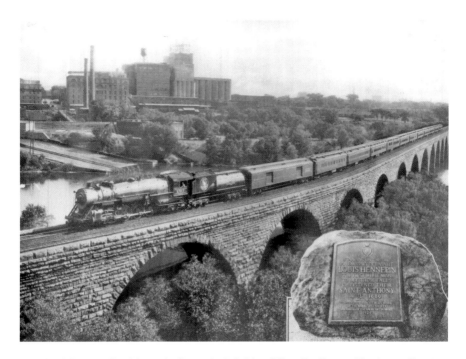

Imagine Minneapolis without the Stone Arch Bridge. When Burlington Northern offered the structure to the Minneapolis Park Board, the board initially declined. *Courtesy of the Minneapolis Collection.*

handedly saved historic landmarks. It is difficult to imagine Minneapolis without the James J. Hill Stone Arch Bridge. But the Minneapolis Park Board refused assuming liability after Burlington Northern abandoned it. Hively posited that without DeLaSalle graduate John Derus's tireless efforts in lobbying the park board and the city, the bridge wouldn't have been preserved.

NORTHEAST BECOMES "NORDEAST"

*St. Anthony was known to almost everyone Northeast as the patron saint of
lost articles—the one to pray to when valuables were missing. This may be one
reason that the name "Northeast" replaced St. Anthony's holy name even though
everything began with the saint's patronage—from the waterfalls to the suburban
northeast Edina-type heaven beyond the city's bounds.
The patron saint of losers was never completely trusted in Northeast.*
—"Northeast: A History," 1976

Northeast became "Nordeast" because of individuals like the unknown
author quoted above, knowledgeable about the past while embracing
a genuinely unique style. The primarily German, Polish and Eastern
European's heritage formed the community. In a sea of Midwestern
dialects, they transformed "Northeast" to "Nordeast." It's as simple as the
pronunciation of Gluek's as "Glicks." German and some Eastern European
languages lack a distinction between *d* from *t* while the midwestern dialect
transforms tense to lax. For years, "Nordeast" was the name used in scorn by
outsiders to describe the hoi polloi on the east side of the Mississippi River.

The old-timers' pronunciation was mimicked and mocked by the city's
elites. "Nordeast" was a slur, but like countless disparaging words in American
history, the people of Northeast transformed the word. Walt Dziedzic, a
longtime Northeast city councilman and Minneapolis Park Board member,
despised the stereotype. He reflected in the *Northeaster* after "50 years in
public life" that "a lot of times people looked down on this community,

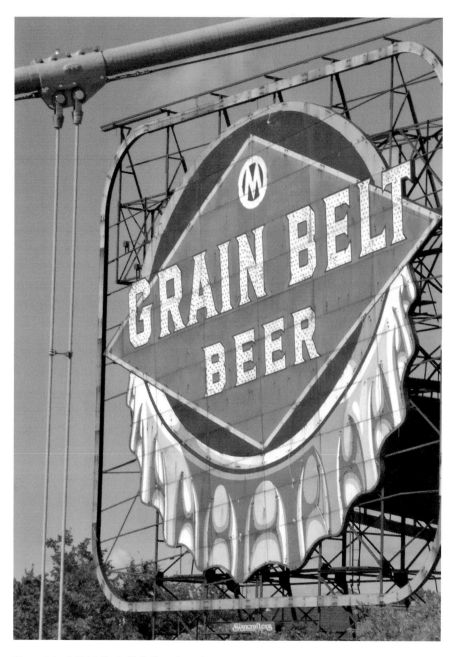

The original 1945 Grain Belt Premium sign was renovated in 1992. Located on Nicollet Island, it welcomes visitors to Northeast Minneapolis. *Courtesy of Sherman Wick.*

saying that Northeast had all the industry and the immigrants and the bars. It was institutionalized prejudice." Over the years, neighbors new and old adopted the name Nordeast—though most preferred the familiar and less cute Northeast. But as time went on, after galleries, artist and renovators nurtured its rebirth, Nordeast appeared in businesses' names, and it became part of the area's identity, especially to outsiders anyway.

Government agencies targeted preservation from grass roots to the national level in old St. Anthony. *Saint Anthony Falls Rediscovered*, stated:

> *Since 1971, most of the Central Riverfront Area (between the Plymouth Avenue and 35 W Bridges) has been part of the city, state, and nationally designated Saint Anthony Falls Historic District. The Riverfront Development Coordination Board was created in 1976 by agreement between the City of Minneapolis, the Minneapolis Housing and Redevelopment Authority, and the Minneapolis Park and Recreation Board and given the responsibility for coordinating and planning development activities in the Central Riverfront Area.*

The Riverfront Development Coordination Board (RDCB) played a pivotal role in the preservation of the Central Riverfront Area.

Old St. Anthony's rehabilitation was one part, while the longstanding ethnic businesses were another in the area's revival. Kramarczuk, Mayslack's and Nye's Bar embraced Nordeast pride with a smidgen of kitsch for outsiders. They were honest to their identities, decades before the perennial Northeast landmarks became cool.

And there was the Quarry development—a strip mall, nothing exceptional there. But it was a beginning. It retained and brought families back to Northeast. Finally, artists and galleries were followed by restaurants, bars, music and craft beer. And it was Northeast, regardless of its pronunciation.

Today, Nordeast is a brand. The place is dotted with businesses named Nordeast, Northeast or NE, from restaurants and bars to plumbing companies and breweries. Today, brewed in New Ulm, Minnesota, at the August Schell Brewing Company, Grain Belt Nordeast is a popular brand of beer. It sells the élan of the eponymous working-class neighborhood—Northeast: a place where people worked hard and succeeded in America; it declined but got back on its feet and reasserted itself like never before.

URBAN RENEWAL: ST. ANTHONY EAST AND WEST

St. Anthony East and West was a successful collaboration between community leaders and the federal, state and municipal governments. The projects involved properties that were between the Mississippi River, Central Avenue and south of Broadway Street. Those neighborhoods contained the poorest and most dilapidated properties but, as Millet said, were places where "urban renewal really did work."

New Boston was not included in urban renewal. The Central Avenue corridor, then Northeast's primary business district, was constructed later. As David A. Lanegran and Judith A. Martin said in *Where We Live: The Residential Districts of Minneapolis and St. Paul*, "In Northeast Minneapolis, Central Avenue...never reached so pronounced a state of economic decline as some other shopping strips in the aging inner ring. This was partly due to the many ethnic specialty shops that lined the street and catered to specific groups." Before it became a trendy business catch phrase, the neighborhood recognized niche markets. New Boston has evolved as ethnicities have diversified and remained a vital commercial strip.

Before urban renewal, Northeast defended its autonomy. Persistent efforts to reform the city charter were met with distrust. Historically, downtown and the south Minneapolis had battled for and won scarce city resources. A strong alderman representing Northeast could never balance a strengthened mayor. Business leaders like John Cowles Jr. of Wayzata, as well as a cabal from that city and Edina, led the charter reform crusade. The *Minneapolis Argus*, from its Central Avenue office, firmly opposed "the dictator charter." Labor unions, including the AFL-CIO (American Federation of Labor and Congress of Industrial Organizations) and the AFSC&ME (American Federation of State, County and Municipal Employees), focused on the defeat of charter reform. On June 9, 1960, the *Argus* headline read, "People Vote to Retain Government." This victory built political resolve for future battles.

Two neighborhoods, St. Anthony East and West—as well as the suburb to the north and east of Minneapolis—retain the city's original name. But neighborhood names are another legacy of the mid-1960s. Urban renewal divided Northeast into neighborhoods: Beltrami Park, Old St. Anthony, Holland, Sheridan, Windom Park, Audubon and Waite Park. Later boundaries were further divided to include St. Anthony East and West, Logan Park, Bottineau, Marshall Terrace, Columbia, Northeast Park and the Mid-City Industrial Area.

Urban decline in 1965, a year after urban renewal began in Northeast Minneapolis. *Courtesy of the Minneapolis Collection.*

St. Anthony East was a largely Eastern European–immigrant neighborhood. As one of the city's oldest neighborhoods, it had some of the oldest housing stock. Single-family homes had been carved into duplexes or even smaller divisions for rental. When urban renewal began in the 1960s, the homeowners and renters were longtime residents. Poor and elderly immigrants lacked the finances to improve their homes. Thus, the area declined, and in the 1960s, lost residents to the suburbs. The March 12, 1960 *Minneapolis Argus* wrote, "Both St. Anthony West and East Urban Renewal Plans now have amendments which allow a home owner the option of allowing the Minneapolis Housing Authority the right of possible acquisition of his property." Moreover, the paper said, the agency would "restore for continued use those properties that are structurally sound but economically infeasible for the owner to rehabilitate."

Urban renewal commenced in Northeast Minneapolis in 1964. But the process was decades in the making. The Minneapolis City Planning Commission was created to advise the city council on matters of development in 1921. The Minneapolis Housing and Redevelopment Agency formed as the nationwide migration from the cities to suburbs began in 1947. And finally, the Minneapolis Industrial Development Commission organized in 1965. The agencies merged

as the Minneapolis Community Development Agency in 1981. Rehabilitation brought up to code one thousand homes in the neighborhood west of Fifty Street Northeast. In addition, "spot clearance" removed three hundred homes. These poorly constructed homes, despite the continued efforts of residents, could not be saved. In 1968, the east section of old St. Anthony was the site of urban renewal: five hundred homes were rehabbed and almost three hundred substandard homes were removed.

The legacy of Liquor Patrol Limits continued on Spring Street. Before urban renewal, there were five corner bars. The street avoided rehabilitation because of the ordinance—no contractor could or would buy lots and rebuild in the midst of the city's drinking zone. McCabe noted the successes from the 1960s through the '80s: "St. Anthony East was spared from the usual policy of clearing and rebuilding large areas, spot clearance was implemented for structures that deteriorated to the point repair was not possible." Instead of gutting and destroying the neighborhood, improvements were accomplished with the hard work and cooperation of the community. As McCabe said:

> *The people involved in Urban Renewal implementation in St. Anthony East will tell you that it worked because it was a good community effort, and because few neighborhood groups had the positive relationship with the Housing Authority that St. Anthony East had.*

I-335, a federal project, contributed to urban renewal that involved St. Anthony East and West as well as the Beltrami neighborhood. The original "North Loop" plan was unveiled in the 1940s. By the '60s, it was upgraded to a six-lane interstate spur route, I-335, which would link I-94 and 35-W and provide a bypass of downtown. In 1970, federal money was allocated for the purchase of right of way (ROW) properties, and within a few years, 90 percent of the properties were acquired.

But the neighborhoods met the project with strong and organized opposition. As Suzanne McCabe said:

> *Planners envisioned a beltway circling downtown and linking 35W and I-94, not far from East Hennepin Avenue. Residents of Beltrami and St. Anthony East and West envisioned staying put. They organized and went straight up the power structure of the time—Alderman Sivanich, Mayor Albert Hofstede, Congressman Don Fraser, Governor Wendell Anderson. And won. It's said to be the first time a residents' group stopped an interstate freeway anywhere in the country.*

Street scene from 1965: St. Anthony East five years before federal money was allocated for the purchase of right of way properties for I-335. *Courtesy of the Minneapolis Collection.*

Al Hofstede said, "It was going to cut right across on Nicollet Island and take out B.F Nelson and take out five hundred homes." As mayor, Hofstede claimed to have "killed" the project, but the Minneapolis City Council supported residents in opposition in 1976. Regardless of who thwarted I-335, the proposed project impacted redevelopment. *Northeast Minneapolis: Historic Context Study* stated of I-335: "More than $11 million had already been invested in razing 130 homes and 35 businesses in the proposed corridor. New housing, including apartments, condominiums and single family houses, senior housing, and light industry have since been constructed in the corridor."

St. Anthony West also benefited from I-335 because of the state highway department's (MNDOT) actions. In 1975, they purchased B.F. Nelson, once a vital neighborhood employer but now an extremely polluted property. After acquiring the land, the B.F. Nelson plant was immediately demolished. When the pollution was cleaned up, Minneapolis Park Board purchased the property in 1986. It spurred additional urban renewal projects. Without homeowners' input, politicians' and bureaucrats' programs would have never succeeded. Lanegran and Martin said, "Northeast is a blue-collar area, and residents consider it very stable. They

are fiercely proud of their small, neatly kept houses." They loved their property; hence, as the aforementioned authors said, in Northeast, "the hallmark of rebuilding…has been conservation."

I-335's cancellation transformed St. Anthony East. A section of homes in the corridor between University Avenue to Central Avenue and Third Avenue Northeast had been demolished for the project. This land was vacant for six years before the federal government returned it for housing. But the city was slow in making a decision. Eventually, town houses were constructed. Unlike anything in the old neighborhood, the new dwellings replaced homes badly in disrepair. Louis DeMars—a city councilman from the Fifth Ward (1971–80), city council president (1974–80) and DeLaSalle graduate—was interviewed by Linda Mack for "Minneapolis Riverfront Redevelopment Oral History Project." He said:

> *So that killing of I-335 was the key to the redevelopment then. I think maybe the earliest townhouses went in along that corridor just to the north of the railroad tracks in northeast Minneapolis. The Third Avenue Corridor, I think they called it. At the same time, they were cleaning up Nicollet Island with money.*

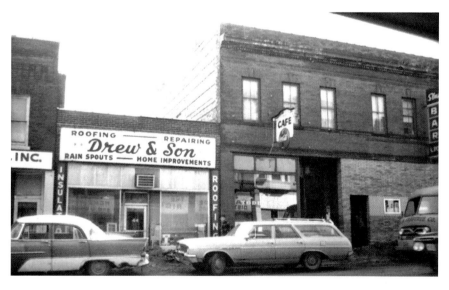

East Hennepin Avenue in 1967. The once vital commercial strip was headed into decline, only to rise again in the twenty-first century, proudly calling itself "Nordeast." *Courtesy of the Minneapolis Collection.*

Early urban renewal projects shied away from the riverfront, where the unimaginably polluted post-industrial landscape had no place in the city's future. After World War II, Anfinson said that the city "turned their back on it [the river] and went to the lakes and abandoned the riverfront." But government leaders clamored for redevelopment in old St. Anthony. Donald Fraser said, "I thought Al Hofstede had, while he was mayor laid the groundwork for reemphasizing the river."

PRACNA

Peter Nelson Hall "started the movement in 1969 when he purchased the Pracna building," Kane wrote in her book's second edition. As a University of Minnesota student, he had a new vision for the city. The Minneapolis riverfront should attract residents of mixed socio-economic backgrounds. Architects, preservationists and businessmen like Hall became the movement's vanguard.

Frank Pracna constructed a wood-frame structure in 1884. It burned down but was replaced by the current building in 1890. The bar opened as a partnership with Minneapolis Brewing Company and showcased "Golden Grain Belt Beers." During Prohibition, Pracna closed. When it reopened, St. Anthony had deteriorated into an industrial slum. The bar did not recover.

Hall renovated the Pracna building, which he believed was the first loft in Minneapolis, with a "contract deed." Traditional loans were impossible, so in 1969, he renovated the three-story building with a loan from Louis Zelle's father at First National Bank. Hall made an offer to the owner of the building after it had deteriorated into a machine shop with "a pattern maker" and fishing equipment sales upstairs. Hall moved in with his wife and two-year-old son. But Pracna's future was threatened by the State Highway Department's plan for a new Third Avenue Bridge. But eventually the state settled on rebuilding it. Hall recounted the unsavory nature of Main Street Hall. He said, in "The Minneapolis Riverfront Redevelopment Oral History Project":

> *People were killed down there. Even after we moved in, there was a fellow they called the philosopher...He looked like a philosopher, gray beard. He'd take his social security check and go cash it at Surdyk's Liquor and get booze and go into the tunnels near Pracna and just sleep...I think he was probably killed for his money.*

Hall renovated the building again in 1973 and created Pracna on Main, a bar and restaurant. Slowly, businesses and condos sprouted as old St. Anthony began its own path of urban revitalization.

St. Anthony Main

Before financing St. Anthony Main, Louis Zelle was the chairman of Jefferson Transportation Company. The multistage mixed-use development was where he combined his civic and business interests. On the philanthropic side, he founded the Center Arts Council in 1952, the predecessor to the Minnesota Opera Company. He also was a Walker Art Center and Guthrie Theater board member and the latter's president from 1971 to 1975.

At St. Anthony Main, Zelle attempted to renovate the past and turn a profit. Owning property then considered worthless, Zelle implemented a popular national development plan. St. Anthony Main followed the model

In 1974, Louis Zelle began the transformation of the former industrial area once known as Lower Town into St. Anthony Main. *Courtesy of Sherman Wick.*

of "festival market places." Real estate developer James Rouse and architect Benjamin Thompson are credited with the popular trend after Faneuil Hall Marketplace in Boston was completed in 1976. In the 1970s, abandoned industrial areas near downtowns were revitalized with "European-style" markets: mixes of local tenants rather than national chains, large commons areas and straightforward renovated architecture. Other examples included Underground Atlanta, Harbor Place (Baltimore), Pier 39 (San Francisco), Navy Pier (Chicago) and Bandana Square in St. Paul—which suffered a similar fate to St. Anthony Main in the end.

Zelle had begun St. Anthony Main as early as 1974. With public funding and tax help, he renovated and added infill buildings. The first phase was the renovation of the Saterlee and Salisbury Mattress firm constructed in 1878. The 100,000-square-foot project was completed in 1976, as well as an essential new housing component with the Winslow House condominiums in 1980. Zelle also added 90,000 square feet with the Martin-Morrison Building and the Upton Building, which included the Union Iron Works addition, by 1985. The shopping and entertainment complex he created was ahead of its time. But its success depended on shoppers from the suburbs, which proved difficult, especially with the tempestuous local weather. St. Anthony Main lost money and eventually led to Zelle declaring chapter eleven bankruptcy in 1989–90. His bus company was retained, but St. Anthony Main was sold at a tremendous discount. The mall was quickly replaced by office space with most of the mall closed off from the public.

St. Anthony Main was a great idea that, in the end, failed. But Zelle might have been decades before his time with the recent condo boom, retail could return in the future. Louis Zelle's *Star-Tribune* obituary on January 28, 2003, appropriately praised him as "one of a close-knit handful of civic leaders who changed the cultural landscape of the Twin Cities."

RIVERPLACE

Riverplace was controversial from the start. The original plan on Main Street across from Nicollet Island to the corner of East Hennepin Avenue called for massive towers. The project even attempted to include Nye's. Fortunately, Robert Boisclair failed to acquire that property.

However, Boisclair had strong connections to Northeast. His French Canadian grandparents married at Our Lady of Lourdes and his parents

In 1967, East Hennepin's urban decline led to urban renewal. Architecturally indistinct buildings were the first to meet the wrecking ball. *Courtesy of the Minneapolis Collection.*

met at the same parish. Moreover, he graduated from DeLaSalle. As a developer, his plans were ambitiously large, thanks to an introduction made by former vice president Hubert H. Humphrey. Boisclair Corporation with Kajima Development Corporation, a Japanese firm, formed the partnership of East Bank Riverside Partners.

The Riverplace development was announced in 1978 and originally included—like St. Anthony Main—shops, offices and housing. Housing was on a colossal scale compared to the previous project, but Riverplace was an entirely new construction. Unlike St. Anthony Main, it did not include adapted reuse. The biggest problem for the neighborhood was the scale—thirty-eight- and thirty-four-story towers. DeLaSalle alums Al Hofstede and Louis DeMars strongly supported Riverplace while state representative Phyllis Kahn spearheaded neighborhood opposition. In the end, the height of the towers was decreased to twenty-one and twenty-seven stories, and the spacing preserved a scenic vista of Our Lady of Lourdes. The September 12, 1979 *Minneapolis Argus* stated the planned "multi-use structure" included office space, retail, condominiums, a plaza, a greenway, a parking ramp and a supermarket. In the same article, Minneapolis city councilman Walt Dziedzic called the project "a gift from heaven," but

As East Hennepin declined, the commercial strip became known for years as a district for new and used automobile dealerships. *Courtesy of the Minneapolis Collection.*

others were more critical. While Tom Haggedorn of the Housing and Redevelopment Authority (HRA) was elated about the "$120,000 annually in taxes" that the city would collect, Will Hatfield of the Historic Riverfront Redevelopment Coalition said the project "falls short" and the "proposal would alter the historic nature and value of the area."

Riverplace opened with much hoopla. But like St. Anthony Main, the retail portion of the complex was plagued by problems. Riverplace suffered from an identity crisis. After retail failed, it became Mississippi Live, an enormous nightclub with several stages for music. When that venue closed, it transformed into an office and residential space. Riverplace suffered a similar fate to another Boisclair development—St. Paul's Galtier Plaza (1986), now known as Cray Plaza. In "the Minneapolis Riverfront Redevelopment Oral History Project," Hively responded to the former *Star-Tribune* architecture critic Linda Mack's query, "Looking back do you see it [Riverplace] as an unmitigated disaster?" Hively responded, "No, I don't. I think it was a noble plan. They had too much commercial inside and it was directly competitive with St. Anthony Main. The two were just far enough…without an appropriate transition."

CLASSIC NORTHEAST BUSINESSES

Classic businesses with ethnic roots defined working-class Northeast Minneapolis. These traditions continued as neighborhoods' demographics changed and transformed from old fashioned to cool.

Twenty-somethings dance beside senior citizens at Nye's Polonaise Room's bar. Al Nye purchased the bar in 1955. Since the 1880s, working-class watering holes were on the site. It was once part of the Minneapolis Brewing Company chain of local taverns in a building constructed in 1907. After success with the bar, Nye bought the three-story building on the same block with a colorful past. From 1905 to 1920, it was a harness shop and later a rooming house, a hotel in the 1920s and, finally, a barbershop and a sign maker shop before Nye purchased it was in 1967. He built Nye's Polonaise Room, which eventually connected the two buildings, in 1964. Featuring Polish and American cuisine with a curved piano bar, red carpet, paneling and booths, the place has not changed an iota over the years as its eternal cool transcended generations, and the polka music has never stopped.

A few blocks down is East Hennepin's Surdyk's Liquor Store, which has served Northeast since the repeal of Prohibition. Three generations have sold a variety of beers, wines and spirits in two locations along Hennepin. Joseph Surdyk began the store (at 201 East Hennepin Avenue) that Bill inherited. With his son Jim, Bill moved the business to 303 East Hennepin Avenue and expanded it. The new location's October 5 and 6, 1979 grand opening was heralded in the *Minneapolis Argus*. Interviews with Bill and Jim, monthly ads and a detailed account of the celebration were printed.

Mayslack's Bar has been a Northeast landmark since 1955. In the old Little Poland neighborhood, the former polka bar's fame began with original owner Stan Mayslack. The 285-pound former professional wrestler ensured civility with his menacing size and demeanor. The famous beef sandwich endures with the motto "nobody beats Mayslack's meat," even as rock bands have long since replaced polka bands.

Since 1954, Kramarczuk has been a Northeast mainstay. Wasyl Kramarczuk immigrated in 1949, and with his wife, Anna, he has served authentic sausages, breads and Eastern European specialties. As a butcher in the Ukraine, Wasyl escaped the Bolsheviks and immigrated to Germany. In a displaced persons camp in Landshut, Bavaria, his business acumen improbably shone, when he ran a kiosk before bringing his dream to Northeast. When Kramarczuk opened his butcher shop, he quickly added a

Kramarczuk, the popular Northeast mainstay, opened in 1954, serving authentic Eastern European sausages and breads and eventually branching out into a full-service deli and restaurant. *Courtesy of Sherman Wick.*

bakery and a restaurant with cuisine from the old country. The Kielbasa Festival annually celebrates past and present with street food, European beers and music. An emphasis on quality food has made Kramarczuk, Mayslacks's Bar and Nye's Polonaise Room Northeast institutions.

THE QUARRY

The Quarry shopping center was an essential part of bringing families back to Northeast. Located between the Windom Park and Northeast Park neighborhoods, the development allowed local self-sufficiency with grocery, clothing, hardware and home improvement stores.

The shopping center was a dream decades in the making. Over the years, an avalanche of ideas circulated for the site. Before I-35W was constructed, Herman Zinter, a twenty-two-year-old architecture student, proposed a park on the property in the December 31, 1959 *Minneapolis Argus*. The idea went nowhere; the student lacked political authority. Proposals came and went until First Ward city councilman Walt Dziedzic espoused a shopping center. In the December 16, 2009 *Northeaster*, he reflected, "I thought one thing we needed was a nice big grocery store. Northeast only had some medium-sized convenience stores at the time." In August 1993, Ryan Companies, in cooperation with the Minneapolis Community Development Agency (MCDA), developed the Quarry. When Ryan Companies redeveloped the land, it had been zoned light industrial. A limestone quarry, a truck terminal, body repair shop, truck rental and ice cream distribution center had occupied the property. And it was heavily polluted. As "The Quarry: A Planning Development History of the Northeast Minneapolis Retail Center (2007)" stated, "Ground water became heavily contaminated with petroleum and chlorinated solvents." Still, the forty-two-acre site and twelve buildings were demolished and cleaned up. It opened in October 1997. In real estate terms, it was defined as a brownfield redevelopment—a former industrial site that was contaminated and was overseen by the Minnesota Pollution Control Agency (MPCA). A Phoenix Award for environmental remediation was received from the Environmental Protection Agency. The cooperative efforts of the developer and the neighborhood were lauded by the federal agency.

It was feared the Quarry would degrade the Central Avenue business corridor, but that did not happen. Instead, immigrants and entrepreneurs continued organically to redevelop Minneapolis's most diverse business districts. Northeast experienced a demographic shift. The decaying central cities were diagnosed by then Minnesota state representative from Southwest Minneapolis Myron Orfield. For the nonpartisan Brookings Institution, in *Metropolitics: a Regional Agenda for Community and Stability*, he wrote:

> *North and Northeast Minneapolis and the East Side of Saint Paul were once tightly knit, ethnic, working-class neighborhoods. Today, they are in the*

throes of rapid social and economic change. Politically, these neighborhoods are passing from and old guard that is white, socially conservative, and dominated by organized labor to younger, more socially liberal whites and people of color.

Northeast Minneapolis made the successful transition. The old New Boston business district now consists of restaurants, grocery stores and retail outlets from around the world. Scandinavian, Polish and Latvian immigrants' shops were reborn as Afghani, Palestinian, Thai, Columbian, Mexican and Ecuadorian restaurants. Together with the Quarry, the largest retail development outside downtown Minneapolis, they meet the basic needs of families.

THE NORTHEAST ARTS DISTRICT

The Northeast Arts District began decades ago in Northeast. Artists orchestrated the renovation of neglected industrial properties that captivated architects' imagination for reuse.

For over thirty-five years, Frank Stone has maintained a fine art gallery dedicated to his and others' art. Appropriately, his art is sculpted with found industrial objects from junkyards. The Rogue Buddha Gallery is a contemporary art gallery in the heart of the old Little Poland. It hosts mostly painting exhibitions that have included the artwork of the Mekons' Jon Langford as well as gallery owner Nicholas Harper. His painting in a magical realism style reflects the Northeast neighborhood by incorporating elements of the Russian and Eastern Orthodox-style art.

After Northeast's decline, art studios transformed the industrial ruins. Artists were attracted by inexpensive rents and inspired post-industrial studio space. The California Building, in the 1970s, was the first artists' studio. Artists rented space that was constructed as a grain mill in 1914, and the two-story structure served as a Studebaker parts distributor. A six-story part grain mill—the first powered by electricity in the city—had been constructed in 1919. John Kremer and Jennifer Young renovated the structure in 1991, the first of many renovations by the couple.

The Thorp Building (1618–20 Central Avenue Northeast) is a complex of industrial buildings first constructed in 1901. Structures were added in 1937 and thereafter. It once housed the Thorp Fire Proof Doors and Northern

Pump buildings but was operated by General Mills during World War II as a Norden bombsights factory. Norden bombsights were invented by Carl Norden, a Dutch immigrant who had worked with the United States Navy. The analog computer improved accuracy by calculating bombs' trajectory while measuring flight conditions linked to the bomber's autopilot. Radar-based bomb systems replaced it after the war when General Mills turned to nascent computer technology. The brick-and-granite building is known as "the birthplace of Art-A-Whirl." The mixed-use property combines art studios, galleries and businesses. It hosted the inauguration of Minneapolis mayor Betsy Hodges with an estimated four thousand attendees on January 2, 2014.

The Northrup King Building was constructed in 1917. The ten-building complex is beside two sets of railroad tracks that shipped seeds throughout the country. After it closed in the late 1980s, it reopened as studios with over 250 artists. It is the largest in the Northeast Arts District.

The Grain Belt Brewing buildings are another mixed-use renovation. The sprawling Romanesque Revival structure is where the much smaller John Orth Brewing began in 1850. Carl Strunk designed the brewery in 1893.

The massive Northrup King and Company complex specialized in seeds, which were shipped throughout the country via the nearby rail line. *Courtesy of the Minneapolis Collection.*

Additional buildings were added over the years: the Grain Belt bottling house (1906), the warehouse (1910) and the keg house (1950). Grain Belt Brewing was sold to businessman Irwin Jacobs and financed by Carl Pohlad of Marquette Bank (and a decade later, the Minnesota Twins) in 1975. In 1976, G. Heileman purchased and brewed the beer in La Crosse, Wisconsin, while also brewing Grain Belts' former competitors—which were also owned by the company—St. Paul's Schmidt's Beer and Old Style, Heileman's flagship beer. For years, the complex's future was in question, but Jacobs sold it in 1989. RSP Architects bought the brewery in 1999 and renovated it into offices in 2002. The wagon shed and shops were converted into the Pierre Bottineau Community Library in 2003. The offices were converted into luxury apartments by ESG Architects in 2007.

The former Cream of Wheat building is a shining example of industrial architecture. Combining Art Deco and Classical Revival elements, the tall tower in the middle topped with a pyramid strikes an impressive pose. North Dakota wheat farmers created Cream of Wheat in 1893. After success with the hot breakfast cereal, they relocated to Minneapolis's Mid City Industrial Park. The cereal, made from wheat middlings removed from white flour, was abundant in the Mill City. In 1961, Nabisco/Kraft purchased Cream of Wheat and continued operations until 2002. In 2006, Cream of Wheat was renovated into CW Lofts, with 120 condominiums.

The Casket Arts Building was a longstanding Northeast business. Recently converted to artist studios, the Northwestern Casket Company buildings were constructed in 1887 and operated until January 2005. Two additional buildings were renovated: the carriage house, with horse-drawn hearses, and the nearby factory. The brick, wood floors, iron, steel and cast concrete were restored and the distinguished architectural elements preserved for over one hundred tenants in 2006.

In recent years, new renovations have creatively rehabilitated abandoned industrial buildings. The Q.arma Building (1224 Quincy Street Northeast) has twenty-plus artists studios. It is part of a complex for C.W. Olson Manufacturing Company, constructed between 1917 and 1955 and revamped in 2003. Solar Arts (711 Fifteenth Avenue Northeast) was modified with 109 eco-friendly solar panels while maintaining the charm of its historic character. Its piquant tenants include a dozen artists, creative professionals and Northeast craft brewing stalwart, the Indeed Brewing Company.

Artists impact even housing in Northeast. As *Northeast Minneapolis: Minneapolis Historic Context Study* said, "In the 1970s, artists' interest in colonizing the areas nearest downtown became evident. The efforts of

The Solar Arts building, formerly C.W. Olson Manufacturing Company, was renovated in 2003 and includes 109 solar panels and is home to Indeed Brewing. *Courtesy of Sherman Wick.*

Artspace Projects Inc. and developers, artists, and community organizers resulted in the development of studio and living space in former industrial buildings." Artspace Jackson Flats (901 18 ½ Avenue Northeast) are thirty-five affordable rentals for artist and their families in the Northeast Arts Corridor. Urban Works Architecture completed a four-story new construction in 2013. Rentals are based on artists' income and a selection interview to create a community of artists. The $10 million project was developed in partnership with the Northeast Minneapolis Arts Association (NMAA) and the Northeast Community Development Corporation.

The Northeast Minneapolis Arts District was formally designated in 2003. The districts borders are Broadway Avenue Northeast on the south, Twenty-sixth Avenue on the north, Central Avenue on the east and the Mississippi River on the west. The arts district now exceeds four hundred galleries and studios. The NEMAA has, since 1995, annually held Art-A-Whirl on the

third weekend of May. The festival has grown from a modest neighborhood exhibition of art to a major regional showcase of art and music that attracts five hudnred individual artists and collectives and an estimated thirty thousand patrons.

THE PAST RETURNS IN THE PRESENT

Northeast Minneapolis began because of the Falls of St. Anthony. Water power brought pioneers and, later, immigrants. Factories were built. The faithful found solace in churches organized for founding factory owners and factory workers alike. And they needed fun—German and Eastern Europeans loved beer.

Since the late 1980s, Northeast has become a destination for college students, then college graduates and finally families. Wolniewicz wrote

Northeast Minneapolis then and now: in 1950, the bank provided loans for underserved immigrant workers. Today, it's home to a hipster tap room. *Courtesy of the Minneapolis Collection.*

in 1973, "The area earned a reputation as a blue collar working man's community." Northeast had dramatically changed twenty-five years later. *Northeast Minneapolis: Minneapolis Historic Context Study* surmised, in 1998:

> *From its earliest settlement, Northeast Minneapolis has been a community comprised largely of industries and workers and their families. Today, the number of blue-collar workers has declined significantly. As revealed by decades of advertisements for cheap land and houses, real estate promoters have always been quite clear that Northeast was a suitable place to raise a family, but one that had few pretensions. For over one hundred years, a relatively stable employment base, good public transportation and services, and a strong network of churches and schools have contributed to the high level of home ownership that has anchored the area through economic and social transitions.*

Northeast's revival also reemphasized the Mississippi River and old St. Anthony. Since the 1970s, Northeast and Minneapolis began the slow return to the river. After all, it was the Mill City before it was the City of Lakes. As Anfinson said in "The Minneapolis Riverfront Redevelopment Oral History Project," "It's kind of ironic to me that Minneapolis is called the City of Lakes, when really it's the city of the river and St. Anthony Falls." Over time, visitors and citizens alike have rediscovered the historic beauty with the assistance of municipal, state and federal money directed to the redevelopment of the riverfront. Al Hofstede said in 2008 for "The Minneapolis Riverfront Redevelopment Oral History Project," "People now are recognizing the river. The fireworks now are here, the Stone Arch Bridge, all this stuff down here." And to think, the Stone Arch Bridge, now the city's favorite scenic vista for tourists, newlyweds and local TV news teams, was nearly destroyed. Today, it is a source of local pride with a breathtaking view of downtown, old St. Anthony and the falls that powered the dreams of speculators and early industry.

New immigration has powered change in the area, too. Northeast reflects immigration trends in the Twin Cities. In 2000, the Minneapolis Foundation reported 77 percent arrived from Latin America, Asia and Africa. Each group was unheard of in Northeast's past. New immigrants have rehabilitated neglected and abandoned businesses like the Germans, Italians, Eastern European and Lebanese before them. The diversity of family owned businesses, especially in New Boston, is staggering. The shopping, and especially the food possibilities, are endless, with Afghani, Thai, Indian, Mexican and numerous Middle Eastern businesses.

The new immigrants have also reinvigorated local faith communities. Somalis, Palestinians, Afghanis and Muslims from around the world have established mosques in Northeast. Churches have also met the needs of new immigrant families. Mass is bilingual, like in the old days at Sts. Cyril and Methodius Catholic Church. Spanish is provided for Ecuadorian immigrants, who are welcomed by daughters, sons and grandchildren of Slovakian and Polish parishioners.

After Grain Belt Brewing closed in 1975, a 125-year tradition was lost. Mass-market beers took over Northeast for the first time. Local brewing disappeared until 1987. In the enormous shadow of Grain Belt Brewing, James Page Brewing created local beers on Quincy Street Northeast. The

Owner and brewer Rob Miller is also the face of the distinctive Dangerous Man Brewing Company's logo. *Courtesy of Sherman Wick.*

microbrew aggressively developed regional styles, including, appropriately, a wild rice beer. But the company's precarious financing collapsed, and contract brewers were used. Finally, in 2005, James Page closed—just as a Minnesota brewing revolution was about to begin.

Omar Ansari opened Surly Brewing Company in Brooklyn Park in January 2006. The craft brewery soon found a fanatical local and national following with its flavorful beers. Ansari believed the state's antiquated post-Prohibition liquor laws impeded the growth of the craft beer movement. Local boosters wanted a beer scene like those in Colorado, Oregon and California and lobbied for reform. In 2011, Governor Mark Dayton signed the omnibus liquor bill HF 1326—the "Surly Bill." The three-tier system that separated alcohol manufacture, distribution and retail sale for small-scale brewers ended. Brewers could brew, sell pints or growlers and distribute to restaurants, bars and liquor stores.

The law set in motion the development of the Northeast Brewers District. Indeed Brewing Company was the first to open in the summer of 2012, followed by 612 Brew Company (2013), Dangerous Man Brewing Company (2013), Northgate Brewing Company (2013), Sociable Cider Werks (2014), Norseman Distillery (2014), Bauhaus Brew Labs (summer of 2014), Fair State Brewing Cooperative (late summer 2014) and Insight Brewing Company (fall 2014). Fulton Brewing, named after a Southwest Minneapolis neighborhood, moved most of its brewing operations to a huge fifty-one-thousand-square-foot space at 2540 Second Street Northeast in 2014. Once again, Northeast Minneapolis has a variety of neighborhood beer of high quality.

Like artists before them, brewers and distillers rehabilitated vacant factories. Or, as in the case of Rob Miller—the face on the Dangerous Man Brewing Company logo—the brewery has repurposed the old Northeast State Bank (also known as Thirteenth Avenue State Bank). The bank, organized in 1947, attended to the underserved economic needs of the immigrants and their families. On the corner of Thirteenth Avenue and Second Street Northeast and within a few blocks of the Grain Belt Brewery, it is where, no doubt, countless employees deposited their paychecks.

Northeast Minneapolis remains revered as a place for diverse groups of people and is now a destination for the hip, cool and urbane. Magic happens when people from disparate backgrounds work together toward the goal of making the best of something, whether it's lumber, coffins, corn seeds, paintings, ceviche, dolmades, pretzels, pizza, tacos or craft beer. Communities grow on the belief that they truly have something worthwhile to share, and time after time, this has happened in Northeast.

SELECTED BIBLIOGRAPHY

Aby, Anne, ed. *The North Star State*. St. Paul: Minnesota Historical Society Press, 1997.

Anderson, Philip J., and Dag Blanck, eds. *Swedes in the Twin Cities: Immigrant Life and Minnesota's Urban Frontier*. St. Paul: Minnesota Historical Society Press, 2001.

Anfinson, Scott F., ed. *The Minnesota Archaeologist: Archaeology of the Central Minneapolis Riverfront, Part 1 and Part 2*. 2nd ed. St. Paul: Minnesota Archaeology Society, 1990.

Atkins, Annette. *Creating Minnesota: A History from the Inside Out*. St. Paul: Minnesota Historical Society Press, 2007.

Atwater, Isaac, ed. *The History of the City of Minneapolis, Minnesota*. New York: Munsell and Company, 1893.

Blegen, Theodore C. *Minnesota: A History of the State*. Minneapolis: University of Minnesota Press, 1975.

Bond, J.W. *Minnesota and Its Resources*. Chicago: Keenshee, 1856.

Chittendon, Newton H. *Stranger's Guide to Minneapolis and Surrounding County*. Minneapolis: Tribune Printing, 1869.

Costello, Augustine E. *The History of the Fire and Police Departments of Minneapolis*. Minneapolis: Relief Association Publishing Company, 1890.

Crockett, Richard. *The Quarry: A Planning Development History of the Northeast Minneapolis Retail Center*. Minneapolis: Windom Park Citizens on Action, 2007.

Cross, Marion E., trans. *Father Louis Hennepin's Description of Louisiana: By Canoe to the Upper Mississippi River in 1680*. Minneapolis: University of Minnesota Press, 1938.

Dahlquist, Alfred J. "Maple Hill Cemetery." *Minnesota Genealogist* (December 1978).

Day, Holly, and Sherman Wick. *Insider's Guide to the Twin Cities*. 3rd ed. Guilford, CT: Globe-Pequot Press, 2002.

Doche, Viviane. *Cedars by the Mississippi: The Lebanese Americans in the Twin Cities*. San Francisco: R and E Research Associates, 1978.

Ebbot, Elizabeth, and Kathy Davis Graves. *Indians in Minnesota*. 5th ed. Minneapolis: University of Minnesota Press, 2006.

Finance and Commerce of the Twin Cities (Minneapolis, MN), February 21, 1913.

Folwell, William Watts. *A History of Minnesota*. Vols. 1–4. St. Paul: Minnesota Historical Society, 1922.

Garraty, John A., and Mark C. Carnes. *A Short History of the American Nation*. Vols. 1 and 2. 8th ed. New York: Addison, Wesley, Longman.

Gelb, Norman, ed. *Jonathan Carver's Travels through America 1766–1768: An Eighteenth-Century Explorer's Account of Uncharted America*. New York: John Wiley and Sons, Incorporated, 1993.

Green, William D. "Eliza Winston and the Politics of Freedom in Minnesota, 1854–60." *Minnesota History* (Fall 2000).

Hart, John Fraser, and Susy Svatek Ziegler. *Landscapes of Minnesota: A Geography*. St. Paul: Minnesota Historical Society Press, 2008.

Holcombe, R.I., ed. *Compendium of History and Biography of Minneapolis and Hennepin County, Minnesota*. Reprint, Chicago: Henry Taylor and Company, 1914.

Holmquist, June Drenning, ed. *They Chose Minnesota: A Survey of the State's Ethnic Groups*. St. Paul: Minnesota Historical Society Press, 1981.

Hoverson, Doug. *Land of Amber Waters: The History of Brewing in Minnesota*. Minneapolis: University of Minnesota Press, 2007.

Johnson, Kathryne. "Northeast Landmark Starts Second Life: Little Sisters of the Poor St. Joseph's Home for the Poor Becomes Stonehouse Square Apartments." *Hennepin County History* (Fall 1980).

Jones, Cassie. "Jackson Flats Open for Artists and Families in NE Minneapolis." *The Journal* (June 24, 2014).

Kane, Lucile M. *The Falls of St. Anthony: The Waterfall that Built Minneapolis*. St. Paul: Minnesota Historical Society Press, 2013.

Kieley, Genny Zak. *Heart and Hard Work: Memories of "Nordeast" Minneapolis*. Minneapolis: Nodin Press, 1997.

Kramarczuk, Myron. *Touched by Two Worlds: The Kramarczuk Family's Flight to Freedom*. Clifton, NJ: Computoprint Corporation.

Lass, William E. *Minnesota: A History*. 2nd ed. New York: W.W. Norton and Company, 1998.

Long, Stephen H. *Voyage in a Six-Oared Skiff to the Galls of St. Anthony in 1817*. Reprint, Philadelphia: Henry B. Ashmead, Book and Job Printer, 1860.

Lumberman and Manufacturer, November 24, 1876.

Maccabee, Paul. *John Dillinger Slept Here: A Crook's Tour of Crime and Corruption in St. Paul 1920–1936*. St. Paul: Minnesota Historical Society Press, 1995.

Mann, Charles C. *1491: New Revelations of the Americas Before Columbus*. 2nd ed. New York: Vintage Books, 2011.

Martin, Judith A., and David A. Lanegran. *Where We Live: The Residential Districts of Minneapolis and Saint Paul*. Minneapolis: University of Minnesota Press, 1984.

McCabe, Suzanne. "St. Anthony East: The History of a Community." Unpublished paper, 1997.

Millett, Larry. *AIA Guide to the Twin Cities: The Essential Source on the Architecture of Minneapolis and St. Paul*. St. Paul: Minnesota Historical Society Press, 2007.

Minneapolis Argus (Minneapolis, MN), November 12, 1959, to August 31, 1961; January 1, 1970, to June 9, 1971; and January 3, 1979, to September 26, 1979.

Minneapolis: Development Coordination Board. *Minneapolis Riverfront.* Minneapolis: Minneapolis Riverfront Development Coordination Board, 1980.

Minneapolis Labor Review (Minneapolis, MN), August 28, 1925.

Minneapolis Riverfront Redevelopment Oral History Project: A Series of Interviews Conducted by Journalist Linda Mack. Sound recordings and transcripts. St. Paul: Minnesota Historical Society, 2008–2009.

Minneapolis Star-Tribune (Minneapolis, MN). "Disastrous Breaks in the Early Dams of St. Anthony." September 25, 1904.

———. "Louis Zelle Obituary." January 28, 2003.

"Minneapolis: 'The Lowell' of the West." *Hennepin County History* (Winter 1981–82) (reprint from the *Daily Graphic* (New York), August 17, 1878).

Minneapolis Tribune (Minneapolis, MN), August 14, 1893.

Minnesota History Quarterly (Winter 1998/1999).

Mississippi Valley Lumberman, July 1, 1887; January 20, 1888.

Morris, Lucy Leavenworth Wilder. *Old Rail Fence Corners: Frontier Tales Told by Minnesota Pioneers.* 2nd ed. St. Paul: Minnesota Historical Press, 1976.

Muller, Alix J. *History of the Police and Fire Departments of the Twin Cities.* St. Paul: American Land and Title Register Association Publishers, 1899.

Nathanson, Iric. *Minneapolis in the Twentieth Century: The Growth of an American City.* St. Paul: Minnesota Historical Press, 2010.

Neill, Edward D., and George E. Warner. *History of Hennepin County and the City of Minneapolis.* Minneapolis: North Star Publishing Company, 1881.

New York Times. "Licked Up by the Flames." August 14, 1893.

Nord, David Paul. "Minneapolis and the Pragmatic Socialism of Thomas Van Lear." *Minnesota History* (Spring 1976).

Northeaster (Minneapolis, MN). "Latvians Sell Building, Rent Space Now." April 20, 2006.

———. "W. Dziedzic on 50 Years in Public Life." December 16, 2009.

Orfield, Myron. *Metropolitics: A Regional Agenda for Community and Stability.* Washington, D.C.: Brookings Institute and the Lincoln Institute of Land Use, 1997.

Parsons, E. Dudley. *The Story of Minneapolis.* Minneapolis: Colwell Press, 1913.

Pennefeather, Shannon M., ed. *Mill City: A Visual History of the Minneapolis Mill District.* Minneapolis: Minnesota Historical Society Press, 2003.

Petersen, Penny A. *Hiding in Plain Sight: Minneapolis' First Neighborhood.* Minneapolis: Marcy-Holmes Neighborhood Association/NRP, 1999.

———. *Minneapolis Madams: The Lost History of Prostitution on the Riverfront.* St. Paul: Minnesota Historical Society Press, 2013.

Peterson, Garneth O., and Carole Zellie. *Northeast Minneapolis: Minneapolis Historic Context Study.* Submitted to Minneapolis Heritage Preservation Commission by Landscape Research, 1998.

Pike, Zebulon Montgomery. *The Expeditions of Zebulon Montgomery Pike to the Headwaters of the Mississippi, through Louisiana Territory, and in New Spain, During the Years 1805-6-7.* Reprint, New York: Francis Harper, 1895.

Rog, Frank. *Let Me Be Frank: Growing Up on the Mississippi River, Northeast Minneapolis 1936–1950*. N.p.: self-published, 2002.

Saint Anthony Falls Rediscovered: The Architecture of Minneapolis' St. Anthony Falls Historic District. St. Cloud, MN: *St. Cloud Democrat*, 1862.

Sexton, Barbara, and Lauraine Kerchner. "Maple Hill Cemetery, Hennepin County, Minnesota." *Minnesota Genealogist* (June 1981).

St. Anthony East Neighborhood Association. "St. Anthony Easy, the History of a Community." Unpublished, 1997.

St. Anthony Express (St. Anthony, MN), May 31, 1851 to December 30, 1854.

Steffens, Lincoln. *The Shame of the Cities*. New York: McClure, Phillips and Company, 1904.

St. Paul Daily Globe (St. Paul, MN), June 8 and 9, 1892; August 14, 1893; August 24, 1886.

Sun (Edina). "Northeast: A History." August 1976.

Upham, Warren. *Minnesota Place Names*. St. Paul: Minnesota Historical Society Press, 2001.

Westergren, Ebbe. *Snoose Boulevard and the Golden Mile: Swedish Immigrant Life in Minneapolis in the Early 1900s*. Sweden: Kalmer Läns Museum, 2006.

Williams, J.F., ed. *The Minnesota Guide*. 2nd ed. Bedford, MA: Applewood Books, 1869.

Wills, Jocelyn. *Boosters, Hustlers, and Speculators: Entrepreneurial Culture and the Rise of Minneapolis and St. Paul, 1849–1883*. St. Paul: Minnesota Historical Society Press, 2005.

Wingerd, Mary Lether. *North Country: The Making of Minnesota*. Minneapolis: University of Minnesota Press, 2010.

Wolnewicz, Richard. *Ethnic Persistence in Northeast Minneapolis: Maps and Commentary*. Minnesota Project on Ethnic America, 1973.

INDEX

Z

About the Authors

Holly Day and Sherman Wick live in Minneapolis with their two children, Astrid and Wolfgang, and are longtime family members of the Minnesota Historical Society and the Film Society of Minneapolis and St. Paul. Holly is a writing instructor at the Loft Literary Center and served as a staff writer for Minneapolis community papers *Southeast Angle*, the *Bridge*, *Pulse of the Twin Cities* and *Downtown Journal* for over a decade, and John Wiley published her books *Music Theory for Dummies*, *Guitar All-in-One for Dummies*, *Piano All-in-One for Dummies* and *Music Composition for Dummies*. Globe-Pequot Press published all three editions of Holly and Sherman's books *The Insider's Guide to the Twin Cities*, and Wilderness Press published two editions of their book *Walking Twin Cities*.